Artists Communities

A Directory of Residencies in the United States Offering Time and Space for Creativity

Introduction by
Stanley Kunitz

Alliance of Artists' Communities

ALLWORTH PRESS, *New York*

Published by Allworth Press,
an imprint of Allworth Communications, Inc.,
10 East 23rd Street, New York, NY 10010

Editors: David Biespiel and Tricia Snell
Database Management: Miriam Z. Feuerle
Cover Photo (of The MacDowell Colony): Ellen Foscue Johnson
Cover Design: Douglas Design Associates, New York, NY
Book Design: Sharp Des!gns, Holt, MI

This directory was funded by a grant from The Pew Charitable Trusts.

The opinions expressed in this report are those of the authors and
do not necessarily reflect the views of The Pew Charitable Trusts.

ISBN: 1-880559-65-X

Library of Congress Catalog Card Number: 96-84643

Printed in Canada

In memory of
Anthony Vasconcellos,
1959–1995

Contents

Other Venues

Indices

Acknowledgments

The editors would like to express thanks to:

Staff of all of the artists' communities listed in this directory—for their cooperation in filling out our forms and answering our many questions. Most artists' communities are under-staffed and we appreciate the time given us by the many overworked people who are devoted to providing artists with time and space to work.

Michael Wilkerson (Fine Arts Work Center at Provincetown, and an Executive Committee member and former Chairman of the Alliance), and **Mary Carswell** (The MacDowell Colony and the former Chairman of the Alliance of Artists' Communities)—for their invaluable help in the development of this directory.

Ree Schonlau and staff at the Bemis Center of Contemporary Arts—for their early compilation of information on artists' communities in the United States.

Theodore S. Berger and Mary Griffin of the New York Foundation for the Arts—for completing the 1995 study that provided the basis of our research for this directory, and for their continued interest in and support of the field.

Robert Sheldon, Literature Projects Director at the Western States Arts Federation (WESTAF)—for ongoing advice and steering us toward Allworth Press, our publishers.

Tad Crawford, Robert Porter, Ted Gachot, and other staff at Allworth Press—for their excellent advice and the care with which they have treated our first directory.

The National Endowment for the Arts—for providing seed money to the Alliance of Artists' Communities, for funding the New York Foundation for the Arts' 1995 study, and for continuing to provide funding to the field during this time of crisis for arts funding in the United States.

The John D. and Catherine T. MacArthur Foundation—for conducting their special initiative on artists' communities that led to the founding of the Alliance of Artists' Communities, for providing seed money to the Alliance, and for continuing their invaluable support by funding our recent education and outreach activities.

The Pew Charitable Trusts—for the support that has been essential to the Alliance of Artists' Communities' development over the past two years and for their support of the New York Foundation for the Arts' 1995 study of the field. The Trusts' belief in the importance of the work of artists' communities has allowed us to present you with this book.

Introduction

Port of Embarkation, Ports of Call: Notes from Memory
by Stanley Kunitz

In Henry James's seventieth year a young man wrote to him inquiring what early force or circumstance had impelled him to embark on his arduous creative voyage. James's reply resonates with the eloquence and vehemence of language welling up from a great depth.

> The port from which I set out was, I think, that of the *essential loneliness of my life*—and it seems to me the port, in sooth, to which again finally my course directs itself. This loneliness (since I mention it!)—what is it still but the deepest thing about one? Deeper about me, at any rate, than anything else, deeper than my "genius," deeper than my "discipline," deeper than any pride, deeper above all than the deep counter-minings of art.

Whenever I recall that passage, it summons up an image of myself at twenty-two, early in 1928, packing my single suitcase with all my worldly possessions for the train-ride from Worcester, Massachusetts, to New York, the magnet city of the arts, where I was eager, despite my qualms, to submit myself to the testing. I was leaving Worcester without regrets, for in my hometown I felt, somehow, trapped and isolated, and I was hungry for the taste of cosmopolitan excitement and freedom. In the months that followed I moved into an affordable basement apartment in Greenwich Village and a nondescript editorial job in the Bronx that challenged me to make it bearable. At night I wrote unhappy poems. When I sent them out, they invariably came back to me, but sometimes with an encouraging comment. I was much too reclusive and shy to acquire the new friends I had hoped for.

My life abruptly changed when I was invited, out of the blue, to be one of the first guests at Yaddo in Saratoga Springs, on the estate left in service to the arts by Spencer and Katrina Trask. In that magnificent setting it seemed appropriate to recall Yeats's praise of beauty and high

ease. Liberated from my workaday cares and stresses, and stimulated by the conversation at the dinner table as much as by the wine, I dared to think I might soon be done with my apprenticeship.

In my tower room I wrote poem after poem and began to put together the manuscript of my first collection, *Intellectual Things*, published by Doubleday, Doran in 1930. By then most of its contents had appeared in *Poetry, The Dial, The Nation, The New Republic, Commonweal,* and other periodicals. The editor who broke the news to me on the phone of the acceptance of my book turned out to be the poet Ogden Nash. For a fleeting moment I enjoyed the sensation of being fortune's child.

* * *

At The MacDowell Colony, in the midfifties, I wrote a poem, "As Flowers Are," that I cannot separate from the eventfulness of my visit there and the timeless panorama of those rolling New Hampshire woods and fields. The closing stanza recaptures for me the bliss I knew in the course of one of my late afternoon walks, when I believed I was dissolving into the surrounding landscape, along with my cluster of tangled feelings:

> Summer is late, my heart: the dusty fiddler
> Hunches under the stone; these pummelings
> Of scent are more than masquerade; I have heard
> A song repeat, repeat, till my breath had failed.
> As flowers have flowers, at the season's height,
> A single color oversweeps the field.

I had just been through a year of mingled transport and turmoil. At work in my cabin, I felt that I had found the peace and order and privacy that I desperately needed. My fellowguests, I soon discovered, included three couples from the New York world of painters—Paul and Peggy Burlin, Giorgio Cavallon and Linda Lindeberg, James Brooks and Charlotte Park—to whom I immediately became attached, with what proved to be a lasting bond. It was these new friends who, after our return to the city,

introduced me to the artist Elise Asher; and it was my marriage to Elise that led to my intimate association with the master generation of American Abstract Expressionist painters just before they stepped into the brilliant limelight. The poems I wrote in Peterborough that summer were among the latest, in their final form, to be included in my *Selected Poems 1928–1958* (Atlantic–Little, Brown, 1958). When the book was rewarded with more than usual attention, I felt guilty about having failed to make due acknowledgement of my indebtedness to The MacDowell Colony. I trust it is not too late to do so now.

*　*　*

"A poem is solitary and on its way," said Paul Celan, the poet of the Holocaust, without pausing to explain his cryptic remark. A poem is on its way, I think, because it is in search of people, for only a human response will complete its existence. Most artists—and above all, most poets—need and love their solitude, but no more than they need and love the idea of a community. Even the most highly personal work of art has a social premise. In my own experience, when I have suffered from the absence of a community, I have felt obliged to do something about creating one.

The reason I spend a good part of the year on Cape Cod—aside from the sea, the sky, the dunes, our garden, our house, our friends—is my attachment to The Fine Arts Work Center in Provincetown.

Each year, on the first of October, twenty Fellows—ten visual artists, ten writers—arrive in town from every section of the country and sometimes from abroad, to begin their seven-months' residency. They are emerging artists, at the very beginning of their career, selected from hundreds of applicants on the basis of the quality of their submitted work. Soon they are settled into the Center's compound on the historic site of Day's Lumberyard, where in earlier periods the painters Charles Hawthorne, Edwin Dickinson, Hans Hofmann, George McNeil, Myron Stout, and Fritz Bultman, among others, could be found working in their cheap rented studios. The concept of a workplace in a community of peers remains the actuating principle of the Center today.

Despite its hardscrabble beginning—the Center was founded in 1968 with little more than a dime and a prayer to assure its survival—its Fellows have gone out into the world and consistently won nearly all the major honors and prizes, including the MacArthur "Genius" Award and the Pulitzer Prize for Poetry (twice in a row, in fact, 1993–1994).

A few years ago, as one of the founding fathers, I spoke at the dedication of the new Common Room, whose construction required the sublimation of the massive coal bins inherited from the lumberyard era. "Through all the years of my involvement here," I said, "I have never thought of the Work Center as an institution, but as an adventure, an exhilarating bet on the future of the arts in America. Originally the bins were used for storing coal; now they will be dedicated to a higher form of energy, the imagination."

*　*　*

Postscript: The Arts in Crisis

Like all cultural organizations in the United States, our artists' communities are suffering from dwindling federal and state support and seriously threatened by the apparent success of the campaign for the total elimination in the near future of the National Endowment for the Arts. Contrary to popular misconception, other advanced industrial countries routinely spend five to fifteen times more per head on the arts than we do. The latest available statistics show that such expenditures amount to only $4 per head per year in the United States, compared with $19 in Britain, $43 in France, and $55 in Sweden.

What are we to make of this discrepancy? In the history of nations, the neglect or suppression of the arts is an augury of national decline. Poetry and myth—to which all the arts contribute—are the element that from generation to generation holds a people together and keeps alive the spirit of their covenant.

"Degrade first the Arts," wrote William Blake, "if you'd Mankind Degrade."

New York
June 1996

Preface

The Alliance of Artists' Communities compiled this directory with a twofold purpose: *first,* to put information about artists' communities into the hands of more artists around the country, and *second,* to improve general understanding of the field among artists, educational institutions, government and private policymakers, and the general public.

If you are an artist or scholar looking for an artists' community that fits your special needs, please read the next few paragraphs and "How to Use this Directory," below, to help take full advantage of the information contained in this directory.

If your interest leans toward our second purpose, you might best begin by reading Stanley Kunitz's eloquent introduction, or the testimonial essays written by artists, about their residency experiences. Then, for a look at the history, challenges, and needs of the field of communities, see "An Overview of the Field of Artists' Communities," by Michael Wilkerson, who has a long and dedicated relationship with the field. He is now the Executive Director of the Fine Arts Work Center in Provincetown, was previously the Executive Director of the Ragdale Foundation, and is an Executive Committee member and former Chairman of the Alliance.

Some Generalizations about the Communities Listed in this Directory

The criteria for inclusion in this directory comes from the Alliance's guidelines for institutional membership. (Membership in the Alliance, however, was not a requirement for inclusion; our goal was to present as comprehensive a view of the entire field as possible.) The guidelines are as follows:

- A primary purpose of the organization is support for artists in the creation of work;
- The organization brings artists together into a community, removing them from their everyday obligations and providing uninterrupted time to work, in a specific site that is dedicated to that mission;

- The organization selects artists for residencies through a formal admissions process that is rigorous in terms of artistic quality and regional, national, and international in scope; and
- The organization is not-for-profit, has artists represented in its governance, and maintains a paid professional staff.

In short, the seventy communities featured here provide studios and housing for artists (and sometimes scholars) in a community environment that supports more than one artist at a time.

The list of seventy communities is based on the New York Foundation for the Arts' 1995 study (funded by the National Endowment for the Arts and The Pew Charitable Trusts) of the field of artists' communities, supplemented by lists compiled by the National Association of Artists' Organizations, the Visual Artists Information Hotline, and the Alliance of Artists' Communities. Still, research on the field is so nascent that we have likely omitted some communities. If so, we would like to hear from you so that we can improve the next edition. (Note: Two artists' communities that we felt fit our criteria, the Bellagio Study and Conference Center and the Helene Wurlitzer Foundation of New Mexico, declined to be included in the directory to avoid an increase in the number of artists applying to their programs. A few others, such as The Griffis Art Center, did not respond to our requests for information.)

Upon contacting the communities on the various lists mentioned above, we found that some did not fit the Alliance's definition of an artists' community, though they conducted similar programs. In order not to confuse our definition, as well as not to miss the opportunity to publicize these programs to artists, we include them in a separate list called "Other Venues." These organizations provide a variety of valuable services, such as: single-person residencies (where a community environment is not part of the experience), fellowship grants (where no studio or housing is provided), and

studio collectives (where no housing is provided, and studios are rented by artists).

Also, some organizations on the "Other Venues" list are artists' communities still in the start-up phase. Others may have temporarily discontinued their residency program while they raise more funds or restructure. We suggest that you call or write directly for details on their current programs.

Finally, please keep in mind that "Other Venues" is merely an overflow list and is not the result of comprehensive research. The same is true for our International Artists' Communities list, which comes directly from the newly forming International Association of Residential Arts Centres and Networks, known as *Res Artis*. These two lists are presented here to help artists in need of support, and no doubt they could be expanded. The Alliance's main goal in publishing this directory, however, is to define and publicize artists' communities in the United States.

How to Use this Directory

The seventy communities are arranged alphabetically. Representatives from each community provided information concerning their residency program and approved the final version of their entry. Each entry includes basic facts (phone, address, e-mail), facilities and housing descriptions, admissions background (average number of artists present at one time, ratio of artists applying and artists accepted), scholarship, fellowship, and stipend opportunities, and statements by a former resident and by the community's director. The entries also identify which communities are members of the Alliance of Artists' Communities.

All of the information is listed concisely in a standard format to help you quickly find the information you want and compare specific attributes that are important to you. You will find that each community has a unique approach to the support of their artists. The question is only which is best for you.

Many artists' communities must charge nominal residency fees in order to cover some of their operating costs. Some, however, offer fellowships, financial assistance, or work exchanges—be sure to check to see what a community may be able to provide. All commu-

nities with fees are working to reduce them through a variety of other programs and fundraising campaigns. However, a stay at an artists' communities is a bargain when you consider the tangible benefits: time, space, facilities, the company of peers, and freedom from domestic chores. Not to mention the less tangible benefits—the positive, long-term effects on your work.

Because this directory comes from the field —conceived and compiled by the Alliance of Artists' Communities, with each artists' community approving its own entry—we believe it to be the most accurate reflection of our field to date. Still, deadlines change, fees rise or fall, funding for fellowships comes and goes. Application forms and requirements (such as manuscript pages, slides, tapes, recommendation letters) seem to change the most often of all, and this is why we have not included specific information about them in this directory. *Artists should contact the communities directly to find out exact requirements for applications, fees, and documentation necessary to apply and attend.*

Indices

At the back of the directory, five indices, in the form of charts, will help you target a community suitable for your needs. You may want to select communities based on an artistic category, geographical region, season, admission deadline, costs, available stipends, or accommodation for a disability.

If, for example, you are a sculptor with limited funds and three weeks free in February, consult the Seasons and Deadlines chart. There you'll find the communities that are open during the winter, and you can then consult the Artistic Categories chart to see which of these support sculptors. Then, cross-reference to the Fees and Stipends chart to see what's available from those communities.

If you are in need of wheelchair accessibility, check the Disabled Access chart to see which communities have accessible housing, bathrooms, and studios. All of the artists' communities in this directory, even if they do not have specific equipment or facilities, reported a willingness to adapt facilities to accommodate disabled artists. Since some communities are in

rural areas with rough terrain, though, it's important to find out what adaptations are possible.

Our Hopes for this Directory

The Alliance of Artists' Communities regularly receives calls and letters from artists requesting information about residency programs. The number of these inquiries has risen dramatically since the National Endowment for the Arts was forced to cut the majority of their fellowship programs. These are hard economic times for most artists, and finding time and space in which to work is more difficult than ever.

The Alliance also receives, however, a remarkable number of calls from people, many of them artists, who have decided to establish new artists' communities. These decisions are not made lightly, given the prerequisite time, labor, and fundraising involved. But by the time this directory goes from galleys to print, at least five new communities will have been born. A quiet, grassroots movement is afoot, in response to the falling-off of public programs that support artists, to create new residencies that directly serve artists' most immediate needs.

Collectively, artists' communities represent a century-old, national support system for artists and thinkers. In 1995, the seventy artists' communities listed in this directory provided residencies to about 3,600 residents. It's our mission to strengthen and expand this support system, encourage more artists to participate in it, and by doing so, nurture the new cultural work of our country.

All of us who have worked on producing this book hope that it will help you find the support you need in your work, your career, and your ability to grow as an artist.

Tricia Snell, Executive Director
Alliance of Artists' Communities

What Are Artists' Communities?

Artists' communities are professionally run organizations that provide time, space, and support for artists' creative research and risk-taking in environments rich in stimulation and fellowship. Whether they are located in pastoral settings or in the middle of urban warehouse districts, artists' communities have been founded on the principle that through the arts, culture flourishes and society's dreams are realized. Some of America's most enduring classics have been created at artists' communities: Thornton Wilder's *Our Town*, Aaron Copland's *Appalachian Spring*, James Baldwin's *Notes of a Native Son*, and Milton Avery's paintings, to name a few.

Artists apply for residencies at a community, submitting a variety of materials, such as slides, manuscripts, or tapes, illustrating their work and intentions to the community's jury or panel.* If their application is successful, they arrange the details of their residency with the community's staff. They may receive a stipend or be required to pay a fee, depending on the community, and details about equipment and materials needs, accommodations, and reimbursement for expenses vary.

Once at a community, artists are given studios or workspaces, housing (or reimbursement for the cost of housing), and often meals. Their residencies may last anywhere from a few weeks to a year. During their residency, artists are free to work twenty-four hours a day if they choose, though some communities may require some light duties to be performed.

According to the Alliance's survey of the field of artists' communities and residency programs for this directory, about 3,600 artists were residents at American artists' communities in 1995. This 3,600 includes painters, writers, composers, sculptors, filmmakers, photographers, performance artists, storytellers, choreographers, installations artists, architects, art historians, scientists, and scholars. (See the Artistic Categories chart at the back of this directory for a comprehensive list.) To engender ideas and dialogue that cross disciplinary, aesthetic, cultural, gender, social, and geographic barriers, most artists' communities aim for a broad mix of residents at any one given time.

Artists' communities and those who support them are committed to the principle that art stimulates new ways of thinking and new ways of seeing. It should come as no surprise then that the voices and visionaries of our own times continue to be cultivated at artists' communities: poets like Gwendolyn Brooks and Louise Glück, fiction writers Fae Myenne Ng and Allan Gurganus, nonfiction writers Alex Kotlowitz and Stanley Crouch, composers Ned Rorem and John Adams, visual artists Lawrence Wiener and Portia Munson, choreographer Bill T. Jones, performance artist Guillermo Gomez-Peña, and the experimental theatre company Mabou Mines, all created work during residencies at artists' communities. Many lesser known artists are working at artists' communities now, and in the months and years to come their books, exhibitions, pieces, performances, and productions will become known to us.

The future of American culture depends on supporting a broad array of artists. Providing this support is the fundamental, vital work of artists' communities.

*See also "Some Generalizations about the Communities Listed in this Directory," contained in the Preface.

Artists' communities are the nation's research and development laboratories for the arts. Founded almost exclusively by artists and occupying virtually every kind of imaginable space—from grand country estate to abandoned military base to renovated urban factory—they spring from many different roots, but they serve exclusively to nurture art and to support artists at the most vulnerable and invisible junctures of the creative process.

The field's origins go back to the beginning of art. There is written record of ancient Greek and Roman writers and artists retreating to the countryside to places where they could work, free of the influences of the marketplace. Throughout more recent eras, artists' work places were typically organized by wealthy patrons, who would provide a studio and a haven for the artist to create a work the patron had commissioned. In the United States around the end of the nineteenth century, several country estates were made into artists' communities by their owners, and in order to take advantage of the opportunities they offered, one had to know or be a member of the owner's family. Sometimes, though, artists joined together on their own to seek not only a special place, but a community of like-minded souls who understood the fragility of the work in progress and the concomitant need for affirmation, support, and enlightened critique from their peers.

The artists and writers of these early American communities participated in everything from feeding chickens to landscape painting to writing novels to editing literary magazines to putting on plays in the adjacent outdoor theater. The environments were beautiful and the physical and emotional support levels outstanding. But still, an artist couldn't just apply to go to one of them, and, for many years, only two places in the United States—MacDowell and Yaddo—accepted applications from artists without family connections in what we would now consider a standard selection process.

Today, artists still need places to work and other artists to commune with, but the mechanisms for support of the creation of new work have changed dramatically. In the United States, the impulse to support artists has been democratized, both by government and foundation-sponsored individual fellowships, and by the creation of artists' communities that are open to all by application and that are supported by a variety of sources. And as has been discovered by the founder of every artists' community so far, once the doors are open, the artists will come.

The standard evolution of an artist community is that at first, no one knows about it outside the founder's circle of friends and acquaintances. Within a few years, hundreds are applying, the management is more professional, there is at least a semblance of a sustaining development effort, and the consuming questions change from household maintenance to cultural diversity, sufficient fairness in the panel process, and fundraising.

Today, based on the Alliance of Artists' Communities' definition of an artists' community (see Preface), we estimate that about seventy to eighty formally organized artists' communities exist in the United States, serving thousands of artists annually. The seventy communities listed in this directory, for example, collectively provide residencies to about 3,600 artists each year. By contrast, the National Endowment for the Arts' Literature Fellowships, at their pinnacle, supported approximately seventy-five writers a year; the Lila Wallace and Lannan fellowships, between ten and twenty each; most state arts council fellowships, a similarly small number.

The field of artists' communities is growing so rapidly that during the year spent compiling this directory, the Alliance of Artists' Communities was in communication with nine new communities in the developing stages. Other communities are likely up and running that we have not even heard about. (It is certain that this directory will require updating almost as soon as it is published; anticipating this, the Alliance is maintaining the directory's information on a database that will be continually updated until a second edition of the directory becomes needed.)

New artists' communities tend to serve emerging artists. As the organization becomes better known, it serves artists at more advanced stages in their development and careers, so that at maturity—where MacDowell and Yaddo and a few others now stand—admission is much more difficult than at a newer place. Other organizations focus on particular art forms or offer specialized facilities, such as filmmaking, computer graphics, sound recording, printmaking, or ceramics. This does not mean that one community is "better" than another—there are drawbacks to popularity and the long odds on admission—but it points out that the continual emergence of new artists' communities is providing a system of support to a greater number of artists each year.

The expansion of the field of artists' communities is demand-driven, the demand coming *from* the artists. This reverses the usual context, in which much is demanded *of* artists: teach in the schools, work with prisoners and in nursing homes, read at numerous bookstores to promote the novel once it's finally published, serve as a volunteer editor/curator/producer-director; raise a family; make a living. Not one of these worthy tasks has much to do with what the artists themselves want and need most, which is the opportunity to create new art.

In recent years there has been much discussion of "the support system for artists." But this is not an organized or even vestigial system. Even in the art world, little is known about artists as creators or about the nature of the creative process, and little support is offered to artists. To remedy this lack of a support system, artists' community founders and directors (like myself) have joined together to form the Alliance of Artists' Communities, which has in four years' existence become an increasingly strong voice for this growing field. Together, we are trying to build a more organized system to understand the needs of artists and to offer help where it is most critically required. Clearly, time and space to work (i.e., residency programs) are still a primary need. And more and more these days, artists' communities are offering production, exhibition, performance, and publication as an outgrowth of their residency programs, recognizing that the "products" of the creative process are also in need of support.

Artists' communities aren't the only support or even the primary support artists have available. But those of us who run artists' communities do know artists very well, perhaps uniquely well, since we live as well as work with them. We believe that artists' communities can serve as a support system for a great many artists as well as a voice for the needs, lives, and hopes of artists.

The continued growth of the field of artists' communities will make it increasingly possible for artists to find the proper match in terms of level of intensity, type of colleagues, disciplines served, atmosphere, length of residency, convenience of access, urban or rural environment, equipment and facilities available, curatorial stance of the board and/or staff, and other variables. In order words, to serve as a real support system for artists in this country.

Along with the demand by artists for opportunities to create new work, there is a second motivation for starting an artists' community: the preservation and stewardship of exceptional places. Artists' communities own, lease, or manage thousands of acres of nature preserve, woodlands, prairie, oceanfront, wetlands, and mountains. Some also occupy and care for a vast range of beautiful buildings, many of which are on the National Register of Historic Places. But, as Ragdale's founder, Alice Reyerson Hayes, explained, "it wasn't just the house and the land I wanted to save [by starting an artists' community]; I wanted to save the feeling that went with it. There's a spirit to this place which is uniquely inspiring, and I thought it too valuable to lose."

That spirit, derived from the place but infused by the creative endeavors of, in some cases, generations of distinguished occupants, suggests that artists' communities are doing something that needs more examination and replication outside the arts: creating bonds like those of a new extended family. The informal professional relationships and interdisciplinary insights artists derive from their residencies suggest possibilities for reaching solutions in other fields, or opening this field up to people outside the arts. Some artists' communities are already doing this. The American Academy in Rome accepts a variety of scholars in its program. The primary focus of both the Exploratorium and the STUDIO for Creative Inquiry is to bring together artists and scientists.

Artists' communities may be in a position to take a leadership role in a number of critical efforts: restoring the centrality of artists to our culture; developing new ideas of community and extended family; giving the creative process the same measure of esteem and significance as product, which is badly needed in all sectors of our society, not just the arts. At this point, those of us with experience in the field—not just administrators, but artist-alumni as well—know the importance of these efforts, and of how much artists' communities, simply by fulfilling their mission of supporting groups of artists at work, have achieved.

Despite these achievements, artists' communities, like all arts organizations, are in a difficult environment today. Artists' communities face several unique challenges:

- Artists' communities are financially insecure in large part because we have few opportunities to earn income (e.g., by charging admission) unless we create public programs that are separate from our residency program. Public programs are no guarantee of financial stability either, but without them, an artists' community's revenue sources are slim.

- Artists' communities' emphasis on process (rather than product) creates an invisibility problem for us, which in turn further exacerbates the income problem. Because support for an artists' community does not immediately lend visibility or status to the donor (as, for instance, support for an exhibition, performance, or publication does), it is difficult to attract donors.

- The first concerted effort to advocate for the field of artists' communities began in 1992, when the Alliance of Artists' Communities was founded. The field has not yet had enough time to work together to develop a foundation of strong national support that can be relied upon during the current period of general austerity in the arts.

It is not surprising then that the 1995 New York Foundation for the Arts' *Study of Artists' Communities and Residency Programs* (funded by the National Endowment for the Arts and The Pew Charitable Trusts) described the entire field as, in general, "stuck, often for many years,

at the emerging organization level, unable financially to take the next step." The most obvious cause of the field's economic problems is its lack of visibility. Earlier this year, a database search at a university library, combing 14,000 publications by computer, yielded no articles at all under "artists' communities," "artist colonies," or "artists' residency programs."

Furthermore, some artists' communities are so committed to the creative process that they are reluctant to play the famous alumni card as a strategy for visibility and the funding that follows it, even though all of the Alliance of Artists' Communities' members and most others have had major artists in residence and significant, lasting works created on their grounds. Fame and external reward are the very opposite of the quiet, internal work that artists' communities support. Therefore, an institutional personality transplant sometimes may be needed before artists' communities can seek recognition for the famous artists that we have supported.

There will be no real progress for artists and artists' communities until we are better known and understood. By exposing others to the ways of artists' thinking during the creative process, we may gain esteem and respect, and society, in turn, will be investing that respect in people who may carry within them the basis for solving difficult problems. A better organized field of communities actively communicating with each other will help the field create both large and small opportunities for continued expansion and influence. That is one of the central missions of the Alliance of Artists' Communities.

The brief history of the Alliance of Artists' Communities is a story of attempting to solve difficult problems. Eighteen artists' communities were included in the John D. and Catherine T. MacArthur Foundation's one-time funding initiative of 1990. These eighteen communities decided to meet in early 1991, an event that led to the formal founding of the Alliance of Artists' Communities in 1992. The Alliance was aided in its founding by the MacArthur Foundation, which underwrote our first two meetings and gave us a small start-up grant, and by the National Endowment for the Arts, which gave us an initial grant and, perhaps more significantly, challenged us to define artists'

communities as "a dynamic field, not just a list of grantees."

In the past four years, we have largely fulfilled that challenge. We have created a communication network for artists' communities that provides for the exchange of information, ideas, and resources; compiled information and statistics on the field that are helpful to artists and artists' community directors; raised the level of visibility of artists' communities on the national arts and political landscapes; established ties with international artists' communities; established field-wide standards for artists' communities; and launched a campaign to broaden the diversity of artists served at artists' communities.

In 1995, with funding from The Pew Charitable Trusts, we have compiled this directory, which will provide artists with vital information about residency programs as well as go a long way toward educating the general public, arts policy-makers, and arts funders about our field. We are also holding a national symposium on artists' communities and the nature of creativity (entitled "American Creativity at Risk"), to be held at Brown University and the Rhode Island School of Design in November 1996 (The Pew Charitable Trusts provided a leadership grant for this project also). While the Alliance has held seven member meetings since 1991, this symposium will be our first public meeting, that is, including the entire field of artists' communities as well as many other arts leaders from around the country. Concurrent to this work, we are conducting a variety of public education and outreach projects (with funding from the John D. and Catherine T. MacArthur Foundation).

The Alliance has made it possible, for the first time, for the many organizations under its umbrella to move from "emerging" status toward the kind of long-term stability enjoyed by only a few communities, yet critical to all. That stability is important, not only in terms of preservation of environments and histories, but also to ensure that artists everywhere will have a solid national network of diverse places to work. As the economics of making art continues to become more difficult, the widespread availability of artists' communities becomes more central to the lives of more artists.

The Alliance's priority is to become a voice for the entire field. As we do this, we will work to make artists' communities better known and understood. In the past, artists' communities themselves have had little opportunity to learn of or about each other. And our own supporters have at times displayed a weak understanding of the size and breadth of our field, of the nature of artists we serve, and of the ways we serve them. Toward both visibility and unification, we have begun by publishing the directory that is now in your hands. This volume is a tool that we will use to increase knowledge of our field among artists, arts organizers, funders, and patrons.

Obviously, these efforts toward advocacy and visibility represent the groundwork toward adequate funding. It's important to note how important more funding is to this field. Many of us charge a daily fee to the artists we support, some on a sliding scale, some at a fixed rate, only because other funding sources won't bring the operating budget into balance. We can serve an even better and broader representation of artists without such fees, but now they tend to be rising, not falling. And even organizations that don't charge a fee have, at times, awesome capital needs or limitations on how many months their programs operate due to lack of resources (one of our members has no heat in its buildings, for instance, another no electricity).

Programmatically, we would like to do more curating of special, themed residencies, more international work, more blending of artists with thinkers of other disciplines, particularly toward the purpose of creating more visibility and respect for artists as problem solvers, visionaries and decision-makers. There should be a follow-up to the New York Foundation for the Arts' study of the field of artists' communities that investigates and tries to further codify the intangible benefits of artists' communities.

We would like to produce more publications, exhibitions, and documentation of what goes on at our communities. We would like to utilize our reservoir of talented alumni to create books, articles, films, videos, exhibitions, and CD-ROMs about our field. We would like to forge links with broadcasting, cable, computer technologies, and the new national information infrastructure that is rapidly developing.

To do any of the above, let alone all or a

significant portion of it, we will need to develop significant new sources of revenue. Even if we make no dramatic program changes the demand for our services by outstanding artists so far outstrips available space and time that we know we must grow. As awareness of our field grows, we hope to encourage the creation of new, multimillion dollar funding programs to which any artists' community can apply, dedicated to fulfilling some of our best ideas. We would like to look back at this time, when the first directory of our field was published and when we held our first national symposium about the value of creativity, as the catalytic beginning of a new era for artists' communities and, by extension, for artists in America.

Michael Wilkerson, Executive Director
Fine Arts Work Center in Provincetown

Sharon Greytak, Filmmaker

As a filmmaker, I have been in residence at The MacDowell Colony several times since 1987 to work on scripts and most recently to film several sections for the feature film, *The Love Lesson.* My experiences there have been some of the most important and gratifying of my professional life.

I can best describe the great affection I hold for MacDowell through a parallel of my first residency and the most recent one.

In April 1987, I arrived at the colony just before the dinner bell. I had seen only the wooded path to my studio, dropped my bags, and wandered down to Colony Hall. "No twenty-four-hour Korean delis here," I thought. The dining room was in full swing. Table conversations were lively and friendly and pleasant. So far so good.

For several weeks prior, I had wondered if I could be productive in what I thought would be an artificial environment for creativity. Urban life had always fed my work. I worried that nature would soften me. But my New York City apartment was full of distractions, and the writing was slow.

After a hearty New England supper, the group gravitated down a narrow hallway, and into a large room where residents played Ping-Pong, shot pool, and read by the fire.

I thought: "Oh, I've made a terrible mistake. I must have been working too hard. Someone's sent me away for a long rest."

The rustic scent of mahogany, the pinging and ponging, made me yearn for some familiar concrete beneath my feet.

The next morning, however, I began writing with a clarity and energy I had not felt in a long time. Within three days I had written what would have otherwise taken two weeks. I was taking more risks with the content of the piece. The environment was influencing me, and I could not believe the enormous gift I had been given—of time and faith in the value and direction of my work.

And not just my work. Residencies at The MacDowell Colony have enabled me to collaborate with other artists outside of my field. Music for my first feature film, *Hearing Voices,* was written by New York composer Wes York. German composer Cord Meijering composed the score for *The Love Lesson.* Collaborations like these are not rare at the colony. It is staggering to watch such strong connections develop between artists who live thousands of miles apart, or merely two blocks from one another. There is a basic level of trust and common purpose that fosters these joint creations. Outside of the MacDowell environment, these collaborations would be difficult at best to create.

MacDowell works a magic of its own. Years later, during a residency to work on the script for *The Love Lesson,* I wrote a scene involving a snowball fight between two people in the woods. For the sake of blocking camera direction and general atmosphere, I visualized the scene using the layout and environment of my studio at MacDowell. Two years later, at 5:30 A.M., in deep March snow, I found myself filming that scene at the colony. Setting up an exterior wide shot of Watson Studio, I had rehearsed the actors several times running downstairs and breaking into their snowball fight. In the last few moments of preparation, I sat alone, taking in the image of this glorious and elegant studio. Set slightly on a hill and surrounded by pine trees, it is symmetrical in proportion, with stately columns, a crisp white picket fence, and a centered doorway inset with an oval portrait glass. Daylight was just beginning to brighten the sky as we prepared for the take. The silence of the woods and the muffled presence that snow permits made me acutely aware of having come full circle. Never would I have imagined that something written within those walls would later be realized on screen in the place of its origin. It was a rare moment of clarity, a tangible window in time where I felt comfortable with, and understood better, the purpose of my artistic life.

Jane Hamilton, Writer

I was twenty-five when I first went to Ragdale. It was years before I would receive a grant or sell a novel, but that four weeks in Lake Forest was the first time I thought that maybe, possibly, I could actually justify spending time writing, that I could give a name, perhaps even out loud, to this thing I needed to do. Professionally, so to speak, I had only waitressed and picked apples. Writing was in the category of an idle fancy to grow out of, a hobby, something on a par with counted cross-stitch or checkers. After a month of quiet by day at Ragdale, and by night the good conversation of artists in all stages of their careers, I came home believing I could write.

Rilke said that in order to write he needed "unconfined solitude . . . (a daily routine) without duties, almost without external communication." As a mother and the wife of a farmer, those specifications for the writing life have alternately made me want to weep into a five gallon drum and laugh my head off.

For any artist, there is the profound problem of integrating the life of the imagination with the noise, the mess, the details, and the relationships of real life. Over the years, Ragdale, both psychologically and physically, has made it possible for me to write novels. Whether an artist has a job or a family, or both, on top of the responsibilities to the artist's real work, there are the incessant demands of the ordinary world.

Without money for time and space, there were weeks, months, years when I had to hold that thought. And then, eons later, there was the bitter work of trying to find the thought that had seemed important—No, that was important! Wasn't it?—on the scrap of paper, on my desk, in the bedroom, where there were also laundry piled, and bills to be paid, shoes to be taken to the repair. Better to look on the floor, where the scrap surely had fluttered among the dust and catalogs, unread books, last year's tax returns.

I have spent many moments through the years, as my children have gone through their wonderful stages, most of which involve a great deal of noise, and in the face of the unrelenting chaos of real life, closing my eyes, shutting out the disaster at hand, and thinking of myself walking down Green Bay Road, taking the turn into the drive, walking into the Ragdale house, smelling, seeing, feeling the stillness, and best of all, listening and hearing absolutely nothing. It is at Ragdale that Rilke's prescription for the creative life is secure. It is at Ragdale that I escaped real life long enough to gather all of the scraps that had gathered on my desk, and begin the long work of turning the various and myriad thoughts into one novel.

I've felt at Ragdale, more than any place I've ever been, that the individual voice and vision of the painter, the sculptor, the poet, is still important, and indeed essential. It is not always easy to believe that our lone voices matter or are being heard in the modern age. Above all, what Ragdale gives the artist, for the weeks or months we are staying, is the confidence that anything, all things are possible. If we are lucky, we carry that priceless feeling back to real life.

Linda Tarnay, Choreographer

A day in the life: Being an early riser, I am the first to greet the rabbits and guinea hens who populate The Yard grounds. I bicycle down the hill to the Menemsha dock, where I buy coffee and doughnuts at the gas station. I join the fishermen and the boating people in an early inspection of the day—the wind, the water, the weather—these things *matter* here.

During my reverie on the jetty, I think about the dance I'm working on: What do I want to accomplish at today's rehearsal? How can I keep the third section from sagging in the middle? What will the total shape of the dance be? It is delicious to have the time and tranquility for these reflections.

Returning to The Yard, I see that some dancers are sitting on the front steps, hugging their coffee cups. They will not have to do battle on the subway to get to their morning class; they need only cross the driveway to the cool and spacious Barn Theater. I am teaching company class this morning. Tomorrow I will be a student. Quietly we begin coaxing our bodies into warmth and flexibility. I love this time when we all come together to practice, to submit our muscles and our egos to the demands of the work.

After class we meet with Yard founder/director Patricia Nanon to discuss the week's schedule and other business. Who will go grocery shopping in Vineyard Haven? Who will drive to the beach?

I rehearse first, a two-hour slot before lunch. The dancers, the space, and the time are all there, waiting for me. I have not had to squeeze rehearsal time between my own teaching job and my dancers' other obligations. I have not had to call all over town looking for studio space. The dancers are not exhausted from waitressing at nights and weekends, while still keeping their dance lives going. I feel prepared for the rehearsal. I am able to work efficiently. The dancers (wonderful, all of them) are ready to try anything.

I have asked another choreographer, David Dorfman, to come watch a run-through at the end of my rehearsal. He gives me some useful suggestions: Bring in the central figure sooner. Overlap two of the sections.

We lunch on fruit and yogurt, what's left of last night's casserole, and bread baked by one of the dancers. After lunch, while another group rehearses, I climb up to my little gabled room and, using a stopwatch, I time the remaining music of the dance and think how to shape that time. Elsewhere in the house, dancers are doing laundry, sewing costumes, or sunbathing on the deck.

There are no group rehearsals this afternoon between two and four, so some of us head for Lucy Vincent Beach. I have come to know by heart the humpbacked curve of the clay cliffs, the rich smell of the vegetation that encloses the path to the beach, the way the waves slurp around the slippery black boulders at the edge of the sea.

Rehearsals resume. Meanwhile, choreographer H. T. Chen, our cook for the evening (we take turns) is fishing from the Menemsha jetty. Later, he presents us with a sushi extravaganza. We eat family-style around a long table. There's a lot of noise and laughter, even through the washing up. Our group is becoming closer.

After supper I return alone to the theater. The grass is damp, and the rabbits are out again. A cricket, lodged in the rafters somewhere, rasps away. I plug in the tape deck, play my music, and wander around the studio in a sort of trance, plotting traffic lines, peopling the space with ghost dancers performing wondrous feats. Some of my visions may find their way into my dance; more likely, something more interesting will emerge unexpectedly in to-morrow's rehearsal. I sleep blissfully. No sirens, no screaming crazies on the street. Only the soft clanging of the Menemsha buoy and the delicate rustle of the fog creeping through the trees.

Lynne Yamamoto, Sculptor

In the days since I left Sculpture Space, I have been appreciating more and more the richness of my experience. I realize how important it was to have access to the assortment of materials that can be found in Utica. When I was there in 1993, one of the projects I was working on was an installation for *Construction in Process IV*, to be exhibited in Lodz, Poland, which concerned women who worked in the textile industry there.

The installation was entitled *"Let Them Eat Cake": for the Textile Workers in Lodz.* In the title card I mentioned that the forks and wool had been brought from Utica, New York: the forks from Empire Recycling, the wool from Water-bury Felt.

The connection between Lodz, textile work-ers, and my residency at Sculpture Space began when I visited an exhibit at the Oneida County Historical Society in Utica. The Director, Dou-glas Preston, creates well-researched exhibits, though the text panels are never as interesting as speaking to him in person. Name a subject, and he will quickly pull out several books on it for you, as well as give you a synopsis and cri-tique of the book's contents. He is generous with his time and knowledge, and I found him genuinely enthusiastic about helping me. Our encounter influenced my work dramatically.

After describing my Lodz project to him, he handed me the book *United We Stand: The Role of Polish Workers in the New York Mills Textile Strikes, 1912 and 1916.* The book describes Pol-ish Americans as the second largest ethnic group in Utica. The majority are immigrants, or descended from immigrants, who came to work in the textile mills in Utica and environs in the late nineteenth century. After reading the book, I contacted one of the authors, who lives in nearby Deerfield. He suggested that I contact someone at the Waterbury Felt for a tour to see what the interior of a functioning textile mill looks like.

Waterbury Felt is probably the only textile mill still functioning in this area. Sid Copper-wheat, the plant manager, gave me a stunning

tour. He's worked there for decades, as have several other members of his family. Many floors were strangely empty (in fact, his son's band practices on one of them, amongst the boxes of felt). Several hundred people must have worked here at the factory's height; thirty-five people work here now. Mr. Copperwheat showed me the enormous machines' rollers that pass sheets of cloudlike felt. The rollers are wood; they still use wood bobbins and thistles. Shuttles fly on looms as long as twenty feet. In the older building, bits of wool still hang from ceiling beams. The wood partitions have darkened with age, though remain sturdy, and the stairs show the wear of thousands of footsteps. The modern and the ancient coexist in the mill: in the dim light, as I explored, I saw half-opened bales of raw wool and synthetic fluff alongside large wicker baskets from past eras.

This tour, my encounters with Mr. Preston, my work at Sculpture Space—the privacy, the quiet and concentrated time I enjoyed during my residency—was crucial to immersing myself in the work and lives I was exploring.

Artists'
Communities
Directory

FOUNDED Organization 1894, Residency Program 1896.

LOCATION 11 acres atop the Janiculum, the highest hill within the walls of Rome.

CATEGORIES Visual artists in arts and crafts, book art, ceramics, clay/pottery, digital imaging, drawing, fiber/textile, film/videomaking, folk art, glass, industrial art, installation, jewelry, mixed media, painting, paper art, photography, printmaking, sculpture, and woodworking; fiction writers, literary nonfiction writers, playwrights, and poets (by nomination only by the American Academy of Arts and Letters); composers and performance artists; architects, graphic designers, industrial designers, landscape designers, set designers, and urban designers; art conservators, art historians, historians, historic preservationists; collaborative teams, conceptual artists, environmental artists, inderdisciplinary artists, media artists, multimedia artists, new genre artists.

FACILITIES Studio; library, dining hall, photographic archive, laboratory darkrooms. Housing, housing bathrooms, studios, and public bathrooms are wheelchair-accessible.

FOR CURRENT APPLICATION REQUIREMENTS:

7 East 60th Street
New York, NY 10022-1001

TEL
(212) 751-7200

FAX
(212) 751-7220

E-MAIL
n/a

WWW
http://www.humnet.ucla.edu/
amacadmy/home2.html

HOUSING Private room and bath in the McKim, Mead, and White Building.

MEALS 2 meals provided per day, except Sunday and holidays.

RESIDENT SEASON September–August.

AVERAGE LENGTH OF RESIDENCIES 6–11 months, depending on field.

NUMBER OF ARTISTS IN 1995 14 (selected from 800 applicants).

AVERAGE NUMBER OF ARTISTS PRESENT AT ONE TIME 12–14.

APPLICATION DEADLINE November 15.

SELECTION PROCESS Outside panel of prominent professionals in each discipline, drawn from all regions of the country, and changed annually.

APPLICATION FEE $40.

SPECIAL PROGRAMS None.

STIPEND $5,800–$8,900, depending on length of term.

ARTIST PAYS Travel, some food (see "Meals"), personal needs, materials; no residency fee.

ARTIST DUTIES None.

OTHER ACCOMMODATIONS None—though the Academy accepts applications from artists and scholars who wish to rent space for two weeks to several months.

PUBLIC PROGRAMS Exhibitions, concerts, lectures, symposia—both in Rome and in the United States.

HISTORY The Academy sprang from the vision of American architect Charles Follen McKim, abetted by the artists with whom he had col-

"Academic atmosphere is thought to be stifling, but in Rome at the American Academy the air of thoughtful, honest, hopeful activity is fresh beyond expectation." —Frank Stella

laborated at the 1893 World's Columbian Exposition in Chicago: architects Daniel Burnham and Richard M. Hunt, painters John LaFarge and Francis Millet, and sculptors Augustus Saint-Gaudens and Daniel Chester French.

MISSION "To serve as the foremost overseas center for independent study and advanced research in the fine arts and humanities."

PAST ARTISTS INCLUDE David Hammons, Roy Lichtenstein, Nancy Graves, Mary Miss, Frank Stella, Philip Guston, Samuel Barber, Aaron Copland, Lukas Foss, David Lang, Michael Graves, Richard Meier.

FROM THE DIRECTOR "The Academy is by no means a luxurious place, but we have an inconceivably luxurious educational offering—the heart of which is a community of interesting people."
—Adele Chatfield-Taylor

Anderson Ranch Arts Center

FOUNDED Organization 1966, Residency Program 1986.

LOCATION In the resort community of Snowmass Village, 10 miles west of Aspen, 200 miles west of Denver.

CATEGORIES Visual artists in book arts, ceramics, clay/pottery, digital imaging, drawing, installation, mixed media, painting, photography, printmaking, sculpture, woodworking; general scholars; inderdisciplinary artists, and new genre artists.

FACILITIES and HOUSING 18 studios; fully equipped photography darkrooms, woodshop, ceramics and printmaking facilities, with additional equipment for bronze/aluminum casting and welding; single-occupancy dorm-style rooms/shared bath, and cafeteria/meeting building. Housing, housing bathrooms, some studios and some public bathrooms are wheelchair-accessible.

MEALS 5 dinners and 5 continental breakfasts provided per week; artists make all their other meals.

FOR CURRENT APPLICATION REQUIREMENTS:

P.O. Box 5598
Snowmass Village, CO 81615

TEL
970-923-3181

FAX
970-923-3871

E-MAIL
artranch@rof.net

WWW
n/a

RESIDENT SEASON October 15–April 25.

AVERAGE LENGTH OF RESIDENCIES 6 months.

NUMBER OF ARTISTS IN 1995 12 (selected from 250 applicants).

AVERAGE NUMBER OF ARTISTS PRESENT AT ONE TIME 12.

APPLICATION DEADLINE March 15.

SELECTION PROCESS Outside panel of nationally recognized professionals.

APPLICATION FEE $10.

SPECIAL PROGRAMS Pam Joseph Fellowship for Artists of Color.

STIPEND Modest materials stipend.

ARTIST PAYS Travel, some food (see "Meals"), personal needs, some materials; no residency fee.

ARTIST DUTIES 20 hours/month of volunteer work to Anderson Ranch.

OTHER ACCOMMODATIONS None.

PUBLIC PROGRAMS Summer workshops, gallery exhibitions, lectures, art auction, field expeditions, community outreach program.

HISTORY Founded in 1966 by ceramicists Paul Soldner and Brad Reed, using log buildings of a former sheep ranch. Major renovation program has developed state-of-the-art facilities.

MISSION "To provide a stimulating environment that promotes individual artistic development and excellence in the making and understanding of the visual arts. The ranch philosophy embraces both the crafts and fine arts, and the traditional as well as the avant garde, as means of personal expression."

"Anderson Ranch provided me with the resources I needed to bring all my divergent interests and modes of working into a multi-dimensional installation. The time, space, and supportive community . . . allowed me to conceive a work like no other I had ever imagined." —James Cambronne

PAST ARTISTS INCLUDE Thomas R. Anderson, Beate Ronning Arnesen, Malinda Beeman, Doug Casebeer, Michael F. Connelly, Gail Fredell, Julia Galloway, Jenna Goldberg, Hugh Harwood, Derek Johnston, David Mabbott, Alleghany Meadows, Jill Oberman, Selime Okuyan.

FROM THE DIRECTOR "Excellent facilities, program, and administrative staff support a creative environment emphasizing the production of work, personal growth, and interchange among artists." *—James Baker*

FOUNDED Organization 1951, Residency Program 1951.

LOCATION On 26-acre site of the former Western Clay Manufacturing Company, 3 miles from Helena.

CATEGORIES Visual artists in ceramics, clay/pottery, installation (related to clay), and sculpture.

FACILITIES Studio space (electric and gas kilns, wood, salt, soda, raku). Community is in the planning stages for making facilities accessible to disabled residents.

HOUSING Provide a resource for obtaining local rentals or house-sitting.

MEALS Artists purchase their own food and prepare their own meals.

RESIDENT SEASON Year-round.

AVERAGE LENGTH OF RESIDENCIES 2 months–2 years.

NUMBER OF ARTISTS IN 1995 20 (selected from 65 applicants).

FOR CURRENT APPLICATION REQUIREMENTS:

2915 Country Club Avenue
Helena, MT 59601

TEL
406-443-3502

FAX
406-443-0934

E-MAIL
archiebray@desktop.org

WWW
http://www.imageplaza.com/mt/art/abray/abf.html

AVERAGE NUMBER OF ARTISTS PRESENT AT ONE TIME 19 in summer; 9 during rest of the year.

APPLICATION DEADLINE March 1.

SELECTION PROCESS Resident director and committee of two professionals.

APPLICATION FEE $20.

SPECIAL PROGRAMS None.

STIPEND None.

ARTIST PAYS $150/month residency fee, travel, food, personal needs, materials.

ARTIST DUTIES Unspecified communal duties.

OTHER ACCOMMODATIONS No pets.

PUBLIC PROGRAMS Community classes, Children's Program, workshops, open house.

HISTORY The Archie Bray Foundation was founded in 1951 by Archie Bray, Sr., as a place for serious ceramic artists to work.

MISSION "To make available for all who are seriously and sincerely interested in any of the branches of the ceramic arts, a fine place to work."

PAST ARTISTS INCLUDE Peter Voulkos, Richard Notkin, Ken Ferguson, Kurt Weiser, Chris Staley, Carlton Ball, Val Cushing, John Gill, Andreas Gill, Clary Illian, Warren MacKenzie, Akio Takamori.

FROM THE DIRECTOR "When the Archie Bray Foundation was established over forty years ago, the idea was clear—'To make available for all who are seriously and sincerely interested in any of the branches of the ceramic arts, a fine place to work.' The legacy created at the Foundation has developed through this idea by the people who have come here to work. . . . The artistic free-

"I feel a sense of everyone who has ever worked here. There is debris left at the Bray from all those artists—pots and sculptures in every corner. Other places have wiped away their past. Here it is preserved." —David Cravenho

dom offered at the Bray encourages diversity and continues to attract fine ceramic artists from all over the world." —*Josh DeWeese*

FOUNDED Organization 1912, Residency Program 1991.

LOCATION 70 acres of wooded hillside, in East Tennessee, 3 miles from the entrance to the Great Smoky Mountains National Park, 40 miles from Knoxville.

CATEGORIES Visual artists in ceramics, clay/pottery, drawing, fiber/textile, film/videomaking, glass (stained glass, not hot glass), installation, jewelry, mixed media, painting, paper art, photography, printmaking, sculpture, and woodworking; art conservators, art educators, and art professionals; conceptual artists, environmental artists, and multimedia artists.

FACILITIES and HOUSING Private studio; shared house with private bedrooms. Housing, housing bathrooms, studios, and public bathrooms are wheelchair-accessible; community accommodates disabled residents and is in the planning stages (new studio in construction) for making facilities more accessible.

MEALS Provided at half-price when school is operating with kitchen use; otherwise, artists purchase their own food and prepare their own meals.

RESIDENT SEASON September–August.

AVERAGE LENGTH OF RESIDENCIES 11 months.

NUMBER OF ARTISTS IN 1995 4 (selected from 65 applicants).

AVERAGE NUMBER OF ARTISTS PRESENT AT ONE TIME 4.

APPLICATION DEADLINE April 30.

SELECTION PROCESS Outside panel of professionals in each category, followed by phone interviews of semi-finalists and campus visit/interview with finalists.

APPLICATION FEE $10.

SPECIAL PROGRAMS Concerts.

STIPEND None, though some scholarships available.

ARTIST PAYS $175/month residency fee, travel, most food (see "Meals"), personal needs, materials.

ARTIST DUTIES Eight hours per week in duties to school, in studios, gallery, office, or public schools.

OTHER ACCOMMODATIONS Family and guests, for nominal fee.

PUBLIC PROGRAMS Gallery, opportunities for teaching.

HISTORY Founded in 1991.

MISSION "To enrich lives through art by developing aesthetic appreciation and fostering self-expression through practical experiences."

PAST ARTISTS INCLUDE Jeff Brown, Phil Moulthrop,

FOR CURRENT APPLICATION REQUIREMENTS:

556 Parkway
Gatlinburg, TN 37738

TEL
423-436-5860

FAX
423-430-4101

E-MAIL
n/a

WWW
n/a

Carol Gentithes, Vicki Jensen, Fred Johnston, Morgan Owens, Joni Kost.

FROM THE DIRECTOR "The Artist-in-Residence Program gives pre-professional, self-directed artists time and space to develop a major body of work in a creative community environment." —*Bill Griffith*

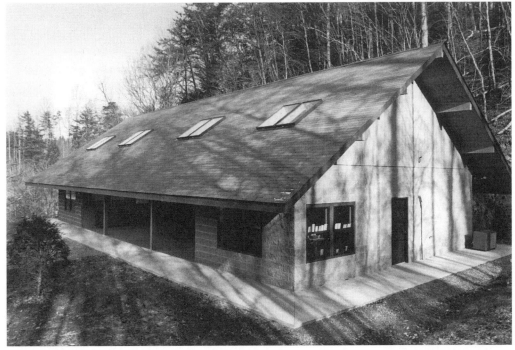

PHOTO: CYNTHIA HUFF

Art Awareness, Inc.

FOUNDED Organization 1975, Residency Program 1975.

LOCATION 100 acres of fields and woodlands on a turn-of-the-century resort in the Catskill Mountains.

CATEGORIES Visual artists in drawing, installation, painting, photography, printmaking, and sculpture; choreographers, composers, theater directors, performance artists; architects; collaborative teams, conceptual artists, environmental artists, interdisciplinary artists, and new genre artists.

FACILITIES and HOUSING 4 cabins with bathroom and small kitchen that provide combination living and studio space and can house up to 4 artists each; 6-bedroom apartment in the nearby Morse Inn; 5-bedroom apartment with kitchen and 2 bathrooms on first floor of print studio building; 9 bedrooms in Lexington Hotel; print studio contains bedroom and bathroom.

MEALS Artists purchase their own food and prepare their own meals.

RESIDENT SEASON June–August.

FOR CURRENT APPLICATION REQUIREMENTS:

Route 42, Box 177
Lexington, NY 12452-0177

TEL
518-989-6433

FAX
518-989-6398

EMAIL
n/a

WWW
n/a

AVERAGE LENGTH OF RESIDENCIES 3 weeks.

NUMBER OF ARTISTS IN 1995 4 performing groups (selected from 30 applicants); 7 visual artists (selected from 150 applicants).

AVERAGE NUMBER OF ARTISTS PRESENT AT ONE TIME 10.

APPLICATION DEADLINES May 30 and October 30 for the following year.

SELECTION PROCESS Outside panel of professionals in each category.

APPLICATION FEE None.

SPECIAL PROGRAMS None.

STIPEND None.

ARTIST PAYS Travel, food, personal needs, materials; no residency fee.

ARTIST DUTIES None.

OTHER ACCOMMODATIONS Family, pets, and guests may be accommodated, on an individual basis.

PUBLIC PROGRAMS Exhibitions, installations, performances.

HISTORY Founded in 1975 as a community art school and evolved into offering a program of artists' residencies, exhibitions, and a performing arts season of dance, music, and theatre.

MISSION "To support the development of new works by visual and performing artists and the presentation of new and established works to a regional audience in the Catskills."

PAST ARTISTS INCLUDE Eiko & Koma, Bill T. Jones/Arnie Zane and Company, Elizabeth Streb and Ringside, Split Britches Company, Ann Carlson, Fred Tomaselli, Bob Bingham, Janine Antoni, Christy Rupp, Siobhan Liddel, James Luna, Jim Durham.

"How crucial the time at Art Awareness has been for my company. We had open time with no interruptions; in New York City, where the company is based, this would simply not be possible. The conditions at Art Awareness were totally conducive to hard work. There was an enormously relaxed atmosphere, complete with administrators with open hearts and minds who did everything and anything to accommodate our time." —Elizabeth Streb

FROM THE DIRECTOR "Our greatest satisfaction comes from seeing the excitement of artists working with great dedication to develop new works and then having the pleasure of bringing the artists and public together to share these new creations." —*Pamela Weisberg*

PHOTO: ROY VOLKMANN

Art Farm

FOUNDED Organization 1993, Residency Program 1992.

LOCATION On a working farm, 2 miles from the clay bluffs of the Platte River, 140 miles west of Omaha.

CATEGORIES Visual artists in ceramics, clay/pottery, drawing, installation, mixed media, painting, sculpture, woodworking; conceptual artists, environmental artists, and multimedia artists.

FACILITIES Studio space in farmyard barns; up to 20 acres of land available for environmental projects; electric kilns, woodworking and metalworking equipment, tractor loaders and trucks.

HOUSING Room in 100-year old farmhouse, equipped with kitchen and laundry facilities.

MEALS Artists purchase their own food and prepare their own meals; a vegetable garden is grown for residents' use.

RESIDENT SEASON May 1–October 31.

FOR CURRENT APPLICATION REQUIREMENTS:

1306 West 21st Road
Marquette, NE 68854

TEL
402-854-3120

FAX
402-854-3120

E-MAIL
n/a

WWW
n/a

AVERAGE LENGTH OF RESIDENCIES 2–3 months.

NUMBER OF ARTISTS IN 1995 2 (selected from 50 applicants).

AVERAGE NUMBER OF ARTISTS PRESENT AT ONE TIME 3 (4 maximum).

APPLICATION DEADLINES April 1 for summer; 2 months prior to residency the rest of the season.

SELECTION PROCESS Currently, selections made by directors.

APPLICATION FEE None.

SPECIAL PROGRAMS None.

STIPEND None.

ARTIST PAYS Travel, food, personal needs, materials (though some—wood, clay, scrap metal—available); no residency fee.

ARTIST DUTIES 15 hours per week assistance to Art Farm in general construction and carpentry, grounds maintenance, or office work.

OTHER ACCOMMODATIONS No children or pets, though guests and family may visit if accommodations are available.

PUBLIC PROGRAMS Some opportunity to exhibit work in the local community.

HISTORY Incorporated in 1993 by artists Ed Dadey and Janet Williams. In search of studio space, Dadey moved a number of barns in the area to his family farm. The work of restoring, repairing, and converting barns for studio space continues. Artists have come from U.S., Britain, South Korea, Germany, and Israel.

MISSION "To provide a worksite, resources, and support for artists, providing them with time to experiment with new ideas or projects while working and living in a rural environment."

"I do miss the farm. I miss the open spaces and the privacy. I especially miss not having any concept of time!" —Theresa Handy

PAST ARTISTS INCLUDE Mary Alice Pratviel, Theresa Handy, Johnny Walker, Tanya Preminger, Sandy Abrams, Susan Francis, Seung Jae Choi, Annette Merkenthaler, Glenn Trado, Debbie Siegel, Ruth Dennis, Fred Rose.

FROM THE DIRECTOR "Art Farm's physical presence is in its buildings and land. More elusive to describe is the ambiance, the subtle influence of the environment's impact on time and space. Time is kept by sun and night sky, not by clock and calendar. Space is marked by proximity to sound and silence. The sky and your ears will be filled with the sound and shapes of an incredible number of birds and insects. And, like it or not, the weather will be your collaborator in all undertakings." —Ed Dadey

ART/OMI

FOUNDED Organization 1992, Residency Program 1992.

LOCATION A converted 1830 farmhouse in New York's historic Hudson River Valley, near Chatham.

CATEGORIES Visual artists in drawing, fiber/textile (with own equipment), film/video-making (with own equipment), installation, mixed media, painting, paper art (with own equipment), photography (limited equipment available), printmaking (limited equipment available), sculpture, and woodworking; fiction writers, literary nonfiction writers, playwrights, poets, screenwriters, and translators; performance artists; art critics; collaborative teams (visual/performance), conceptual artists, environmental artists, interdisciplinary artists, and new genre artists.

FACILITIES In Ledig House studios. Housing and studios are wheelchair-accessible; community accommodates disabled residents.

HOUSING Rooming in nearby houses.

FOR CURRENT APPLICATION REQUIREMENTS:

55 Fifth Ave., 15th Floor
New York, NY 10003

TEL
212-206-5660

FAX
212-727-0563

E-MAIL
n/a

WWW
n/a

MEALS All meals provided.

RESIDENT SEASON Visual artists, July 4–26; writers, year-round.

AVERAGE LENGTH OF RESIDENCIES Visual artists, 3 weeks; writers, 2 weeks to 2 months.

NUMBER OF ARTISTS IN 1995 26 (selected from 350 applicants).

AVERAGE NUMBER OF ARTISTS PRESENT AT ONE TIME 25.

APPLICATION DEADLINES Visual artists, March 1; writers, ongoing.

SELECTION PROCESS Outside panel of professionals in each category.

APPLICATION FEE None.

SPECIAL PROGRAMS Monotype Project; Critic-in-Residence.

STIPEND None.

ARTIST PAYS Travel, personal needs, materials; no residency fee.

ARTIST DUTIES None.

OTHER ACCOMMODATIONS None.

PUBLIC PROGRAMS Open Day exhibitions, Invitational Sculpture Exhibition, Columbia Community Gallery, lectures, concerts.

HISTORY Founded in 1992 by a small group of individuals, ART/OMI immediately began bringing together artists from around the world. The success of the first program led to acquiring a nearby farmhouse and establishing Ledig House International Writers' Colony.

MISSION "To foster arts' ability to transcend political, cultural, and intellectual boundaries."

"I'll never get over ART/OMI. It's astounding that a seemingly full chapter of my life could unfold in three weeks." —Cheryl Donegan

PAST ARTISTS INCLUDE Dumisani Mabaso, Joana Prezybyla, Karsten Wittke, Elena Beriolo, Cheryl Donegan, Ad Jong Park, Atsushi Yamaguchi, Michael Bramwell, Wenda Gu, Diego Toledo, Richard Waske, Geng Jianyi.

FROM THE DIRECTOR "ART/OMI welcomes the participation of outstanding artists from as many countries as possible. By bringing together creative individuals from all over the world, ART/OMI hopes to foster a cultural forum where ideas and perspectives about art and life can be exchanged. The interaction of the artists with one another is as important as the art that they create. In an age riven with increasing factionalism and tribalism, ART/OMI hopes to contribute to greater international understanding and tolerance." —Linda Cross

ArtPace

ALLIANCE OF ARTISTS' COMMUNITIES MEMBER

FOUNDED Organization 1993, Residency Program 1994.

LOCATION Downtown San Antonio.

CATEGORIES Always one artist from San Antonio region is chosen, as well as one national and one international artist. Visual artists in arts and crafts, book art, ceramics, clay/pottery, digital imaging, drawing, fiber/textile, film/video-making, folk art, glass, industrial art, installation, jewelry, mixed media, painting, paper art, photography, printmaking, sculpture, and woodworking; audio artists; collaborative teams, conceptual artists, environmental artists, interdisciplinary artists, media artists, multimedia artists, and new genre artists.

FACILITIES and HOUSING 3 studios, complete metal and wood-working facilities (other technical facilities available through cooperative exchanges); 3 apartments; studios and public bathrooms are wheelchair-accessible; beginning in 1997, all areas will be wheelchair-accessible; if artists with sight, hearing, or other disabilities are selected, every effort will be made to accommodate them.

FOR CURRENT APPLICATION REQUIREMENTS:

445 North Main Avenue
San Antonio, TX 78205-1441

TEL
210-212-4900

FAX
210-212-4990

E-MAIL
info@artpace.org

WWW
n/a

MEALS Artists purchase their own food and prepare their own meals.

RESIDENT SEASON Year-round.

AVERAGE LENGTH OF RESIDENCIES 2 months (plus 1 month exhibition).

NUMBER OF ARTISTS IN 1995 12 (9 selected by an independent panel from 300 applicants), 3 selected by curator.

AVERAGE NUMBER OF ARTISTS PRESENT AT ONE TIME 3.

APPLICATION DEADLINES By nomination only, every 2 years (dates vary).

SELECTION PROCESS By nomination to an outside panel of professionals and curatorially in the 3 categories: San Antonio region, national, and international.

APPLICATION FEE None.

SPECIAL PROGRAMS The London Studio Program: selection of San Antonio–based artists to work in London Studio for up to 6-week residency (stipend, $300/week); The Hudson Showroom Exhibitions: selection of Texas-based artist to exhibit recent work (stipend, $500).

STIPEND $1,500 per month. The Foundation provides travel, materials, photo documentation, and exhibition brochure.

ARTIST PAYS Personal needs only; no residency fee.

ARTIST DUTIES None.

OTHER ACCOMMODATIONS None.

PUBLIC PROGRAMS Symposia, lectures, workshops.

HISTORY Founded in 1993 by Linda Pace and her children to create an International Artist-in-Residence program in San Antonio.

MISSION "To advance the knowledge and practice of contemporary art in San Antonio, Texas, and to serve as a catalyst for the creation of vanguard art projects of wide significance. . . . To provide opportunities for artists working in a range of media to create and present work in San Antonio; to promote public awareness of an involvement in the contemporary arts in the San Antonio area; and, by encouraging experimentation in the arts, to contribute to the evolution of new ideas in the field. Further, ArtPace aims to help realize those artists' projects that cultivate new, expanded and culturally diverse audiences. Through its work, the Foundation seeks to position San Antonio's artists, ideas and accomplishments within a national and international context."

PAST ARTISTS INCLUDE Annette Messager, Felix Gonzalez-Torres, Jesse Amado, Tracey Moffatt, Jun Nguyen-Hatsushiba, Joe Daun, Antony Gormley, David Avalos, David Zamora-Casas, Cisco Jimenez, Leonardo Drew, Ken Little.

FROM THE DIRECTOR "ArtPace is a research and development facility for contemporary art, encouraging individual experimentation and exploration and promoting dialogue about contemporary art and ideas within and beyond this community." —*Linda Pace, Trustee*

Atlantic Center for the Arts

FOUNDED Organization 1977, Residency Program 1982.

LOCATION 67 acres on tidal estuary, fronting Turnbull Bay, on the east coast of central Florida.

CATEGORIES Visual artists in arts and crafts, book art, ceramics, clay/pottery, drawing, fiber/textile, film/videomaking, folk art, installation, jewelry, mixed media, painting, paper art, photography, printmaking, sculpture, and woodworking, graphic art, and furniture design; fiction writers, journalists, literary nonfiction writers, playwrights, poets, screenwriters, translators; actors, audio artists, choreographers, composers, dancers, film directors, theater directors, electronic artists, musicians, performance artists, storytellers, and production designers; architects, clothing designers, graphic designers, landscape designers, set designers, urban designers; art educators, art historians, and critics; collaborative teams, conceptual artists, environmental artists, interdisciplinary artists, media artists, and multimedia artists.

FACILITIES Painting studio, sculpture studio with kiln, darkroom, dance studio, music/digital recording studio (pianos and keyboards), black box theater with sprungwood floor, library. Housing, housing bathrooms, studios, and public bathrooms, recording studio, darkroom, and sculpture studio are wheelchair-accessible.

HOUSING 28 individual bedrooms with private bath, small refrigerator and desk area; communal living, eating, and kitchen space.

MEALS Artists purchase their own food and prepare their own meals.

RESIDENT SEASON Year-round.

AVERAGE LENGTH OF RESIDENCIES 3 weeks.

NUMBER OF ARTISTS IN 1995 100 (selected from 400 applicants).

AVERAGE NUMBER OF ARTISTS PRESENT AT ONE TIME 25.

APPLICATION DEADLINES Varies, approximately three months prior to start of residency.

SELECTION PROCESS Master Artists set criteria and select 8-10 Associate Artists with whom to work.

APPLICATION FEE None.

SPECIAL PROGRAMS Music in Motion (for pre-selected composers and ensembles), Summer Teacher Training Institute (for Florida teachers).

STIPEND None, though scholarships are available.

ARTIST PAYS $100/week residency fee, travel, food, personal needs. Additional, optional housing fee of $25/night.

ARTIST DUTIES Meet with Master Artist and fellow Associate Artists 3 hours/day, 5 days/week to discuss issues relative to the discipline and contemporary art scene, and each other's work.

FOR CURRENT APPLICATION REQUIREMENTS:

1414 Art Center Avenue
New Smyrna Beach, FL 32168

TEL
904-427-6975

FAX
904-427-5669

E-MAIL
acansb@artswire.org
acansb@aol.com

WWW
n/a

"ACA provides, so far as I know, much the most congenial atmosphere in America for an intense brief period of work—both concentrated daily dialogue and private creation."

—Reynolds Price

OTHER ACCOMMODATIONS Groups welcome; children accommodated; no pets.

PUBLIC PROGRAMS Artists-in-Residence Program: exhibitions, receptions, INsideOUT (residency's culminating presentation), outreaches. Also, in-town facility: exhibitions, receptions, adult/children workshops, gallery talks, lectures, tours, outreaches, internships.

HISTORY The idea of an interdisciplinary residence facility where "you can't see anything man-made, where people, if they wish to think creatively, can," blossomed in the mind of Doris Leeper, sculptor, painter, and environmentalist, in 1977. In 1979, The Rockefeller Foundation provided a planning grant. In 1982, poet James Dickey, sculptor Duane Hanson, and composer David Del Tredici were the community's first residents.

MISSION "To promote artistic excellence by providing midcareer artists an opportunity to work and collaborate with some of the world's most distinguished contemporary artists in the fields of composing and visual, literary, and performing arts, while coordinating interaction with community members through on-site and outreach presentations, performances and exhibitions."

PAST ARTISTS INCLUDE Alex Katz, Robert Creeley, Joan Tower, Marilyn French, Edward Albee, Reynolds Price, Carolyn Forche, Sonia Sanchez, Allen Ginsberg, Robert Rauschenberg, Trisha Brown, Mel Chin

FROM THE DIRECTOR "The artists-in-residence program provides midcareer artists an opportunity to work closely with Master Artists and colleagues from around the world in an intense three-week retreat. The artists divide their time between formal exchanges with artists in their discipline, casual interaction with artists from all disciplines, private time to pursue individual projects, and if interested, collaborative investigation with other artists. The setting presents a tranquil backdrop to the intense and stimulating activity that takes place during the residency." *—Suzanne Fetscher*

Bemis Center for Contemporary Arts

FOUNDED Organization 1981, Residency Program 1985.

LOCATION In 2 urban warehouses and half a block of open urban property on the fringe of downtown Omaha.

CATEGORIES Visual artists in book art, ceramics, clay/pottery, drawing, fiber/textile, film/video-making, folk art, industrial art, installation, mixed media, painting, paper art, photography, printmaking, sculpture, and woodworking; audio artists, film directors, and performance artists; collaborative teams, conceptual artists, environmental artists, interdisciplinary artists, multimedia artists, and new genre artists.

FACILITIES and HOUSING 5 studios with apartments; 10,000 sq. ft. installation work space; 10,000 sq. ft. sculpture facility with 15 ft. ceilings; use of professional darkroom and printmaking workshop; fabrication studio spaces. Housing, housing bathrooms, studios, and public bathrooms will be wheelchair-accessible by 1997. Installation space and fabrication studio space are wheelchair-accessible.

FOR CURRENT APPLICATION REQUIREMENTS:

724 South 12th Street
Omaha, NE 68102

TEL
402-341-7130

FAX
402-341-9791

E-MAIL
bemis@artswire.org

WWW
n/a

MEALS Artists purchase their own food and prepare their own meals.

RESIDENT SEASON Year-round.

AVERAGE LENGTH OF RESIDENCIES 3–6 months.

NUMBER OF ARTISTS IN 1995 22 (selected from 375 applicants).

AVERAGE NUMBER OF ARTISTS PRESENT AT ONE TIME 7.

APPLICATION DEADLINE September 30.

SELECTION PROCESS Outside panel of professionals in each category.

APPLICATION FEE $25.

SPECIAL PROGRAMS Exhibitions, slide shows, lectures, performances, concerts.

STIPEND $500 per month.

ARTIST PAYS Travel, food, personal needs, materials; no residency fee.

ARTIST DUTIES One public slide lecture.

OTHER ACCOMMODATIONS Guests accommodated.

PUBLIC PROGRAMS Encounters Education Program, Gallery Talks, Bemis Urban Mural Project.

HISTORY Founded by artists Jun Kaneko, Tony Hepburn, Lorne Falke, and Ree Schonlau. In 1985, Bemis moved into the former Bemis Bag Company building, hence the choice of name. In 1996, Bemis moves into new permanent home, the McCord Brady Building.

MISSION "To support exceptional talent. . . . To provide well-equipped studios, living accommodations, and a monthly stipend to visual artists."

"Bemis is a fantastic thing to have out in the middle of America. It was a real meeting place away from the usual art-centered group. Working at Bemis was certainly different. I'm still trying to digest what happened there." —Manual Neri

PAST ARTISTS INCLUDE Manuel Neri, David Finn, Miriam Bloom, Alice Aycock, David Nash, Sue Rees, Emma Rushton, Susan Harrington, David Maab, Kyoto Ota Okuzawa, Phyllis McGibbon, Albert Ebert, Mark Joyce.

FROM THE DIRECTOR "The Bemis has had a distinctive role as a curator of artists. Our main interest lies in the creative development of the artists themselves. To that end, we offer long periods of supported time for residencies, giving artists large studios and well-equipped work facilities. Bemis is a place for artists to make work." —*Ree Schonlau*

Blue Mountain Center

FOUNDED Organization 1982, Residency Program 1982.

LOCATION In the central Adirondacks.

CATEGORIES Visual artists in book art, ceramics (no wheel), clay/pottery, digital imaging (no equipment), drawing, fiber/textile, film/video-making, folk art, installation, mixed media, painting, paper art, photography, printmaking, and sculpture; fiction writers, journalists, literary nonfiction writers, playwrights, poets, screenwriters, and translators; choreographers, composers, dancers, film directors, theater directors, performance artists, and storytellers; collaborative teams, conceptual artists, interdisciplinary artists, media artists, and multimedia artists.

FACILITIES and HOUSING Room and board (plus studio for visual artists and composers). Community accommodates disabled residents and is in the planning stages of making facilities more accessible.

MEALS All meals provided.

FOR CURRENT APPLICATION REQUIREMENTS:

P.O. Box 109
Blue Mountain Lake, NY 12812

TEL
518-352-7391

FAX
n/a

E-MAIL
n/a

WWW
n/a

RESIDENT SEASON June–October.

AVERAGE LENGTH OF RESIDENCIES 1 month.

NUMBER OF ARTISTS IN 1995 58 (selected from 300 applicants).

AVERAGE NUMBER OF ARTISTS PRESENT AT ONE TIME 14.

APPLICATION DEADLINE February 1.

SELECTION PROCESS Outside panel of professionals in each category.

APPLICATION FEE $20.

SPECIAL PROGRAMS None.

STIPEND None.

ARTIST PAYS Travel, personal needs, materials; no residency fee.

ARTIST DUTIES None.

OTHER ACCOMMODATIONS None.

PUBLIC PROGRAMS Conferences and seminars for groups of up to 25 people concerned with social, economic, and environmental issues.

HISTORY Founded in 1982 by Adam Hochschild in an 1899 Adirondack "great camp" that was built by William West Durant.

MISSION "To offer time, peace, and community to writers and artists, especially those with an interest in environmental and social justice issues."

PAST ARTISTS INCLUDE James Lardner, Bill McKibben, Valerie Maynard, Josip Novakovich, Oliver Sacks, Christine Jerome, Leslie Savan, Bill Finnegan, Phyllis Bennis, Richard McCann, Ethelbert Miller, Tom Athansiou.

FROM THE DIRECTOR "Blue Mountain Center is a community of commitment and practice where generous humor and the willingness to 'pitch in' are highly valued." —*Harriet Barlow*

FOUNDED Organization 1983, Residency Program 1983.

LOCATION South of Market District in San Francisco.

CATEGORIES Installation artists; collaborative teams, conceptual artists, environmental artists, interdisciplinary artists, media artists, multimedia artists, and new genre artists.

FACILITIES and HOUSING 1-bedroom, loft-style apartment. Housing and public bathrooms are wheelchair-accessible.

MEALS Artists purchase their own food and prepare their own meals.

RESIDENT SEASON Year-round.

AVERAGE LENGTH OF RESIDENCIES 3 months.

NUMBER OF ARTISTS IN 1995 7 (selected from 350 applicants).

AVERAGE NUMBER OF ARTISTS PRESENT AT ONE TIME 2.

FOR CURRENT APPLICATION REQUIREMENTS:

525 2nd Street
San Francisco, CA 94107

TEL
415-495-7101

FAX
415-495-7059

E-MAIL
n/a

WWW
http://tesla.csuhayward.edu/cappstreet

APPLICATION DEADLINES Call for current deadlines and application procedure.

SELECTION PROCESS Outside panel of professionals in each category.

APPLICATION FEE None.

SPECIAL PROGRAMS Public Arts Programs, lectures, catalog.

STIPEND $4,000, plus $8,000 for materials.

ARTIST PAYS Food, personal needs; no residency fee.

ARTIST DUTIES None.

OTHER ACCOMMODATIONS None.

PUBLIC PROGRAMS Lecture series, tours.

HISTORY Founded in 1983 in an unusual Mission District house designed by artist David Ireland, Capp Street Project moved in 1989 and again in 1994. The current South Park neighborhood space was designed by Stanley Saitowitz.

MISSION "To provide opportunities for contemporary artists working in diverse media to create and present site-related art installations in the San Francisco Bay Area; to encourage experimentation in the arts . . .; to contribute to the evolution of new ideas in contemporary art."

PAST ARTISTS INCLUDE Ann Hamilton, Mel Chin, Buster Simpson, Bill Viola, Fred Wilson, Willie Cole, James Luna, Reiko Goto, Joanna Haigood, Donald Lipski, Mildred Howard, Francesc Torres.

FROM THE DIRECTOR "Capp Street Project continues to grow in stature as an institution dedicated to supporting contemporary artists and experimental installation art. Over the past twelve years Capp Street Project, an organization which began as an experiment, has become

"*Capp Street Project supported me and my project with great respect and insight and gave me the freedom to experiment. The work was presented not only to the art community, but also to the broader public. This encouragement and hospitality make the place very special.*" —Ritsuko Taho

a viable part of the cultural fabric of the San Francisco Bay Area. We have developed a reputation for flexibility and openness to the un-imaginable that allows artists to take their work in a new direction and to a new audience."
—Linda Blumberg

The Carving Studio and Sculpture Center, Inc.

FOUNDED Organization 1986, Residency Program 1986.

LOCATION A rehabilitated, extinct marble quarry in the Green Mountains in central Vermont.

CATEGORIES Installation artists, sculptors.

FACILITIES Studio space; compressed air gantry crane, pneumatic tools, forklift crane, foundry, clay studio, 40 acres of stone and granite; studios and public bathrooms are wheelchair-accessible.

HOUSING Apartment rooms.

MEALS Artists purchase their own food and prepare their own meals.

RESIDENT SEASON Year-round.

AVERAGE LENGTH OF RESIDENCIES 2 months.

NUMBER OF ARTISTS IN 1995 8 (selected from 8 applicants).

AVERAGE NUMBER OF ARTISTS PRESENT AT ONE TIME 2.

FOR CURRENT APPLICATION REQUIREMENTS:

P.O. Box 495
Marble Street
West Rutland, VT 05777

TEL
802-438-2097

FAX
802-438-2097

E-MAIL
jimgriff@sover.net

WWW
http://www.sover.net/~jimgriff/index.html

APPLICATION DEADLINES None.

SELECTION PROCESS Independent jury.

APPLICATION FEE None.

SPECIAL PROGRAMS For indigenous people.

STIPEND None.

ARTIST PAYS Travel (sometimes funded), food, personal needs, materials (though extensive tools available and stone access); no residency fee.

ARTIST DUTIES None.

OTHER ACCOMMODATIONS None.

PUBLIC PROGRAMS None.

HISTORY Founded in 1986.

MISSION "To support the tradition of stone carving and to insure its inclusion in the contemporary art scene."

PAST ARTISTS INCLUDE Jesus Moroles, Claire McCardle, Sue Nees, Manuel Neri, Robert Sindorf, B. Amore, Takai Ogai, Matthew Nesbitt, Sidney Giest, Carrol Driscoll, Bart Hanna, Mitsonori Koike.

FROM THE DIRECTOR "The Carving Studio is in transition from a highly regarded technical facility into a fully developed artist facility which includes year-round residents and artists in residence. In the course of a year, we are hosts to artists from all over the globe." —*Mike Winslow*

"*The atmosphere is informal, but there is an energy associated with the Carving Studio that is highly conducive to focused artistic development.*" —Robert Sindorf

FOUNDED Organization 1973, Residency Program 1982.

LOCATION 440 acres in historic Fort Worden State Park.

CATEGORIES Visual artists in arts and crafts, book art, ceramics, clay/pottery, digital imaging, drawing, fiber/textile, film/videomaking, folk art, glass, industrial art, installation, jewelry, mixed media, painting, paper art, photography, printmaking, sculpture, and woodworking; fiction writers, journalists, literary nonfiction writers, playwrights, poets, screenwriters, and translators; actors, audio artists, choreographers, composers, dancers, film directors, theater directors, electronic artists, musicians, performance artists, storytellers, and radio artists; architects, clothing designers, graphic designers, industrial designers, landscape designers, set designers, and urban designers; art conservators, art educators, art historians, art professionals, computer scientists, critics, environmentalists/naturalists, general scholars, historians, historic preservationists, linguists, mathematicians, and scientists; collaborative teams, conceptual artists, environmental artists, interdisciplinary artists, media artists, multimedia artists, and new genre artists.

FACILITIES and HOUSING Detached cottages with 2–3 bedrooms, kitchens, and living areas. Community accommodates disabled residents and is in the planning stages for making facilities more accessible.

MEALS Artists purchase their own food and prepare their own meals.

RESIDENT SEASON September–May.

AVERAGE LENGTH OF RESIDENCIES 1 month.

NUMBER OF ARTISTS IN 1995 12 (selected from 140 applicants).

AVERAGE NUMBER OF ARTISTS PRESENT AT ONE TIME 3–4.

APPLICATION DEADLINE October 1.

SELECTION PROCESS Outside panel of professionals in each category.

APPLICATION FEE $10.

SPECIAL PROGRAMS None.

STIPEND $300 available to approximately 15 artists each year.

ARTIST PAYS Travel, food, personal needs, materials ($100 fee for printmakers selected for stipend); no residency fee.

ARTIST DUTIES None.

OTHER ACCOMMODATIONS None.

PUBLIC PROGRAMS Concerts, performances, writers' conference, exhibitions.

HISTORY Established in 1973, Centrum began its residency program in 1982 and developed its print center in 1985.

FOR CURRENT APPLICATION REQUIREMENTS:

P.O. Box 1158
Port Townsend, WA 98368

TEL
360-385-3102

FAX
360-385-2470

E-MAIL
n/a

WWW
n/a

MISSION "To provide artists with time, space, and solitude to pursue their discipline . . . in a serene and beautiful setting, so that they can finish works in progress or experiment with new ideas."

PAST ARTISTS INCLUDE John Haines, Linda Gregg, Josip Novakovich, John Anderson, Bill Knott, Michael Spafford, Ed Ruscha, Kay Rook, Robert Priest, Juan Alonso, Jeff Bickford, Shirley Scheier.

FROM THE DIRECTOR "Centrum's program is founded on the ideals of quality, integrity, and vision and to assist those who seek creative and intellectual growth." —*Toni Aspin*

PHOTO: MAGGIE BROWN

Contemporary Artists Center

FOUNDED Organization 1990, Residency Program 1990.

LOCATION In the Berkshires of western Massachusetts, 3 hours north of New York City.

CATEGORIES Visual artists in drawing, fiber/textile, mixed media, painting, paper art, photography, printmaking, and sculpture; performance artists; conceptual artists and interdisciplinary artists.

FACILITIES Large, open-painting, sculpture, and mixed-media studios, woodshop, black & white darkroom, woodcut press (4' × 8' images), vulcanizing and other presses. Public bathrooms and gallery are wheelchair-accessible (planning underway elsewhere).

HOUSING Some on-site, others at nearby college townhouses.

MEALS Lunch and dinner included in the summer; no meals, but kitchen available in fall and spring, when artists purchase their own food and prepare their own meals.

FOR CURRENT APPLICATION REQUIREMENTS:

The Historic Beaver Mill
189 Beaver Street
North Adams, MA 01247

TEL
413-663-9555

FAX
413-663-9555

E-MAIL
mwinh@aol.com

WWW
n/a

RESIDENT SEASON Summer residencies, late-June to mid-August; Independent Work Stays, September–November and March–May 15.

AVERAGE LENGTH OF RESIDENCIES 1 week–2 months.

NUMBER OF ARTISTS IN 1995 55 (selected from 200 applicants).

AVERAGE NUMBER OF ARTISTS PRESENT AT ONE TIME Summer, 15–20; Independent Work Stays, 1 or 2.

APPLICATION DEADLINES Applications accepted all year, until slots are filled; Residency grants for summer residency, March 30.

SELECTION PROCESS Advisory board members select residency grants; Contemporary Artists Center's Resident Artists select summer residencies.

APPLICATION FEE None for regular applications; $10 for residency grant applications.

SPECIAL PROGRAMS Exhibition opportunities, such as open exhibitions, invitations to create installations, and an annual juried show.

STIPEND None.

ARTIST PAYS Residency fee (various plans offered, some scholarships available—inquire about details), travel, food (depending on season, see "Meals"), personal needs, materials.

ARTIST DUTIES None (though work-study situations are available).

OTHER ACCOMMODATIONS No pets; guests sometimes for a fee (for meals) and with advance notice.

PUBLIC PROGRAMS Gallery exhibitions and openings; guided tours; occasional lectures.

HISTORY Founded in 1990 by Eric Rudd in what was a mostly vacant 130,000 square-foot mill. Arists began attending that summer.

MISSION "To provide a unique environment for the creation of contemporary art and its exhibition by: 1) utilizing the vast mill space that, as a legacy of the Industrial Revolution, is available throughout North Adams, to create a physical environment conducive to making art; 2) supplying the physical and technical resources necessary for the production of art; 3) encouraging creative diversity and the generation and dissemination of ideas; 4) inviting convocations of artists and others from the international art world to promote a lively exchange of ideas; 5) fostering an appreciation of contemporary art through education, exhibitions, and multimedia events; 6) publishing and documenting the activities of the Contemporary Artists Center; and 7) integrating the program of the Center into the community."

PAST ARTISTS INCLUDE Eleen Auvil, Robert Dilworth, Glenn English, Douglas Geiger, Marion Held, Tim Merrick, Kathleen Sidwell, Ron Snapp, Susannah Strong, Daizo Tajima, Heather Thomas, Rosa Vasquez, Otis Tamasaukas.

FROM THE DIRECTOR "The Contemporary Artists Center has energized people's lives. It could energize yours." —Eric Rudd

FOUNDED Organization 1983, Residency Program 1983.

LOCATION 88 acres at Wheaton Village in rural southern New Jersey.

CATEGORIES Glass artists.

FACILITIES and HOUSING Glass factory; 4-bedroom house; studios and public bathrooms are wheelchair-accessible.

MEALS Artists purchase their own food and prepare their own meals.

RESIDENT SEASON January–March; April–July; September–December.

AVERAGE LENGTH OF RESIDENCIES 3 months.

NUMBER OF ARTISTS IN 1995 12 (selected from 60 applicants).

AVERAGE NUMBER OF ARTISTS PRESENT AT ONE TIME 4.

APPLICATION DEADLINE Late spring.

FOR CURRENT APPLICATION REQUIREMENTS:

1501 Glasstown Road
Millville, NJ 08332

TEL
609-825-6800 (ext. 2733)

FAX
609-825-2410

E-MAIL
n/a

WWW
n/a

SELECTION PROCESS Outside panel of professionals.

APPLICATION FEE None.

SPECIAL PROGRAMS None.

STIPEND $1,500.

ARTIST PAYS Travel, food, personal needs; no residency fee.

ARTIST DUTIES 12 hours/per week working in hot glass studio during visiting hours.

OTHER ACCOMMODATIONS None.

PUBLIC PROGRAMS Museum tours.

HISTORY The Creative Glass Center of America, established in 1983, is a division of the Wheaton Cultural Alliance, Inc.

MISSION "To provide artists with an opportunity to work out their concepts without many of the restrictions imposed by production costs and sales needs to establish a body of work, regardless of personal financial limitations."

PAST ARTISTS INCLUDE Mark Abildgaard, Susan Anton, Patricia Davidson, John de Wit, Garry Jacobson, Eileen Jager, Fred Kahl, Ruth King, David Levi, Karen Naylor, Leslie O'Brien, Kingsley Parker

FROM THE DIRECTOR "The Creative Glass Center of America is a unique international resource center that awards fellowships to emerging and mid-career artists working in glass. GGCA provides the facilities, resources, and funds that allow the artists the opportunity to spend an uninterrupted, concentrated period devoted exclusively to their art—to collaborate and exchange ideas, to experiment, to develop and refine their artistic conceptions, skills, and techniques—free of charge." —*Denise Gonzalez-Dendrinos*

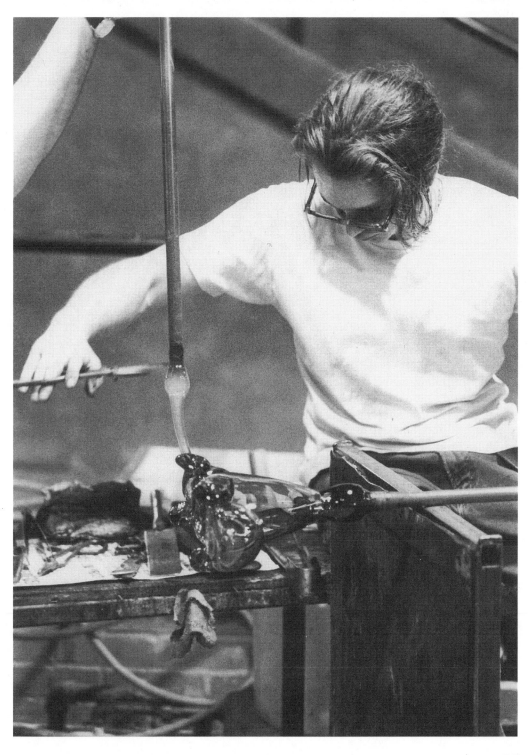

Djerassi Resident Artists Program

FOUNDED Organization 1979, Residency Program 1979.

LOCATION In the foothills of the Santa Cruz Mountains of Northern California, between Stanford University and Half Moon Bay, 40 miles south of San Francisco.

CATEGORIES Visual Artists in book arts, clay/pottery (electric kiln), digital imaging, drawing, fiber/textile, film/videomaking, installation, mixed media, painting, paper art, photography, sculpture, and woodworking; fiction writers, literary nonfiction writers, playwrights, poets, screenwriters, and translators; audio artists, choreographers, composers, electronic artists, peformance artists, radio artists; architects and landscape architects; collaborative teams, conceptual artists, environmental artists, interdisciplinary artists, media artists, multimedia artists, and new genre artists.

FACILITIES and HOUSING Living quarters are in a 7-bedroom house with baths, living room/library, dining room, media room, kitchen, outside deck, and balconies. Rooms in the Artists' House are set up to accommodate writers, each with a large desk, work space, and outdoor deck. Visual art studios and living quarters, with wood-burning stoves, are located in the twelve-sided barn. The Artists' Barn also houses a choreography studio with video camera/monitor, a color photography darkroom, and a composer's studio which is equipped with a grand piano and a MIDI keyboard, as well as recording and playback equipment. Accommodations for hearing-impaired, MS, and chronic fatigue residents. The program is in the planning stages for making facilities more accessible to disabled residents.

MEALS All meals provided.

RESIDENT SEASON April–October.

LENGTH OF RESIDENCIES 4–6 weeks.

NUMBER OF ARTISTS IN 1995 64 (selected from 500 applicants).

AVERAGE NUMBER OF ARTISTS PRESENT AT ONE TIME 9.

APPLICATION DEADLINE February 15.

SELECTION PROCESS Outside panel of professionals in each discipline; panel members change each year.

APPLICATION FEE $25.

SPECIAL PROGRAMS Other Minds Music Festival.

STIPEND Gerald Oshita Memorial Fellowship of $2,500 for composer of color. Other awards on occasion.

ARTIST PAYS Travel, personal needs, materials, supplies; no residency fee.

ARTIST DUTIES None.

OTHER ACCOMMODATIONS Couples or collaborative groups are only accepted if each individual artist qualifies independently; no children or pets; occasional visitors welcome after 4 P.M.

FOR CURRENT APPLICATION REQUIREMENTS:

2325 Bear Gulch Road
Woodside, CA 94062-4005

TEL
415-747-1250

FAX
415-747-0105

E-MAIL
drap@djerassi.org

WWW
http://www.djerassi.org
http://www.otherminds.org/djerassi.html

> "*Djerassi provided me with the necessary elements for sustained creative work: undisturbed privacy, an exceptionally beautiful natural surrounding, and (important for composers) the kind of acoustical quiet unavailable in an urban setting. This kind of ambiance, plus the extraordinary efforts of a dedicated cook, have made the opportunity to work here a memorable experience for me.*" —*John Adams*

PUBLIC PROGRAMS Off-site: salon, festivals, concerts; on-site: sculpture hikes, open house.

HISTORY Founded in 1979 by Carl Djerassi in memory of his daughter Pamela (1950–1978), a poet and painter, the Djerassi Foundation Resident Artists Program was originally a retreat for one female artist annually. Since 1982, multiple artists in all media have come to this 1,400 acre ranch, 600 acres of which are owned by the foundation.

MISSION "To support and enhance the creativity of artists by providing uninterrupted time for work, reflection, and collegial interaction in a setting of great natural beauty . . . to preserve the land on which the Program is situated."

PAST ARTISTS INCLUDE Douglas Dunn, Margaret Fisher, Wayne Peterson, Julia Wolfe, Nora Ligorano/Marshall Reese, Denise Levertov, Fae Myenne Ng, Vikram Seth, Al Young, Carmen Lomas Garza, David Nash, Miriam Schapiro.

FROM THE DIRECTOR "At Djerassi, artists often comment on the inspiration they gather from the abundance of extraordinarily beautiful land at our site. Over forty site-specific sculptures are hidden throughout five miles of mountain trails in a very remote and private location, far from the city. The community of residents is small—about seven to ten at a time—affording the opportunity to get to know your fellow artists over the course of a month-long stay. Food is a fetish at Djerassi! We take special care to serve creative and nourishing evening meals that reward a hard day's labor in the studio."
—*Charles Amirkhanian*

FOUNDED Organization 1979, Residency Program 1979.

LOCATION 300-acre nature preserve in the foothills of Palomar Mountain, overlooking the Temecula Valley, 60 miles north of San Diego, 100 miles southeast of Los Angeles.

CATEGORIES Visual artists in arts and crafts, book art, ceramics, clay/pottery, drawing, fiber/textile, film/videomaking, folk art, glass, industrial art, installation, jewelry, mixed media, painting, paper art, photography, printmaking, sculpture, and woodworking; fiction writers, journalists, literary nonfiction writers, playwrights, poets, screenwriters, and translators; actors, audio artists, choreographers, composers, dancers, film directors, theater directors, electronic artists, musicians, performance artists, and storytellers; architects; collaborative teams and interdisciplinary artists.

FACILITIES 6 cottages with work space, kitchen, bathroom, living/sleeping areas. There is no electricity. Woodstoves heat cottages in the winter and propane provides for apartment-sized stoves, refrigerators, and hot water heaters. Artists needing power must bring their own battery-powered equipment. It's possible for community to accommodate disabled residents, but it may prove difficult. Best to call.

HOUSING Cottage with linens and kitchen accessories.

MEALS Artists purchase their own food (transportation to grocery store is provided) and prepare their own meals.

RESIDENT SEASON Year-round.

AVERAGE LENGTH OF RESIDENCIES 4–6 weeks.

NUMBER OF ARTISTS IN 1995 65 (selected from 95 applicants).

AVERAGE NUMBER OF ARTISTS PRESENT AT ONE TIME 6.

APPLICATION DEADLINES March 1 and September 1.

SELECTION PROCESS Outside panel of 3 professionals in each category.

APPLICATION FEE None; however, upon acceptance there is a $50 processing fee.

SPECIAL PROGRAMS Grant Program (available occasionally), International Program.

STIPEND Varies.

ARTIST PAYS $300/month residency fee, travel, food, shipment of materials, personal needs, materials.

ARTIST DUTIES None.

OTHER ACCOMMODATIONS No children or pets; overnight visitors, other than children, may stay for $20 fee.

PUBLIC PROGRAMS A Dorland Evening (annual fundraiser), Works-in-Progress (a monthly presentation/reading by Dorland residents), monthly theme tours.

FOR CURRENT APPLICATION REQUIREMENTS:

P.O. Box 6
Temecula, CA 92593

TEL
909-676-5039

FAX
n/a

E-MAIL
dorland@ez.net

WWW
n/a

> *"Dorland is attractive in a way no other artists' colony in my experience can rival: verdant mountains in the midst of desert ranch country, with a fascinating population of birds, animals, wildflowers, ponds, orchards, abundant sunlight, clear air. I will always remember with pleasure my stay there as one of the first colonists."* —May Swenson

HISTORY The Dorland land was homesteaded in the 1930s by the mathematician Robert Dorland and his wife, Ellen Babcock Dorland, a world-renowned concert pianist. Wanting to create an artist community similar to those she'd visited on the East Coast, Ellen Babcock Dorland and environmentalist Barbara Horton, in concert with the Nature Conservancy, opened the community in 1979.

MISSION "To provide writers, visual artists, and composers with simple living facilities for concentrated work within a setting of natural beauty. The unspoiled environment and undisturbed solitude foster creativity."

PAST ARTISTS INCLUDE Vernon Taranto, Leon Levitch, Ed Cansino, Maria Neiderberger, Millie Burns, Jane Culp, Russell Christofferson, Joel Sokolov, Noelle Sickels, Robert Willis, Jim Reiss, May Swenson.

FROM THE DIRECTOR "Residents find that the benefits of Dorland usually exceed that of their preconceptions. Once artists settle in (and this can take up to a week) to the lack of noise and interruptions, the natural rhythm of their daily lives can lead them to their innermost selves, that which is frequently forgot-

ten or set aside in their busy lives. This provides an opportunity to expand their talents in new and exciting directions. Dorland gives a chance for change not only at an artistic level, but also on a spiritual level." —*Karen Parrot*

FOUNDED Organization 1976, Resident Program 1980.

LOCATION In the Green Mountains of southern Vermont in the village of Dorset, which is listed on the National Register of Historic Places, about 4 hours from New York City.

CATEGORIES Fiction writers, journalists, literary nonfiction writers, playwrights, poets, screenwriters, and translators; collaborative teams, interdisciplinary artists, and multimedia artists.

FACILITIES Large 3-floor house. Community accommodates disabled residents and is in the planning stages for making facilities more accessible.

HOUSING Private rooms.

MEALS Artists purchase their own food and prepare their own meals.

RESIDENT SEASON Spring and fall.

AVERAGE LENGTH OF RESIDENCIES 2 weeks–1 month.

FOR CURRENT APPLICATION REQUIREMENTS:

P.O. Box 519
Dorset, VT 05251

TEL
802-867-2223

FAX
802-867-0144

E-MAIL
theatre@sover.net

WWW
http://www.genghis.com/theatre.htm

NUMBER OF ARTISTS IN 1995 60 (selected from 100 applicants).

AVERAGE NUMBER OF ARTISTS PRESENT AT ONE TIME 7.

APPLICATION DEADLINES Ongoing.

SELECTION PROCESS Outside panel of professionals.

APPLICATION FEE None.

SPECIAL PROGRAMS None, though actively seeking minority artists.

STIPEND None.

ARTISTS PAY $95/week voluntary residency fee, travel, food, personal needs, materials.

ARTIST DUTIES None.

OTHER ACCOMMODATIONS None.

PUBLIC PROGRAMS None.

HISTORY Built in the early 1800s, the Colony house was renovated in the 1920s by the Sheldon family. From 1960–1978, the Sheldon-Salmon family rented the house to Dorset's professional theatre company. In 1979, the house was purchased by Dr. and Mrs. John Nassivera, with the assistance of the Clarence Geiger Trust.

MISSION "To provide an opportunity for writers to set aside periods of time to work intensely on given projects away from the distractions of everyday life."

PAST ARTISTS INCLUDE Stephen McCauley, Paul D'Andrea, Donald Donnellan, Susan Dworkin, Ellen McLaughlin, Maude Meehan, Jacquelyn Reingold, Lloyd Rose, Edward Tick, Mark Weston, Matthew Witten, Dana Yeaton.

FROM THE DIRECTOR "We are an informal place. It's very quiet and intimate here. We take unpub-

"*The informality of the Dorset House allowed me to get more work done than I have at other colonies. There are no evening readings to eat up valuable time, and if you work late at night you don't have to worry about missing breakfast because no one serves breakfast. The friendly staff is helpful when you need them, and invisible when you don't.*" —Mark Weston

lished people and people just getting started, as well as published writers. 50 percent of our residents are returnees." —*John Nassivera*

Edward F. Albee Foundation/William Flanagan Memorial Creative Persons Center

FOUNDED Organization 1966, Residency Program 1966.

LOCATION In Montauk, Long Island.

CATEGORIES Visual artists (with own equipment) in arts and crafts, book art, ceramics, clay/pottery, digital imaging, drawing, fiber/textile, film/videomaking, folk art, glass, industrial art, installation, jewelry, mixed media, painting, paper art, photography, printmaking, sculpture, and woodworking; fiction writers, journalists, literary nonfiction writers, playwrights, poets, screenwriters, and translators; actors, audio artists, choreographers, composers, dancers, film directors, theater directors, electronic artists, musicians, performance artists, storytellers, and radio artists; architects and set designers; art conservators, art educators, art historians, art professionals, critics, general scholars, historians, historic preservationists, and linguists; conceptual artists, environmental artists, interdisciplinary artists, media artists, multimedia artists, and new genre artists.

FACILITIES Visual artists receive studios; writers work in their bedrooms. Community accommodates disabled residents. Housing, housing bathrooms, and studios are wheelchair-accessible.

HOUSING Renovated barn with communal living arrangements (kitchen and bathrooms).

MEALS Artists purchase their own food and prepare their own meals.

RESIDENT SEASON June–September.

AVERAGE LENGTH OF RESIDENCIES 1 month.

NUMBER OF ARTISTS IN 1995 18 (selected from 200 applicants).

AVERAGE NUMBER OF ARTISTS PRESENT AT ONE TIME 4–5.

APPLICATION DEADLINE April 1.

SELECTION PROCESS Outside panel of professionals in each category.

APPLICATION FEE None.

SPECIAL PROGRAMS None.

STIPEND None.

ARTIST PAYS Travel, food, personal needs, materials; no residency fee.

ARTIST DUTIES None.

OTHER ACCOMMODATIONS None.

PUBLIC PROGRAMS None.

HISTORY Founded by playwright Edward Albee in 1966 in memory of composer William Flanagan.

MISSION "To meet the needs of artists in their formative years and to provide them with time and freedom to work."

FOR CURRENT APPLICATION REQUIREMENTS:

14 Harrison Street
New York, NY 10013

TEL
212-226-2020

FAX
n/a

E-MAIL
n/a

WWW
n/a

> "My studio at Albee's had what seemed like forty-foot high ceilings, with huge barn doors open to the woods. It was pure luxury simply to have the time to think and to give the paintings a chance to breathe." —*Robert Farber*

PAST ARTISTS INCLUDE Donna de Salvo, Katherine Bowling, Carol Hepper, A. M. Homes, Spaulding Gray, Scott Kelley, Heide Fasnacht, Carl Capotorto, David Greenspan, Jacquelyn Reingold, Sherry Kramer, David Simpatico.

FROM THE DIRECTOR "After *Who's Afraid of Virginia Woolf*, it occurred to me to do something useful with the money rather than give it to the government. . . . We want to take a chance on people." —*Edward Albee*

Exploratorium

FOUNDED Organization 1969, Residency Program 1974.

LOCATION In San Francisco's Marina District.

CATEGORIES Artists who are working at the intersection between art and science, including choreographers and performance artists; environmental artists, interdisciplinary artists, media artists, multimedia artists, new genre artists, and phenomena-based artists.

FACILITIES Work space inside the museum. Community accommodates disabled residents.

HOUSING Living space in the city by arrangement.

MEALS Artists purchase their own food and prepare their own meals, but are given a per diem to do so.

RESIDENT SEASON Year-round.

AVERAGE LENGTH OF RESIDENCIES Varies, depending on scope of project.

NUMBER OF ARTISTS IN 1995 14 (selected from 108 applicants).

FOR CURRENT APPLICATION REQUIREMENTS:

3601 Lyon Street
San Francisco, CA 94123

TEL
415-561-0327

FAX
415-563-9153

E-MAIL
n/a

WWW
http://www.exploratorium.edu

AVERAGE NUMBER OF ARTISTS PRESENT AT ONE TIME 3.

APPLICATION DEADLINES None.

SELECTION PROCESS Staff panel and/or professional panel review.

APPLICATION FEE None.

SPECIAL PROGRAMS Teacher training, High School Explainers, Learning Studio, exhibitions, performances.

STIPEND Payment for travel, meals, and materials; negotiated payment for commissioned work.

ARTIST PAYS Personal needs, food (see "Meals"); no residency fee.

ARTIST DUTIES None, other than agreed-upon project or new work or research.

OTHER ACCOMMODATIONS None.

PUBLIC PROGRAMS None.

HISTORY Founded in 1969 by Dr. Frank Oppenheimer as a museum of science, art, and human perception, the Exploratorium is located within the Palace of Fine Arts, the last remaining building of the 1915 Panama Exposition.

MISSION "To communicate the conviction that both nature and people can be understandable and full of new and exciting insights. To provide learning experiences that will stimulate people of all ages to want to know about the world and its phenomena."

PAST ARTISTS INCLUDE Doug Hollis, George Gessert, Carl Cheug, Paul De Marinis, Anna Valentina Murch, Laurie Lundquist, Ruth Asawa, Muriel Rukyeser, Dian Stockler, Toshio Iwai.

FROM THE DIRECTOR "There are cognitive aspects of art, just as there are aesthetic aspects of sci-

ence—and the focus on cognition reveals the overlap between the two disciplines. At the same time, artists and scientists provide windows of understanding and experience of the world around us." —*Dr. Goery Delacote*

The Fabric Workshop and Museum

FOUNDED Organization 1977, Residency Program 1977.

LOCATION Downtown Philadelphia.

CATEGORIES Visual artists in ceramics, drawing, fiber/textile, film/videomaking, installation, mixed media, painting, photography, print-making, and sculpture; performance artists; architects, clothing designers, graphic design-ers, and industrial designers; art conservators and art educators; conceptual artists, media artists, and multimedia artists.

FACILITIES Production studio, visiting artist stu-dio, lecture/media area, silk-screen printing tables. Studios are wheelchair-accessible; com-munity is in the planning stages for making fa-cilities accessible to disabled residents.

HOUSING Local apartments.

MEALS Artists purchase their own food and pre-pare their own meals.

RESIDENT SEASON Year-round.

FOR CURRENT APPLICATION REQUIREMENTS:

1315 Cherry Street, 5th Floor
Philadelphia, PA 19107-2026

TEL
215-568-1111

FAX
215-568-8211

E-MAIL
fw&m@libertynet.org

WWW
http://www.libertynet.org/fw&m

AVERAGE LENGTH OF RESIDENCIES 1 month–six weeks.

NUMBER OF ARTISTS IN 1995 19.

AVERAGE NUMBER OF ARTISTS PRESENT AT ONE TIME 6.

APPLICATION DEADLINES By invitation only.

SELECTION PROCESS Outside panel of profession-als.

APPLICATION FEE None.

SPECIAL PROGRAMS None.

STIPEND None.

ARTIST PAYS Travel, food, personal needs, mate-rials; no residency fee.

ARTIST DUTIES None.

OTHER ACCOMMODATIONS None.

PUBLIC PROGRAMS Exhibitions, lectures, perfor-mances.

HISTORY Founded in 1977 by Marion B. Stroud.

MISSION "Devoted to creating new work in fabric and other materials, encouraging col-laboration among emerging, nationally, and internationally recognized aritsts."

PAST ARTISTS INCLUDE Louise Bourgeois, Chris Burden, Ann Hamilton, Mike Kelley, Lorna Simpson, Jene Highstein, Alison Saar, Mel Chin, Scott Burton, Louise Nevelson, Mona Hatoum, Jim Hodges.

FROM THE DIRECTOR "The Fabric Workshop and Museum has developed from an ambitious ex-periment to a renowned institution with a widely recognized Artist-in-Residence Pro-gram, an extensive permanent collection of new work created by artists at the Workshop, in-

house and touring exhibitions, and compre-hensive educational programming, including lectures, tours, in-school presentations, and student apprenticeships." —*Marion B. Stroud*

PHOTO: © 1994 WILL BROWN

FOUNDED Organization 1968, Residency Program 1968.

LOCATION A converted lumberyard, in the town center of Provincetown, 2 hours from both Boston and Providence.

CATEGORIES Visual artists in book arts, digital imaging, drawing, fiber/textile, installation, mixed media, painting, paper art, photography, printmaking, sculpture, and woodworking; fiction writers, playwrights, and poets; conceptual artists and environmental artists.

FACILITIES and HOUSING Visual artists provided with apartments and separate studio; darkroom, printshop, woodworking equipment available; writers provided with 1–3 room apartments. All apartments have kitchens. Also, gallery and common room. Housing, housing bathrooms, studios, and public bathrooms are wheelchair-accessible; community is in the planning stages for making facilities more accessible to disabled residents.

MEALS Artists purchase their own food and prepare their own meals.

FOR CURRENT APPLICATION REQUIREMENTS:

24 Pearl Street, Box 565
Provincetown, MA 02657

TEL
508-487-9960

FAX
508-487-8873

E-MAIL
n/a

WWW
n/a

RESIDENT SEASON October 1 to May 1.

AVERAGE LENGTH OF RESIDENCIES 7 months.

NUMBER OF ARTISTS IN 1995 21 (selected from 1,000 applicants).

AVERAGE NUMBER OF ARTISTS PRESENT AT ONE TIME 21.

APPLICATION DEADLINE February 1 (postmark).

SELECTION PROCESS Outside panel of professionals in each category, along with the members of the writing and visual arts committees.

APPLICATION FEE $35.

SPECIAL PROGRAMS Munro Moore Award for Emerging Playwrights, Visiting Artists and Writers Series, Hudson D. Walker Gallery Series, Satellite Reading Series, New Provincetown Print Project, Senior Fellowships for Writers and Artists, Collaborative Residency Fellowships, Summer Program, Summer Program Scholarships. Short-Term Residency Program rental space is available in May, June, and September.

STIPEND $375/month. (Visual artists, additional $75/month for supplies.)

ARTIST PAYS Travel, food, personal needs, materials; no residency fee.

ARTIST DUTIES None.

OTHER ACCOMMODATIONS Families okay if Fellow is willing to live off-site; non-refundable fee for pets.

PUBLIC PROGRAMS Reading series and exhibitions.

HISTORY Provincetown has provided work space for artists and writers since the late eighteenth century, and the Work Center, founded in 1968 by a group of eminent artists and writers, plays a key role in maintaining that heritage. Before

"For me, this fellowship has been one of those gifts that drop into your life and change everything. The idea that a writer works best in isolation is a myth; the history of literature shows us that writers do work together, and one of the greatest benefits of my stay here has been the chance to interact deeply with my colleagues. . . . Perhaps the greatest gift . . . has been a spiritual experience. . . . The Indians may have been right when they said there was magic out here on the tip of the cape." —Melanie Sumner

the Center acquired the site, artists such as Robert Motherwell, Myron Stout, Helen Frankenthaler, and Hans Hofmann rented studio space on the grounds of what was then Days Lumber Yard. Jack Tworkov, Fritz Bultman, Hudson D. Walker, Alan Dugan, and Stanley Kunitz were among the Center's founding members.

MISSION "To provide for the establishment and maintenance of . . . a center for artists and writers, consisting of resident Fellows, program committee members, employees, and visiting artists, writers and patrons from all relevant fields of the arts and humanities . . . (and) primarily dedicated to supporting emerging artists and writers at the crucial early states of their careers."

PAST ARTISTS INCLUDE Richard Baker, Ellen Driscoll, Portia Munson, Jack Pierson, Sharon Horvath, Charles Spurrier, Louise Gluck, Michael Collier, Yusef Komunyakaa, Denis Johnson, Jayne Anne Philips, Carole Maso.

FROM THE DIRECTOR "The Fine Arts Work Center is the country's only long-term residency program specifically for emerging artists and writers. The ongoing series of art openings, slide lectures, and readings by resident and visiting writers gives the Work Center and the already culturally advanced surroundings of Provincetown a liveliness often unmatched outside the major cities." —*Michael Wilkerson*

Friends of Weymouth, Inc.

FOUNDED Organization 1978, Residency Program 1978.

LOCATION 22-room Georgian manor house located on 20 acres of land.

CATEGORIES Fiction writers, journalists, literary nonfiction writers, playwrights, poets, screenwriters, translators.

FACILITIES and HOUSING 3 single bedrooms, 2 double bedrooms, 1 room with twin beds, 3 baths. Community will accommodate disabled residents; call for details.

MEALS Artists purchase their own food and prepare their own meals.

RESIDENT SEASON Year-round.

AVERAGE LENGTH OF RESIDENCIES 2–10 days.

NUMBER OF ARTISTS IN 1995 50 (selected from 50 applicants).

AVERAGE NUMBER OF ARTISTS PRESENT AT ONE TIME 2–3.

FOR CURRENT APPLICATION REQUIREMENTS:

P.O. Box 939
Southern Pines, NC 28388

TEL
910-692-6261

FAX
910-692-1815

E-MAIL
n/a

WWW
n/a

APPLICATION DEADLINES None.

SELECTION PROCESS Reviewed by committee of Director and Board of Directors.

APPLICATION FEE None.

SPECIAL PROGRAMS None.

STIPEND None.

ARTIST PAYS Travel, food, living expenses, materials; no residency fee.

RESIDENT DUTIES None.

OTHER ACCOMMODATIONS None.

PUBLIC PROGRAMS Concerts, lectures, readings, symposia.

HISTORY Founded in 1978 on the former estate of novelist James Boyd.

MISSION "To provide a quiet, creative atmosphere for productive writing."

PAST ARTISTS INCLUDE Reynolds Price, Lee Smith, Doris Betts, Fred Chappell, James Applewhite, Ann Deagon, Sally Buckner, Shelby Stephenson, Guy Owen, Paul Green, Thad Stem, Jr., Kaye Gibbons.

FROM THE DIRECTOR
"Friends of Weymouth offers a year-round program in the arts and humanities." —*Lois Wistrand*

"I think the air of casual welcome is important—everyone is made to feel at home, rather than like a guest or client. This really helps the juices flow. The generosity of this place is marvelous—and the fact that it honors work-in-progress rather than just work that's proven and successful. I hope it never loses its warmth and air of trust in the writer's work." —Florence Nash

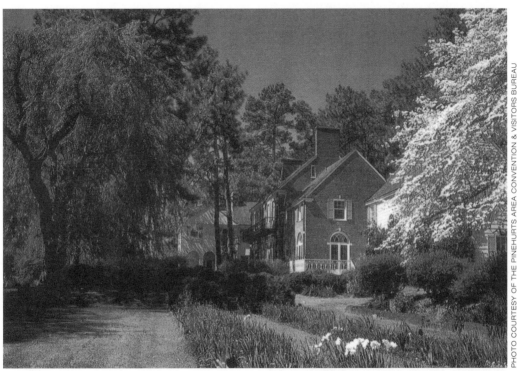

PHOTO COURTESY OF THE PINEHURTS AREA CONVENTION & VISITORS BUREAU

The Gell Writers Center of the Finger Lakes

ALLIANCE OF ARTISTS' COMMUNITIES MEMBER

FOUNDED Organization (Writers & Books) 1980, Residence Program 1988.

LOCATION 25 acres on Canandaigua Lake, in the center of the Finger Lake region.

CATEGORIES Book artists; fiction writers, journalists, literary nonfiction writers, playwrights, poets, screenwriters, and translators; performance artists and storytellers; environmentalists/naturalists; interdicisplinary artists.

FACILITIES and HOUSING 2-bedroom house, with separate work, kitchen, bathroom, and dining space; letterpress print shop. Housing, housing bathrooms, and print shop are wheelchair-accessible; all alarm systems flash as well as sound; community is in the planning stages for increasing accessiblity for disabled residents.

MEALS Artists purchase their own food and prepare their own meals.

RESIDENT SEASON Year-round.

AVERAGE LENGTH OF RESIDENCIES 7–10 days.

FOR CURRENT APPLICATION REQUIREMENTS:

c/o Writers & Books
740 University Avenue
Rochester, NY 14607

TEL
716-473-2590

FAX
716-729-0982

E-MAIL
n/a

WWW
n/a

NUMBER OF ARTISTS IN 1995 45 (selected from 65 applicants).

AVERAGE NUMBER OF ARTISTS PRESENT AT ONE TIME 2.

APPLICATION DEADLINE Ongoing.

SELECTION PROCESS Staff committee.

APPLICATION FEE None.

SPECIAL PROGRAMS 8 Gell Fellowships each year for writers who become involved in community outreach; others pay minimal daily fee and have no involvement with community programs.

STIPEND $1,250 for Gell Fellowship recipients only.

ARTIST PAYS $25–35/day residency fee, travel, food, personal needs, materials.

ARTIST DUTIES Housekeeping; Gell fellows take part in community outreach.

OTHER ACCOMMODATIONS Groups and children accommodated.

PUBLIC PROGRAMS Readings, workshop.

HISTORY Established in 1988 by Writers & Books, a community literary center in Rochester, when Dr. Kenneth and Geraldine Gell deeded the organization 25 acres of land and a house in the Finger Lakes.

MISSION "To foster and promote the creation, understanding, and appreciation of contemporary literature within a setting of serene natural beauty."

PAST ARTISTS INCLUDE Bob Holman, Anne Waldman, Fielding Dawson, Diane Gallo, Amy Guggenheim, David Matlin, Anne LaBastille, Clayton Eshleman, Sharon Strange, Dennis Nurske, William Least-Heat Moon, Bei Dao.

"*The residency allowed me time to work in the magical setting at the Gell House, enabling me to have an extremely productive week working on new material.*" —*Amy Guggenheim*

FROM THE DIRECTOR "The Gell Writers Center offers writers an opportunity and a setting in which to focus upon their writing away from the distractions of their everyday lives. We are especially interested in providing opportunities to emerging or mid-career writers." —*Joe Flaherty*

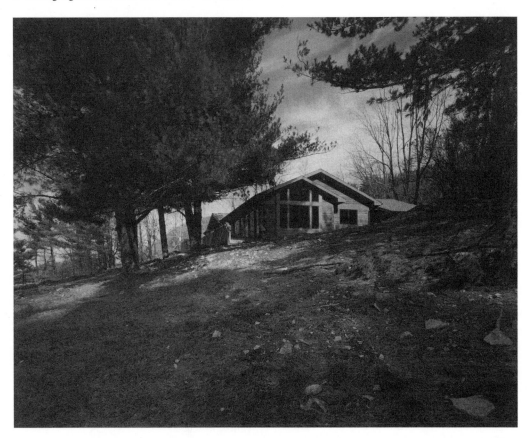

The Hambidge Center for Creative Arts and Sciences

FOUNDED Organization 1934, Residency Program 1988.

LOCATION 600 acres in northeastern Georgia, in the Blue Ridge Mountains, 120 miles from Atlanta, Georgia, and 90 miles from Asheville, North Carolina.

CATEGORIES Visual artists in book art, ceramics, clay/pottery, drawing, fiber/textile, film/video-making, installation, mixed media, painting, paper art, photography, printmaking, and sculpture; fiction writers, literary nonfiction writers, playwrights, poets, screenwriters, and translators; choreographers, composers, dancers, film directors, electronic artists (must provide their own equipment), musicians, performance artists, and storytellers; architects; environmentalists/naturalists; collaborative teams, conceptual artists, environmental artists, interdisciplinary artists, and multimedia artists.

FACILITIES and HOUSING 7 cottage/studios, 5-bedroom Rock House, ceramic studio with electric, gas, and wood-fired stove, limited darkroom. Housing, housing bathrooms, studios, and public bathrooms are wheelchair-accessible.

FOR CURRENT APPLICATION REQUIREMENTS:

P.O. Box 339
Rabun Gap, GA 30568

TEL
706-746-5718

FAX
706-746-9933

E-MAIL
jbarber@artswire.org

WWW
n/a

MEALS Dinner provided Monday-Friday (May–October); artists purchase their own food and prepare their own meals all other times.

RESIDENT SEASON March–December.

AVERAGE LENGTH OF RESIDENCIES 4 weeks.

NUMBER OF ARTISTS IN 1995 80 (selected from 150 applicants).

AVERAGE NUMBER OF ARTISTS PRESENT AT ONE TIME 7.

APPLICATION DEADLINES January 31 and August 31.

SELECTION PROCESS Outside panel of professionals in each category.

APPLICATION FEE $20.

SPECIAL PROGRAMS None.

STIPEND Available only as part of scholarships that cover resident fees.

ARTIST PAYS $125/week residency fee; travel, some food (see "Meals"), personal needs, materials.

ARTIST DUTIES None.

OTHER ACCOMMODATIONS No pets or family; guests may come weekends; groups welcome with advance notice.

PUBLIC PROGRAMS Folk Art Gallery, Nature Trail.

HISTORY The Hambidge Center was founded in 1934 by Mary Crovatt Hambidge as a studio and cottage weaving industry. In 1937, Mary Crovatt Hambidge was the Gold Medal winner in Textiles at the 1937 Paris Exposition; presidents Roosevelt and Truman, Georgia O'Keeffe, and other luminaries of the day were among those who bought her handwoven fabrics. The art center was created in 1973, and in 1988 the

Board decided to focus its energies almost entirely on the Artists' Residency program.

MISSION "To create, protect, sustain, and improve upon facilities and an environment in which creativity and a dynamic interchange between artists from different fields may take place; to provide periods of residency in this environment for artists of exceptional talent in which they may contemplate, conceive, and ultimately create without demands or distractions."

PAST ARTISTS INCLUDE Olive Ann Burns, Mary Hood, Jean Hanff Korelitz, Lynna Williams, Emma Diamond, Martin Herman, Annette Cone-Skelton, Kevin Cole, Michael Liddle, Ben Owen III, M. C. Richards, Lucinda Bunnen.

FROM THE DIRECTOR "Residents at the Hambidge Center are offered the opportunity to work in solitude in cottage-studios scattered throughout our beautiful Appalachian mountain property. Creativity is facilitated here by the power of this land. After a time, the less essential fades away, and one is able to access more authentic qualities in one's self and one's work." —*Judith Barber*

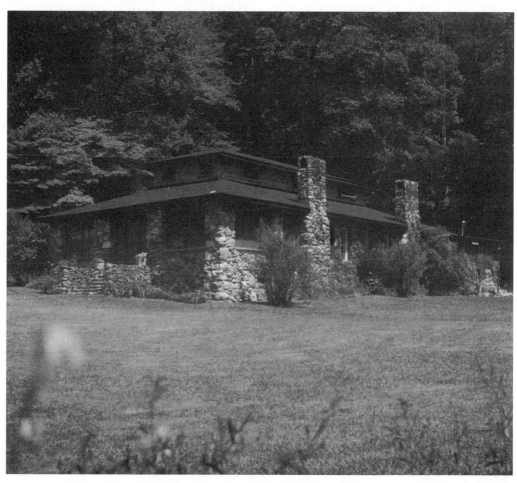

Headlands Center for the Arts

FOUNDED Organization 1982, Residency Program 1987.

LOCATION On 13,000 coastal acres in Marin County, north of San Francisco, just a few minutes from the Golden Gate Bridge.

CATEGORIES Visual artists in book art, ceramics, digital imaging, drawing, fiber/textile, film/videomaking, installation, mixed media, painting, paper art, photography, sculpture, and woodworking; fiction writers, journalists, literary nonfiction writers, playwrights, poets, screenwriters, and translators; actors, audio artists, choreographers, composers, dancers, film directors, theater directors, electronic artists, musicians, performance artists, storytellers, and radio artists; architects, landscape architects, and urban designers; art educators, art historians, art professionals, critics, environmentalists/naturalists, general scholars, historians, historic preservationists, linguists, mathematicians, and scientists; collaborative teams, conceptual artists, environmental artists, interdisciplinary artists, media artists, multimedia artists, and new genre artists.

FOR CURRENT APPLICATION REQUIREMENTS:

944 Fort Barry
Sausalito, CA 94965

TEL
415-331-2787

FAX
415-331-3857

E-MAIL
headlands@artswire.org

WWW
n/a

FACILITIES 13 studios, 2 live/work spaces for writers. Housing, housing bathrooms, one studio, and public bathrooms are wheelchair-accessible.

HOUSING 3 houses, shared among 1–3 other artists; 1 family house (fees required for spouse and children).

MEALS Dinner provided 5 times per week; artists purchase their own food and prepare their own meals all other times.

RESIDENT SEASON February–November.

AVERAGE LENGTH OF RESIDENCIES 3–11 months.

NUMBER OF ARTISTS IN 1995 20 (selected from 350 applicants).

AVERAGE NUMBER OF ARTISTS PRESENT AT ONE TIME In residence: 1–10; living off-site: 6–16.

APPLICATION DEADLINES Early June for California, North Carolina, and Ohio programs (only artists from these states are eligible to apply for residency program); international program deadlines vary for artists from Sweden, Taiwan, the Czech Republic, Mexico, and Canada.

SELECTION PROCESS Outside panel of professionals in each category.

APPLICATION FEE None.

SPECIAL PROGRAMS Bay Area Artists Affiliate Program (studio rental), The Bridge Project (artist residencies involving work with the community or social institutions); special residency for a woman artist in California.

STIPEND $500/month for live-in residents; $2,500 stipend for California non-live-in residents; airfare to and from San Francisco for non-California residents.

> *"I have felt incredible permission and support here to let [my work] be done in a way that is part of my life."* —Ann Hamilton

ARTIST PAYS Some food (see "Meals"), personal needs, materials; no residency fee.

RESIDENT DUTIES Participation in Open House.

OTHER ACCOMMODATIONS Guests up to 2 weeks.

PUBLIC PROGRAMS Open house, lectures, performances, workshops.

HISTORY On what was once Miwok lands, the U.S. government purchased the Marin Headlands in 1841, beginning a century-long military presence that included Civil War gun emplacements and Nike missile bases. Fort Barry was built here in 1907 and occupied the land until 1972 when the National Park Service took it over and created the Golden Gate National Recreation Area. A public/private partnership secured the Headland Center's incorporation in 1982.

MISSION "To provide a laboratory for the development of new work and a place for the exchange of ideas across cultures and professional disciplines . . . to foster creative investigations of the interdependence between human and natural systems."

PAST ARTISTS INCLUDE David Ireland, Ann Hamilton, Fenton Johnson, Beth Custer, Valerie Soe, Zig Jackson, Stephanie Johnson, Wang Po Shu, Lewis Hyde, Mildred Howard, Tony Cragg, Rebecca Solnit, Mei-Ling Hom, Lewis de Soto, Guillermo Gomez-Pena.

FROM THE DIRECTOR "By promoting cultural and professional diversity within our activities, Headlands works to introduce artists and audiences to new creative processes, and to broaden the range of possibilities for art's function in community life." —*Kathryn Reasoner*

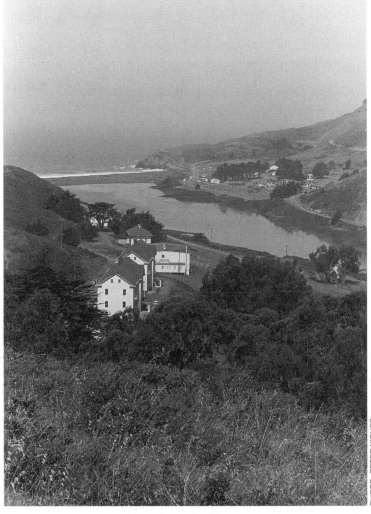

PHOTO: PETER XIQUES

Hedgebrook

FOUNDED Organization 1990, Residency Program 1988.

LOCATION 33-acre farm on Whidbey Island in Washington State.

CATEGORIES Women writers in fiction, journalism, literary nonfiction, playwrighting, poetry, screenwriting, and translation.

FACILITIES and HOUSING 6 fully furnished cottages, including efficiency kitchen, bathroom, desk, and loft; communal bathhouse. Community accommodates disabled residents.

MEALS Breakfast is self-serve, lunch is brought to residents' cottages, dinner is a communal meal in farmhouse dining room.

RESIDENT SEASON Mid-January to May 31. Late June to early December.

AVERAGE LENGTH OF RESIDENCIES 4–5 weeks.

NUMBER OF ARTISTS IN 1995 46 (selected from 374 applicants).

FOR CURRENT APPLICATION REQUIREMENTS:

2197 East Millman Road
Langley, WA 98260

TEL
360-321-4786

FAX
n/a

E-MAIL
n/a

WWW
n/a

AVERAGE NUMBER OF ARTISTS PRESENT AT ONE TIME 6.

APPLICATION DEADLINES October 1 and April 1.

SELECTION PROCESS Outside panel of writers.

APPLICATION FEE $15.

SPECIAL PROGRAMS None.

STIPEND None.

ARTIST PAYS Personal needs, materials; applicants may apply for travel scholarships; no residency fee.

ARTIST DUTIES None.

OTHER ACCOMMODATIONS None.

PUBLIC PROGRAMS Occasional readings in local libraries and bookstores.

HISTORY Hedgebrook was founded in 1988 by Nancy Skinner Nordhoff, a Seattle-area philanthropist. From August 1988 until June 1996, 400 women have come from all over the U.S. to live and write at Hedgebrook.

MISSION "Hedgebrook exists to strengthen the voices of women writers of all ages and from diverse backgrounds by providing a place where they can find connections with one another and with the earth, and the words to build community in the world."

PAST ARTISTS INCLUDE Randy Sue Coburn, Terri del Pena, BarbaraNeely, Susan Zwinger, Ursula K. Le Guin, Mary Kay Blakely, Leslie Li, Mei Ng, A. J. Verdelle, Stephanie Grant, Tillie Olsen, Thalia Zepatos.

FROM THE DIRECTOR "At Hedgebrook, women's many and varied voices are honored and nurtured. For most of them, it's a unique, even life-changing experience. Here, six writers at a time live in woodframe cottages on land that's part

farm and part nature preserve. From the views outside their windows to the freshly picked salads of their lunch baskets, they receive the message: 'Your voice matters. Find the words.'"
—*Linda Bowers*

PHOTO: © 1994 SUSAN DIRK

The Institute for Contemporary Art, P.S. 1 Museum and The Clocktower Gallery

FOUNDED Organization 1972, Residency Program 1976.

LOCATION P.S. 1 Museum is located in Long Island City, Queens, and the Clocktower Gallery is located in Manhattan.

CATEGORIES Visual artists in book art, ceramics, clay/pottery, digital imaging, drawing, fiber/textile, film/videomaking, folk art, glass, industrial art, installation, mixed media, painting, paper art, photography, printmaking, sculpture, and woodworking; performance artists; collaborative teams, conceptual artists, environmental artists, interdisciplinary artists, media artists, multimedia artists, and new genre artists.

FACILITIES P.S. 1 houses 16 studios for international artists; the Clocktower Gallery includes 8 studios for national artists. Studios and public bathrooms are wheelchair-accessible; community is in the planning stages for making facilities more accessible to disabled residents.

HOUSING Paid by artists through respective governments.

FOR CURRENT APPLICATION REQUIREMENTS:

46-01 21st Street
Long Island City, NY 11101

TEL
718-784-2084/212-233-1096

FAX
718-482-9454/212-964-2266

E-MAIL
ica@artswire.org

WWW
n/a

MEALS Artists purchase their own food and prepare their own meals.

RESIDENT SEASON Year-round.

AVERAGE LENGTH OF RESIDENCIES One year.

NUMBER OF ARTISTS IN 1995 11 international, 3 national artists (selected from 1600 applicants).

AVERAGE NUMBER OF ARTISTS PRESENT AT ONE TIME 24.

APPLICATION DEADLINE April 15.

SELECTION PROCESS Foreign government organizations must submit applications for international artists who are then selected by a rotating panel of artists, curators, and art critics. National artists are individually selected by the same jury panel.

APPLICATION FEE None.

SPECIAL PROGRAMS Annual Studio Artist Exhibition and catalogue.

STIPEND International artists are sponsored by participating governments that provide $18,000 for annual living expenses, $2,000 for travel, and $1,000 for materials.

ARTIST PAYS International artists, see "Stipend," above. National artists responsible for travel, food, personal needs, and all studio material costs; no residency fee.

ARTIST DUTIES None.

OTHER ACCOMMODATIONS None.

PUBLIC PROGRAMS Open studio sessions.

HISTORY Beginning in 1976, The Institute for Contemporary Art, through its National and International Studio Program, has awarded workspace annually to artists working in a va-

"*The opportunity to participate in the National Studio Artist Program couldn't have come at a better time for me. I had just moved to New York and was living and working in a tiny space. At P.S. 1 my work was seen by many fellow artists, dealers, and critics at the Open Studios and later during the Studio Artist exhibition. I am grateful for the opportunity provided by this program.*" —Jessica Stockholder

riety of media. The Institute produces a catalogue of the participants' work and organizes a curated exhibition with the Museum.

MISSION "To provide workspace for emerging contemporary artists of exceptional quality . . . to foster a vibrant supportive community of artists from varied backgrounds and disciplines, and to utilize the resources of the Program, The Institute, and New York City to positively impact the work and careers of Program artists during their residency and beyond."

PAST ARTISTS INCLUDE Linda Benglis, Martin Puryear, Annette Messager, Kenny Scharf, David Wojnarowicz, Mike Bidlo, Terry Adkins, Andres Serrano, Lorna Simpson, Jessica Stockholder, Katy Schimert, Ken Chu.

FROM THE DIRECTOR "The National and International Studio Program is one of the few urban artist communities in the country offering precious workspace, exhibition opportunities, publicity, and support in a city where studio rent and access to decision-makers is often out of reach for artists early in their careers. The program's location in New York City, combined with its excellent track record have made it one of the most prestigious awards an emerging artist may receive." —*Alanna Heiss*

PHOTO: THOMAS STRUTH

FOUNDED Organization 1931, Residency Program 1983.

LOCATION In the Berkshire Mountains in the town of Becket.

CATEGORIES Photographers; choreographers, composers, dancers, musicians, and performance artists; historians and historic preservationists; collaborative teams and interdisciplinary artists.

FACILITIES and HOUSING 3 dance studios, 1 choreographic studio, proscenium theatre, blackbox theatre, and outdoor stage. Housing includes clusters of heated cabins, each with common bathroom. Studios and public bathrooms are wheelchair-accessible.

MEALS May–September, all meals provided; October–April, artists purchase their own food (but are provided with a stipend to cover the expense) and prepare their own meals.

RESIDENT SEASON March–October.

AVERAGE LENGTH OF RESIDENCIES 2 weeks.

FOR CURRENT APPLICATION REQUIREMENTS:

P.O. Box 287
Lee, MA 01238

TEL
413-637-1322

FAX
413-243-4744

E-MAIL
n/a

WWW
n/a

NUMBER OF ARTISTS IN 1995 25 companies.

AVERAGE NUMBER OF ARTISTS PRESENT AT ONE TIME 2–4 companies.

APPLICATION DEADLINES Ongoing.

SELECTION PROCESS By invitation only.

APPLICATION FEE None.

SPECIAL PROGRAMS Internship, assistantship, Presenter and Artist Forum.

STIPEND None.

ARTIST PAYS Personal needs; no residency fee.

ARTIST DUTIES None; voluntary presentations, performances, discussions, moderating panels, serving as guest faculty, attending receptions.

OTHER ACCOMMODATIONS Children accommodated; no pets.

PUBLIC PROGRAMS Ted Shawn Theatre, Studio/Theatre, Inside/Out, Music Series, Exhibit Series.

HISTORY In 1930, modern dance pioneer Ted Shawn purchased a historic farm in the Berkshires named Jacob's Pillow to serve as a home and training ground for male dancers. The Artist-in-Residence program was established in 1983.

MISSION "To nurture and sustain the creation, development, preservation, and appreciation of dance as an art form; to create and assist a community of artists whose work encompasses diverse artistic and cultural genres."

PAST ARTISTS INCLUDE Trisha Brown, Liz Lerman Dance Exchange, Urban Bush Women, Pat Graney Dance Company, David Dorfman, Cambodian Artists Project, Paula Josa-Jones/Performance Works, Bill T. Jones/Arnie Zane

> *"The Pillow is always kind of a centering time. It can be really stimulating performing in all that greenery. The atmosphere makes you think about your work, who you are, and why you dance."* —Bill T. Jones

Dance Company, Eiko & Koma, Joanna Haigood, Margaret Jenkins, Ralph Lemon.

FROM THE DIRECTOR "Jacob's Pillow provides both emerging and established choreographers with access to its facility, technical, research, and documentation resources for all of the layered phases involving new work preparation and for essential time to focus on their work in a dance-centered environment." *—Sali Ann Kriegsman*

FOUNDED Organization 1967, Residency Program 1974.

LOCATION In Kohler, Wisconsin, in the Kohler Company factory, the nation's leading manufacturer of plumbing products.

CATEGORIES For any artists who want to work on projects in clay, cast iron, and brass, including, but not limited to, visual artists (arts and crafts, book art, ceramics, clay/pottery, digital imaging, drawing, fiber/textile, film/videomaking, folk art, glass, industrial art, installation, jewelry, mixed media, painting, paper art, photography, printmaking, sculpture, and woodworking); architects, graphic designers, industrial designers, landscape designers, set designers, and urban designers; collaborative teams, conceptual artists, environmental artists, interdisciplinary artists, and new genre artists.

FACILITIES 24-hour studio space at factory; industrial pottery, foundry (cast iron and brass), and enamel shop; photographic services. Community will attempt to meet accessibility needs on an individual basis.

FOR CURRENT APPLICATION REQUIREMENTS:

608 New York Avenue
Box 489
Sheboygan, WI 53082

TEL
414-458-6144

FAX
414-458-4473

E-MAIL
n/a

WWW
n/a

HOUSING 4-bedroom house in the village of Kohler.

MEALS Artists purchase their own food and prepare their own meals.

RESIDENT SEASON Year-round.

AVERAGE LENGTH OF RESIDENCIES 3 months.

NUMBER OF ARTISTS IN 1995 18 (selected from 300 applicants).

AVERAGE NUMBER OF ARTISTS PRESENT AT ONE TIME 4.

APPLICATION DEADLINE August 1.

SELECTION PROCESS Panel of professionals familiar with the program. Panel changes each year.

APPLICATION FEE None.

SPECIAL PROGRAMS None.

STIPEND $120 per week, plus travel reimbursement (within continental U.S.), materials.

ARTIST PAYS Food, personal needs, shipping costs; no residency fee.

ARTIST DUTIES To be available one day per month for educational programs, donation of one piece to John Michael Kohler Arts Center, donation of one piece to Kohler Company.

OTHER ACCOMMODATIONS Guests, for short visits.

PUBLIC PROGRAMS Exhibitions, performing arts productions, educational program, lectures, workshops, classes, outreach.

HISTORY The Arts/Industry Program was founded in 1974, under the auspices of the John Michael Kohler Arts Center.

MISSION "To encourage and support innovative explorations in the arts and to foster an ex-

> *"I don't think I have ever pushed myself quite as hard to get something done. . . . My time here has expanded my reach as an artist. . . . The program allowed me to do work that I would not have ever been able to contemplate in real-world circumstances."* —Andy Yoder

change between a national community of artists and a broad public that will help realize the power of art to inspire and transform our world."

PAST ARTISTS INCLUDE Jack Earl, Joyce Kozloff, Ken Little, Joel Otterson, Nancy Dwyer, Arnie Zimmerman, Win Knowlton, Indira Freitas Johnson, Clarice Dreyer, Ming Fay, Martha Heaverston, Carter Kustera.

FROM THE DIRECTOR "Arts/Industry allows artists the opportunity to create work that would not be possible to make in their own studios."
—*Lynne Shumow*

FOUNDED Organization 1974, Residency Program 1984.

LOCATION Near the University of California at Berkeley.

CATEGORIES Visual artists in book art, digital imaging, drawing, painting (monoprints), paper art, and printmaking (traditional and combined with electronic media, interactive CD-ROMs, 2-D and 3-D animation, digital video, and sound); multimedia artists.

FACILITIES Complete printmaking studio; equipment for lithography, etching, aquatint, relief, letterpress, silk-screen, darkroom; etching room; editioning areas; Macintosh workstations, including digital imaging hardware and software, high-resolution scanners, digital sound and video editing equipment, CD-ROM recorder. Studios, Electronic Media Center, and public bathrooms are wheelchair-accessible. As existing building is retrofitted, community will make facilities more accessible to disabled residents.

HOUSING Local apartments.

FOR CURRENT APPLICATION REQUIREMENTS:

1060 Heinz Avenue
Berkeley, CA 94710

TEL
510-549-2977/2984

FAX
510-540-6914

E-MAIL
kala@kala.org

WWW
http://www.kala.org

MEALS Artists purchase their own food and prepare their own meals (full kitchen available).

RESIDENT SEASON Year-round.

AVERAGE LENGTH OF RESIDENCIES 6 months for fellowship recipients; indefinitely for regular artists-in-residence.

NUMBER OF ARTISTS IN 1995 8 fellowship artists (selected from 22 applicants), as well as 35 other artists-in-residence.

AVERAGE NUMBER OF ARTISTS PRESENT AT ONE TIME 20.

APPLICATION DEADLINES April 26 for fellowship applications; others, ongoing.

SELECTION PROCESS Selections made by Executive Director, Artistic Director, and Programs Director.

APPLICATION FEE None.

SPECIAL PROGRAMS Disadvantaged Youth and Political Refugee Programs, Latin American Refugee workshop, African-American fellowships.

STIPEND None.

ARTIST PAYS Travel, food, personal needs, materials; no residency fee for fellowship recipients ($108-$324/month for regular artist-in-residence).

ARTIST DUTIES None.

OTHER ACCOMMODATIONS None.

PUBLIC PROGRAMS Outreach, gallery, classes.

HISTORY Founded in 1974 by Archana Horsting and Yuzo Nakano as a direct response to the strengths and weaknesses of Stanley Hayter's Atelier 17 in Paris. Originally located in Oakland, Kala moved to Berkeley in 1980 and

expanded facilities in 1995 to include an Electronic Media Center.

MISSION "To provide a diverse, international body of artists with the tools, techniques, and well-organized professional facilities necessary to create high-quality works of art."

PAST ARTISTS INCLUDE Jim Melchert, Rachel Rosenthal, Misch Kohn, Roy DeForest, Krishna Reddy, Nancy Genn, Josephine Ganter.

FROM THE DIRECTOR "The physical production of art in a shared facility such as Kala naturally leads to an exchange of ideas among artists, and presentations of their work in Kala's gallery allows us to share these ideas with the greater public." —*Archana Horsting*

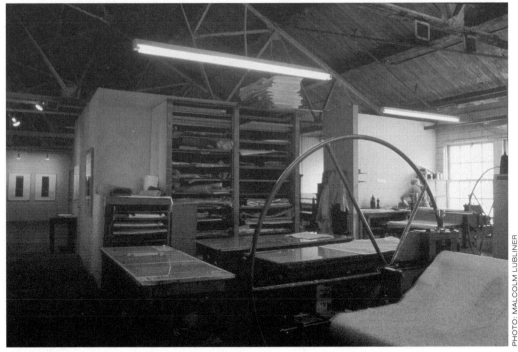

PHOTO: MALCOLM LUBLINER

FOUNDED Organization 1974, Residency Program 1980.

LOCATION On 113 acres of secluded forest and coastline on the Big Island of Hawaii, 45 minutes from Hilo, 1 hour from Volcanoes National Park.

CATEGORIES Visual artists in arts and crafts, book art, ceramics, clay/pottery, digital imaging, drawing, fiber/textile, film/videomaking, folk art, glass, industrial art, installation, jewelry, mixed media, painting, paper art, photography, printmaking, sculpture, and woodworking; fiction writers, journalists, literary nonfiction writers, playwrights, poets, screenwriters, and translators; actors, audio artists, choreographers, composers, dancers, film directors, theater directors, electronic artists, musicians, performance artists, storytellers, and radio artists; architects, clothing designers, graphic designers, industrial designers, landscape designers, set designers, and urban designers; art conservators, art educators, art historians, art professionals, computer scientists, critics, environmentalists/naturalists, general scholars, historians, historic preservationists, linguists, mathematicians, and scientists; collaborative teams, conceptual artists, environmental artists, interdisciplinary artists, media artists, multimedia artists, and new genre artists.

FACILITIES Visual and performance artists are given studio space; writers work in their private rooms. Housing, housing bathrooms, studios, and public bathrooms are wheelchair-accessible.

HOUSING Four 2-story lodges with private rooms, 7 private cottages.

MEALS Artists purchase their own food and prepare their own meals, however, a full-service buffet for breakfast, lunch, and dinner is available.

RESIDENT SEASON Year-round.

AVERAGE LENGTH OF RESIDENCIES 2–8 weeks.

NUMBER OF ARTISTS IN 1995 71 (selected from 80 applicants).

AVERAGE NUMBER OF ARTISTS PRESENT AT ONE TIME 5.

APPLICATION DEADLINES Ongoing.

SELECTION PROCESS Outside panel of professionals in each category.

APPLICATION FEE $10.

SPECIAL PROGRAMS Women's Pacific Islander Program, courses in yoga, Hawaiian culture, and dance.

STIPEND None, though artists receive a 50 percent reduction in lodging fee.

ARTIST PAYS $30–$50/day residency fee; travel, food, personal needs, materials.

ARTIST DUTIES None.

FOR CURRENT APPLICATION REQUIREMENTS:

R.R. #2, Box 4500
Pahoa, HI 96778

TEL
808-965-7828

FAX
808-965-9613

E-MAIL
kh@ILHawaii.net

WWW
http://www.maui.net/~randm/kh.html

"Kalani Honua is the vanguard of how life will thrive in the upcoming millennium ... an eco-village of diverse peoples learning to respect and celebrate their differences and the joy of East-West collaboration." —John Wollstein and Margaret Pavel

OTHER ACCOMMODATIONS Groups and children accommodated.

PUBLIC PROGRAMS Hawaiian culture and arts presentations.

HISTORY Kalani Honua, which means "the harmony of Heaven and Earth" in Hawaiian was founded in 1980 by Richard Koob and Earnest Morgan as an intercultural conference center devoted to the arts, healing, and Hawaiian culture.

MISSION "Kalani Honua welcomes all in the spirit of aloha. We are guided by the Hawaiian tradition of ohana, the extended family, respecting our diversity yet sharing in unity."

PAST ARTISTS INCLUDE Garret Hongo, Richie Havens, Judith Jamison, Shirley Jenkins, Roger Montoya, Mark Kadota, Katherine Yvinskas, Aida Nelson, Paul Horn, Ram Dass, Nona Beamer, Margaret Machado.

FROM THE DIRECTOR "Kalani Honua brings together creative people from around the world, in a comfortable, yet culturally and artistically stimulating environment—where our earth home is actively re-creating itself as molten lava dances in a palette of land, sea, fire, and air. *E komo mai*, welcome." —*Richard Koob*

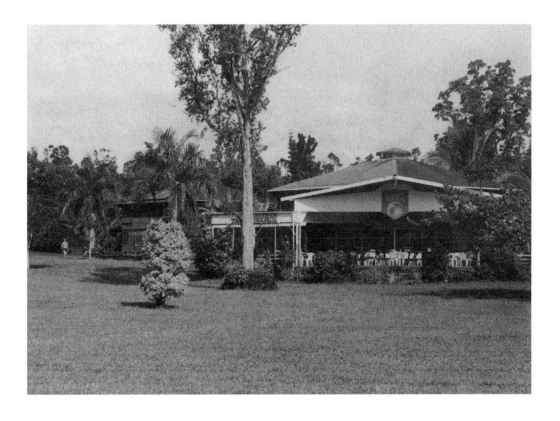

Light Work Visual Studies, Inc.

FOUNDED Organization 1973, Residency Program 1973.

LOCATION At Syracuse University.

CATEGORIES Digital imaging artists and photographers; art historians and critics; collaborative teams and multimedia artists.

FACILITIES and HOUSING Furnished apartment (shared), private darkroom; equipment includes complete black-and-white needs, Hope RA-4 20" color processor, Macintosh Quadra 950, 660AV, and Power Mac 8100, equipped with flatbed, film scanners, and CD-ROM recorder, Photoshop, Painter, Quark Xpress, and Director software. Housing and studios are wheelchair-accessible.

MEALS Artists purchase their own food and prepare their own meals.

RESIDENT SEASON Year-round.

AVERAGE LENGTH OF RESIDENCIES 1 month.

NUMBER OF ARTISTS IN 1995 12 (selected from 300 applicants).

FOR CURRENT APPLICATION REQUIREMENTS:

316 Waverly Ave.
Syracuse, NY 13244

TEL
315-443-1300

FAX
315-443-9516

E-MAIL
cdlight@summon2.syr.edu

WWW
http://sumweb.syr.edu./summon2/
com_dark/public/web/Ll.html

AVERAGE NUMBER OF ARTISTS PRESENT AT ONE TIME 1–2.

APPLICATION DEADLINES Ongoing.

SELECTION PROCESS Decisions made by artistic staff.

APPLICATION FEE None.

SPECIAL PROGRAMS None.

STIPEND $1,200.

ARTIST PAYS Travel, food, personal needs, materials; no residency fee.

ARTIST DUTIES Artists donate one print made during residency to the Light Work collection.

OTHER ACCOMMODATIONS Children accommodated.

PUBLIC PROGRAMS Publications, exhibitions; publish the journal "Contact Sheet," featuring fine reproductions of new work by artists who participate in the program, and artists working on special projects and exhibitions.

HISTORY Founded in 1973 as an artist-run photography and imaging center.

MISSION "To support artists through publications, residencies, and exhibitions."

PAST ARTISTS INCLUDE Laura Aguilar, Zeke Berman, Judith Black, Lynn Cohen, John Fago, Peter Goin, Martina Lopez, Tim Maul, Sybil Miller, Yong Soon Min, Shelly Niro, Hulleah Tsinhahjinnie.

FROM THE DIRECTOR "We interpret the field of photography in broad terms and encourage . . . all types of work." —*Jeffrey Hoone*

"I stayed at Light Work for four, maybe five weeks. I lost track of time. . . . Everything flowed organically. Light Work is a space where I could dream . . . I learned there is a flow to my life, and it's not just nine to five. An artist has to learn to respect that flow."

—Marilyn Nance

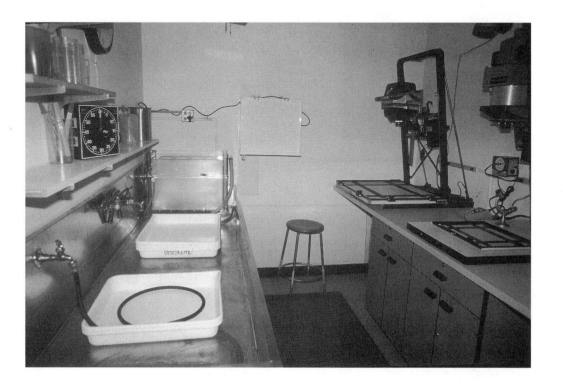

The MacDowell Colony, Inc.

FOUNDED Organization 1907, Residency Program 1907.

LOCATION 450 acres of woodlands and fields near Mt. Monadnock in the southern New Hampshire town of Peterborough, 2 hours by car from Boston.

CATEGORIES

Visual artists in book art, clay/pottery, digital imaging (no equipment), drawing, fiber/textile, film/videomaking, installation, mixed media, painting, paper art, photography, printmaking, sculpture, and woodworking; fiction writers, journalists, literary nonfiction writers, playwrights, poets, screenwriters, and translators; audio artists, composers, electronic artists, performance artists, storytellers, and radio artists; architects, landscape architects, set designers, and urban designers; collaborative teams, environmental artists, interdisciplinary artists, media artists, multimedia artists, and new genre artists.

FACILITIES 32 studios (6 are live-in studios); studios are equipped according to discipline; 2 photography studios; printmaking shop; 16mm film editing suite; composer studio with piano. Savidge Library contains a collection of past residents' work. Housing, housing bathrooms, studios, and public bathrooms are wheelchair-accessible.

HOUSING In addition to the live-in studios, other artists have private bedrooms in one of three residence buildings.

MEALS All meals provided.

RESIDENT SEASON Year-round.

AVERAGE LENGTH OF RESIDENCIES 5 weeks, with maximum of 2 months.

NUMBER OF ARTISTS IN 1995 240 (selected from 1,256 applicants).

AVERAGE NUMBER OF ARTISTS PRESENT AT ONE TIME 32 in summer, 22 during other seasons.

APPLICATION DEADLINES January 15 for May–August residencies; April 15 for September–December residencies; September 15 for January–April residencies.

SELECTION PROCESS Panels of professionals in each discipline.

APPLICATION FEE $20 (one application per person per year).

SPECIAL PROGRAMS Specialized studio facilities; fellowships, travel grants, Edward MacDowell Medal awarded annually for outstanding achievement in the arts (award ceremony includes open house and studio tours).

STIPEND None.

ARTIST PAYS Materials, personal needs, voluntary residency fee. Limited travel funds available for those in financial need.

FOR CURRENT APPLICATION REQUIREMENTS:

100 High Street
Peterborough, NH 03458

TEL
603-924-3886

FAX
603-924-9142

E-MAIL
macdowny@artswire.org

WWW
homepage URL: http://tiworks.com/
mdcolony/mdhome.htm

> *"To enter one's assigned studio in the morning in expectation of a whole day with no distractions to intrude on the project in hand, and to look forward to a succession of such days for the continuity that is so hard to obtain elsewhere, is to feel oneself in the possession of a kingdom. Cheney, my studio in the woods, was a kingdom of happiness where I completed more work than I ever have before in a comparable period. I know of no other place that so perfectly fulfills its purpose as does MacDowell."* —*Barbara Tuchman*

ARTIST DUTIES None; voluntary participation in community outreach, such as readings or visits to local schools.

OTHER ACCOMMODATIONS Collaborations welcome; no pets or guests.

PUBLIC PROGRAMS Edward MacDowell Medal Celebration, community outreach.

HISTORY In 1896 the composer Edward MacDowell and pianist Marian Nevins MacDowell, his wife, bought a farm in Peterborough, where they could rest and work in tranquillity. There, MacDowell said, he was able to triple his creative activity. By expanding the facilities, he hoped to invite other artists to enjoy his farm as a workplace. Using a small fund created in Edward's honor by prominent citizens of his time, the MacDowells carried out their plan. The first colonists arrived before Edward MacDowell died in 1908. Until her death in 1956,

Marian was responsible for the Colony's growth and survival. Under her guidance most of the 32 artists' studios were built.

MISSION "To provide an environment in which creative artists are free to pursue their work without distraction."

PAST ARTISTS INCLUDE Leonard Bernstein, Willa Cather, Alice Walker, Frances Fitzgerald, Aaron Copland, Milton Avery, Thornton Wilder, Barbara Tuchman, Meredith Monk, E. A. Robinson, Studs Terkel.

FROM THE DIRECTOR "In the midst of the current tumult about whether artists must suffer in order to create, whether they deserve the support of their government, whether they are necessary, places like the Colony continue to offer serious and gifted creative artists the time and the environment in which to express themselves." —*Mary Carswell*

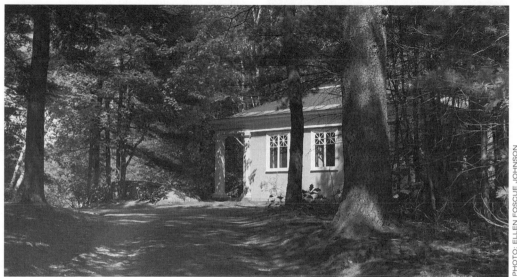

FOUNDED Organization 1989, Residency Program 1989.

LOCATION 400 acres of rolling woodlands and wildlife sanctuary, 15 minutes north of downtown Louisville, Kentucky.

CATEGORIES Visual artists in arts and crafts, book art, ceramics, clay/pottery, drawing, fiber/textile, film/videomaking, folk art, glass (no facilities), installation, jewelry, mixed media, painting, paper art, photography, printmaking, sculpture, and woodworking; fiction writers, journalists, literary nonfiction writers, playwrights, poets, screenwriters, and translators; actors, composers, dancers (no facilities), film directors, theater directors, performance artists, and storytellers; architects, clothing designers, graphic designers, industrial designers, landscape designers, set designers, and urban designers; art conservators, art educators, art historians, art professionals, critics, historians, and scientists; collaborative teams, conceptual artists, environmental artists, interdisciplinary artists, media artists, multimedia artists, and new genre artists.

FOR CURRENT APPLICATION REQUIREMENTS:

101 St. Francis Drive
Mount St. Francis, IN 47146

TEL
812-923-8602

FAX
812-923-3200

E-MAIL
sry847@aol.com or surchoix@aol.com

WWW
n/a

FACILITIES Separate studios for visual artists; writers work in live/work spaces; materials include potters' wheel, kiln, and two VanderCook presses. Housing, studios, kiln, and presses are wheelchair-accessible; community is in the planning stages of making facilities more accessible to disabled residents.

HOUSING Up to 6 residents can live in private rooms in Loftus House, an 11-room house that also includes the Center's offices, residents' kitchen, meeting and living room.

MEALS All meals provided or reimbursed; breakfast is do-it-yourself; lunch and dinner are prepared. Sunday and Monday nights are do-it-yourself dinners, though the Center will reimburse restaurant receipts up to $6.50.

RESIDENT SEASON Year-round.

AVERAGE LENGTH OF RESIDENCIES 1 month.

NUMBER OF ARTISTS IN 1995 85 (selected from 125 applicants).

AVERAGE NUMBER OF ARTISTS PRESENT AT ONE TIME 5.

APPLICATION DEADLINES Ongoing, except for specific fellowships (call for details).

SELECTION PROCESS 3-person panel is convened every 6 weeks, comprised of a writer, visual artist, and arts advocate/administrator. Fellowship panels are comprised of specialists within the area in which award is made.

APPLICATION FEE $15.

SPECIAL PROGRAMS Felhoelter Fellowship in Poetry: 2-week residency for published poet working on first book. Brinly-Hardy Fellowship in Photography: 1-week residency. Indiana Connection Series: 2-week residency for writers and visual artists who will also lead workshops in a neighboring rural community. Kentucky Foundation for Women Fellowship: 2-week fellow-

ship for women writers and visual artists from Kentucky.

STIPEND None, though some fellowship support as described above.

ARTIST PAYS $30/day suggested minimum residency fee; travel, personal needs, materials. Some fellowship recipients have some of their expenses covered.

ARTIST DUTIES None, unless resident receives Indiana Connection Series fellowship.

OTHER ACCOMMODATIONS No pets. Visitors discouraged.

PUBLIC PROGRAMS Workshops, Summer Children's Visual Art Day Camp, Salmagundi Sunday Arts Festival, symposia, pot luck dinners.

HISTORY The MAC began as a joint venture between the Conventual Friars of Our Lady of Consolation Province, several of whom are artists, and a group of southern Indiana and Greater Louisville artists who believed that the 400 rural acres that comprise Mount St. Francis could serve artists in search of a place to work in privacy. The Franciscans, who also operate a retreat center on this property, were the primary financial patrons during the Center's early years. Despite the Franciscan's involvement in the creation of the community, the MAC is not affiliated with the Catholic Church or the Franciscan Order.

MISSION "To provide time and place where artists can concentrate and work."

PAST ARTISTS INCLUDE Constance Garcia-Barrio, Laura Foreman, Anthony Mendoza, Jane Bernstein, Stuart Lishan, Star Black, Iris Adler, Rita Magdaleno, Jerry Noe, Patricia Hampl, Harry Brown, Ingrid Wendt, Doreen Rappaport.

FROM THE DIRECTOR "Most non-artists have a hard time understanding that an artists' community exists to provide a place for work. To most of us, the idea of work carries burdensome connotations of toil and drudgery, but to artists, the word expresses their reason for being." —*Sarah Yates*

Mattress Factory

FOUNDED Organization 1977, Residency Program 1982.

LOCATION In Pittsburgh's historic Mexican War Streets on the North Side.

CATEGORIES Visual artists in installation and mixed media; audio artists and performance artists; landscape architects; collaborative teams and interdisciplinary artists.

FACILITIES and HOUSING 11 studios/galleries; 2 living spaces.

MEALS Artists receive a per diem for meals.

RESIDENT SEASON Year-round.

AVERAGE LENGTH OF RESIDENCIES 1 month.

NUMBER OF ARTISTS IN 1995 12 (selected from 300 applicants).

AVERAGE NUMBER OF ARTISTS PRESENT AT ONE TIME 3.

APPLICATION DEADLINES Ongoing.

SELECTION PROCESS Selections made by the curator and the director.

APPLICATION FEE None.

SPECIAL PROGRAMS Printmaking Program.

STIPEND $500–$1,000.

ARTIST PAYS Personal needs. No residency fee.

ARTIST DUTIES To create and present site-specific installations or performance art in a choice of venue space: residential, industrial, or outdoor.

OTHER ACCOMMODATIONS None.

PUBLIC PROGRAMS Exhibitions.

HISTORY Founded in 1977 in six-story warehouse.

MISSION "To commission new site-specific works, present them to the widest possible audience, and maintain selected individual installations in a growing—and distinctive—permanent collection."

PAST ARTISTS INCLUDE James Turrell, Barbara Ess, Eiko & Koma, Jessica Stockholder, Cady Noland, Buzz Spector, John Cage, Alison Wilding, Tracy Emin, Monika Kulicka.

FROM THE DIRECTOR "Mattress Factory is a research and development lab for artists. . . . Mattress Factory's physical and organizational environments have grown out of and in response to a central focus on creativity." —*Barbara Luderowski*

FOR CURRENT APPLICATION REQUIREMENTS:

500 Sampsonia Way
Pittsburgh, PA 15212-4444

TEL
412-231-3169

FAX
412-322-2231

E-MAIL
slb@psc.edu

WWW
http://www.mattress.org/MFhome.html

Medicine Wheel Artists' Retreat

FOUNDED Organization 1990, Residency Program 1991.

LOCATION Varies, usually in a rural setting, close to water, within 90 minutes of Boston.

CATEGORIES Visual artists in arts and crafts, book art, ceramics, clay/pottery, digital imaging, drawing, fiber/textile, film/videomaking, folk art, glass, industrial art, installation, jewelry, mixed media, painting, paper art, photography, printmaking, sculpture, and woodworking; fiction writers, journalists, literary nonfiction writers, playwrights, poets, screenwriters, and translators; actors, audio artists, choreographers, composers, dancers, film directors, theater directors, electronic artists, musicians, performance artists, storytellers, and radio artists; architects, clothing designers, graphic designers, industrial designers, landscape designers, set designers, and urban designers; art conservators, art educators, art historians, art professionals, computer scientists, critics, environmentalists/naturalists, general scholars, historians, historic preservationists, linguists, mathematicians, and scientists; collaborative teams, conceptual artists, environmental artists,

interdisciplinary artists, media artists, multimedia artists, and new genre artists.

FACILITIES Vary, depending on site (community now leases several sites and plans to purchase a permanent site). Facilities at past sites have included darkrooms, kilns, film and video cameras and editing equipment, printing press, and computers. Community will accommodate disabled residents, but wheelchair-accessiblity depends on the site leased (call for current status). Community plans to make any purchased site accessible to disabled residents.

HOUSING Single rooms in individual cabins or in private bedrooms in a house with other artists.

MEALS All meals provided (vegetarian selection included).

RESIDENT SEASON Year-round.

AVERAGE LENGTH OF RESIDENCIES 2 weeks.

NUMBER OF ARTISTS IN 1995 25 (selected from 30 applicants).

AVERAGE NUMBER OF ARTISTS PRESENT AT ONE TIME 15.

APPLICATION DEADLINES Ongoing.

SELECTION PROCESS Outside panel of professionals in each category and board members.

APPLICATION FEE None.

SPECIAL PROGRAMS Full and partial scholarships.

STIPEND None.

ARTIST PAYS $175–$295 per week (sliding scale) residency fee; travel, personal needs, materials.

RESIDENT DUTIES None, though may elect to do kitchen chores in exchange for a waiver of retreat fee.

FOR CURRENT APPLICATION REQUIREMENTS:

P.O. Box 1088
Groton, MA 01450-3088

TEL
508-448-3717

FAX
508-448-3717

E-MAIL
To be announced; call for address.

WWW
To be announced; call for address.

"My stay was filled with new insights about my art. The balance of talking with others about their process and art-making in general has been wonderful. . . . Every artist needs an experience like this to nurture one's creativity, to rest, and to let the spirit flourish."

—*Marion Turner*

OTHER ACCOMMODATIONS Groups welcome; no pets or guests; future plans include family retreats.

PUBLIC PROGRAMS Medicine Wheel Animation Festival.

HISTORY Founded in 1989.

MISSION "To support new works of art by supporting the artist in production of new work. To provide a retreat opportunity for artists of all disciplines to develop and complete new work."

PAST ARTISTS INCLUDE John McDonald, Cornell Coley, Patricia Meier, Kate Carney, Jonathan Aibel, Richard Griswald, Bob Cohen, Mona Jimenez, Robert Goss, Kelly Rappuchi, Paula Archer, Patricia Platt.

FROM THE DIRECTOR "The Medicine Wheel Artists' Retreat purpose is to encourage artists to schedule an extended, uninterrupted time in which to create. We suggest that artists go on retreat at least once a year." —*Cheri Amarna*

The Millay Colony for the Arts

FOUNDED Organization 1973, Residency Program 1974.

LOCATION 600-acre estate, 3 hours from both Boston and New York.

CATEGORIES Visual artists in book art, digital imaging, drawing, fiber/textile, film/videomaking, folk art, glass, installation, mixed media, painting, paper art, photography, and sculpture; fiction writers, literary nonfiction writers, playwrights, poets, screenwriters, and translators; composers and performance artists; collaborative teams.

FACILITIES and HOUSING Separate living and studio rooms. Community is in the planning stages of making facilities completely accessible to disabled residents by 1997.

MEALS All food provided. Dinners prepared weeknights.

RESIDENT SEASON Year-round.

AVERAGE LENGTH OF RESIDENCIES 1 month.

FOR CURRENT APPLICATION REQUIREMENTS:

East Hill Road, P.O. Box 3
Austerlitz, NY 12017

TEL
518-392-3103

FAX
n/a

E-MAIL
director@millaycolony.org
application@millaycolony.org

WWW
http://www.Millaycolony.org

NUMBER OF ARTISTS IN 1995 60 (selected from 500 applicants).

AVERAGE NUMBER OF ARTISTS PRESENT AT ONE TIME 5.

APPLICATION DEADLINES February 1 for June–September; May 1 for October–January; September 1 for February–May.

SELECTION PROCESS Outside panel of professionals in each category.

APPLICATION FEE None.

SPECIAL PROGRAMS None.

STIPEND None.

ARTIST PAYS Travel, personal needs, materials; no residency fee.

ARTIST DUTIES None.

OTHER ACCOMMODATIONS None.

PUBLIC PROGRAMS None.

HISTORY The Millay Colony for the Arts was begun in 1973 by Norma Millay, sister of the poet Edna St. Vincent Millay, at the poet's home, Steepletop.

MISSION "To give one-month residencies to talented writers, composers, and visual artists; to give them the surroundings they need to work and then to get out of their way."

PAST ARTISTS INCLUDE Millay welcomes artists of all ages and at all points in their career.

"My stay at Millay was rich with artistic opportunity and rejuvenation." —*J. Michael Simpson*

FOUNDED Organization 1993, Residency Program 1994.

LOCATION In a small, gold-mining town near the Continental Divide.

CATEGORIES Visual artists in arts and crafts, book art, ceramics, clay/pottery, drawing, fiber/textile, film/videomaking, folk art, installation, jewelry, mixed media, painting, paper art, photography, and sculpture; fiction writers, journalists, literary nonfiction writers, playwrights, poets, screenwriters, and translators; choreographers, composers, dancers, musicians, performance artists, and storytellers; architects, clothing designers, graphic designers, landscape designers, and set designers; general scholars; collaborative teams, conceptual artists, environmental artists, interdisciplinary artists, multimedia artists, and new genre artists.

FACILITIES and HOUSING 3 studio/living spaces. Community is in the planning stages of making facilities accessible to disabled residents.

MEALS Artists purchase their own food and prepare their own meals.

FOR CURRENT APPLICATION REQUIREMENTS:

P.O. Box 8
Basin, MT 59631

TEL
406-225-3525

FAX
406-225-9225

E-MAIL
nowens@tmn.com

WWW
n/a

RESIDENT SEASON Year-round.

AVERAGE LENGTH OF RESIDENCIES 3 months to 1 year.

NUMBER OF ARTISTS IN 1995 7 (selected from 18 applicants).

AVERAGE NUMBER OF ARTISTS PRESENT AT ONE TIME 2.

APPLICATION DEADLINES Ongoing.

SELECTION PROCESS Selection committee in conjunction with the Montana Artists Refuge board of directors.

APPLICATION FEE None.

SPECIAL PROGRAMS Siteworks Community Art Project.

STIPEND None.

ARTIST PAYS Travel, food, personal needs, materials; $200–$400/month residency fee (some financial assistance, up to 50 percent, to help pay fee), utilities cost varies by session.

ARTIST DUTIES Some work-exchange depending on financial assistance.

OTHER ACCOMMODATIONS Children and groups accommodated.

PUBLIC PROGRAMS Shows, readings, performances, lectures.

HISTORY Founded in 1993 by four local artists and area residents for the purpose of providing living and work space to artists in all mediums.

MISSION "To further the creative work of artists, to create residencies for artists, and to provide arts programs and arts education for both artists and community members."

PAST ARTISTS INCLUDE Martha Shade, Pamela Hartvig, McCarthy Coyle, Nikki Schrager,

Patricia Thomas, Holly Fisher, Mary Carrothers, Jennifer Thompson, Karen Land, Margaret Baldwin.

FROM THE DIRECTOR "The natural beauty and quiet rugged vistas are profound influences on most everyone who visits or lives here. Self-motivated individuals have found the time and space here to focus in an amplified way on new directions, or to refine and clarify current projects." —*M. J. Williams*

Nantucket Island School of Design and the Arts

FOUNDED Organization 1973, Residency Program 1982.

LOCATION On Nantucket Island, 30 miles to sea off coast of Cape Cod.

CATEGORIES Artists Interdisciplinary Residencies: visual artists in arts and crafts, book art, ceramics, clay/pottery, drawing, fiber/textile, film/videomaking, folk art, installation, jewelry, mixed media, painting, paper art, photography, printmaking, sculpture, and woodworking (with own equipment); fiction writers, journalists, literary nonfiction writers, playwrights, poets, screenwriters, and translators; actors, choreographers, composers, dancers, film directors, theater directors, electronic artists, musicians, performance artists, storytellers, and radio artists; architects, clothing designers, graphic designers, industrial designers, landscape designers, set designers, and urban designers; art educators, art historians, art professionals, critics, environmentalists/naturalists, general scholars, historians, historic preservationists, linguists, mathematicians, and scientists; collaborative teams, conceptual artists, environmental artists, interdisciplinary artists, media artists, multimedia artists, and new genre artists.

FACILITIES Studio space, including open 2D, 3D, and performance studio, ceramics studio, skutt electronic kiln, electric wheel, pit firing equipment, black-and-white darkrooms, textile studio, outdoor studio. Community accommodates disabled residents. Housing, housing bathrooms (future), studios, and public bathrooms are wheelchair-accessible; community is in the planning stages of making facilities more accessible to disabled residents. In the past, community has hosted grand mal, blind, and sight- and hearing-impaired residents.

HOUSING Private and shared cottages, with full kitchenette and bath.

MEALS Artists purchase their own food and prepare their own meals; full kitchen available.

RESIDENT SEASON Spring: March–June; fall: September–December.

AVERAGE LENGTH OF RESIDENCIES 3 weeks–2 months, occasionally longer.

NUMBER OF ARTISTS IN 1995 26 (selected from 50 applicants).

AVERAGE NUMBER OF ARTISTS PRESENT AT ONE TIME 6–10.

APPLICATION DEADLINES Ongoing.

SELECTION PROCESS Outside panel of professionals in each category.

APPLICATION FEE $20.

SPECIAL PROGRAMS Artist as Mentor, Artist Stewardship in Education.

STIPEND None, though some financial assistantships/work exchanges are available.

FOR CURRENT APPLICATION REQUIREMENTS:

23 Wauwinet Road
P.O. Box 958
Nantucket, MA 02554

TEL
508-228-9248

FAX
508-228-2451

E-MAIL
n/a

WWW
n/a

> *"The associations that I made with other artists in residence at the NISDA cottages enhanced the experience. There are few opportunities in the visual arts—which makes NISDA even more important."* —Kevin Lee Milligan

ARTIST PAYS Residency fee according to length of stay, cottage size, and studio needs. These include housing/workspace rental (studio: $75/week or $250/month; 1 bedroom with loft: $350/week or $800/month; 1 bedroom cottage: $300/week or $700/month; and studio cottage: $250/week or $600/month); $50/week or $150/month utilities deposit; travel, food, personal needs, materials.

ARTIST DUTIES Maintain one's own cottage and studio space; optional opportunities to lead slide lectures, talks, or performances to Nantucket community.

OTHER ACCOMMODATIONS Artist may bring a partner or friend to share cottage.

PUBLIC PROGRAMS Cultural Arts Lecture Series, exhibitions, events, workshops.

HISTORY Founded in 1973, when artists were housed in the Nantucket Lightship Museum or in private homes. Sea View Barn established in 1978, Harbor Cottages in 1982.

MISSION "To explore the inter-relationship of arts, sciences, humanities, the environment, and art as social voice and conveyor of human spirit. . . . To provide the isolation necessary for focus, the inspiration to create, and artists' dialogue."

PAST ARTISTS INCLUDE Robert Rindler, James Pierce, Brenda Miller, Michelle Stewart, Kevin Lee Milligan, Tom Holden, Corinne Loeh, Aileen Cox, Tammy Wold, Toni Feldman, Susan Van Pelt, Glen Pihl.

FROM THE DIRECTOR "Our Artist Residency Program wholly focuses on personal work and is often the strongest experience and ultimately the most meaningful path towards an artist's personal development." —*Kathy Kelm*

FOUNDED Organization 1965, Residency Program 1965.

LOCATION Conference held in Waterford, CT.

CATEGORIES Playwrights, screenwriters.

FACILITIES Professional theatre and media artists, modular sets, no costumes, minimal lights and props, script in hand. Community accommodates disabled residents; housing, housing bathrooms, studios, and public bathrooms are wheelchair-accessible.

HOUSING Private rooms at Seaside.

MEALS All meals provided.

RESIDENT SEASON July.

AVERAGE LENGTH OF RESIDENCIES 1 month.

NUMBER OF ARTISTS IN 1995 13 (selected from 1,500 applicants); also present are 5 directors, 5 dramaturges, story editors, and 37 actors.

AVERAGE NUMBER OF ARTISTS PRESENT AT ONE TIME 60, including playwrights, directors, dramaturges, and actors.

FOR CURRENT APPLICATION REQUIREMENTS:

234 West 44th, Suite 901
New York, NY 10036

TEL
212-382-2790

FAX
212-921-5538

E-MAIL
n/a

WWW
n/a

APPLICATION DEADLINE December 1.

SELECTION PROCESS 6 month convening of outside panel of professionals.

APPLICATION FEE $10.

SPECIAL PROGRAMS Herbert & Patricia Brodkin Scholarship Award, Charles MacArthur Fellowship, Eric Kocher Playwrights Award, Edith Oliver Fellowship.

STIPEND $1,000 plus transportation.

ARTIST PAYS Personal needs; no residency fee.

ARTIST DUTIES None.

OTHER ACCOMMODATIONS None.

PUBLIC PROGRAMS Staged readings.

HISTORY Founded in 1965 by George C. White and has been under the artistic direction of Lloyd Richards since 1968.

MISSION "To develop talented writers by offering them an opportunity to work with other talented professional theater and media artists."

PAST ARTISTS INCLUDE Israel Horovitz, Jefferey Hatcher, Laura Harrington, Nancy Grome, Tom Griffin, Amlin Gray, Patricia Goldstone, Lucky Gold, Jonas Gardell, Kermit Frazier, Rolf Fjelde, Ken Eulo.

FROM THE DIRECTOR "In 1964 the National Playwrights Conference was born out of necessity. The commercial theatre was barren of new and compelling work by American playwrights. . . . One has only to look to the Broadway season to know that the cycle is repeating itself. New playwrights with perception, conscience, imagination, and craft are needed. The National Playwrights Conference is needed." —*Lloyd Richards*

"There is intense pressure [at the National Playwrights Conference]. No one imposes it. It imposes itself because it was there before anybody arrived. It is there—on the walls where plaques proclaim the names of conference playwrights from the past: John Guare, Lanford Wilson, David Rabe, August Wilson. . . . There is little pretense. There is precision, there is imagination, and there is hard work." —Richard Kalinoski

Norcroft: A Writing Retreat for Women

FOUNDED Organization 1990, Residency Program 1993.

LOCATION 10 acres in the pine and birch woods along the north shore of Lake Superior.

CATEGORIES Women and feminist writers in fiction, journalism, literary nonfiction, playwrighting, poetry, screenwriting, and translation.

FACILITIES and HOUSING Rooms in main lodge with fully stocked and equipped kitchen; writers work in individual writing sheds, separate from lodge. Housing, housing bathrooms, and studios are wheelchair-accessible. Route from housing to studio is wheelchair-accessible. Community is in the planning stages for making facilities more accessible to disabled residents.

MEALS Artists prepare their own meals (food is provided).

RESIDENT SEASON May 1–October 31.

AVERAGE LENGTH OF RESIDENCIES 1–4 weeks.

FOR CURRENT APPLICATION REQUIREMENTS:

32 East First Street, #330
Duluth, MN 55802

TEL
218-727-5199

FAX
218-727-3119

E-MAIL
n/a

WWW
n/a

NUMBER OF ARTISTS IN 1995 60 (selected from 174 applicants).

AVERAGE NUMBER OF ARTISTS PRESENT AT ONE TIME 4.

APPLICATION DEADLINE October 1.

SELECTION PROCESS 3-member outside panel.

APPLICATION FEE None.

SPECIAL PROGRAMS None.

STIPEND None.

ARTIST PAYS Travel, personal needs, materials; no residency fee.

ARTIST DUTIES None.

OTHER ACCOMMODATIONS No pets or guests.

PUBLIC PROGRAMS None.

HISTORY Founded in 1993 by Joan Drury and Harmony Women's Fund.

MISSION "To nurture and support women's writing; to provide more choices and opportunities for women and enabling feminist change."

PAST ARTISTS INCLUDE Martha Roth, Mary Saracino, Rosalie Maggio, Denice Leverett, Pat Francisco, Kim Hines, Maya Sharma, Cindra Halm, Cherry Hartman, Patricia Romney, Marie-Elise Wheatwind.

FROM THE DIRECTOR "Criteria for coming here are a commitment to feminism and a commitment to writing. We want to honor women and their words." —*Joan Drury*

"*Norcroft has given me exactly what I needed and more. . . . At Norcroft I captured the vision.*" —Pat Romney

FOUNDED Organization 1978, Residency Program 1979.

LOCATION On the campus of Northwood University.

CATEGORIES Visual artists in arts and crafts, book art, ceramics, clay/pottery, digital imaging, drawing, fiber/textile, film/videomaking, folk art, glass, industrial art, installation, jewelry, mixed media, painting, paper art, photography, printmaking, sculpture, and woodworking; fiction writers, journalists, literary nonfiction writers, playwrights, poets, screenwriters, and translators; actors, audio artists, choreographers, composers, dancers, film directors, theater directors, electronic artists, musicians, performance artists, storytellers, and radio artists; architects, clothing designers, graphic designers, industrial designers, landscape designers, set designers, and urban designers; art conservators, art educators, art historians, art professionals, computer scientists, critics, environmentalists/naturalists, general scholars, historians, historic preservationists, linguists, mathematicians, and scientists; collaborative teams, conceptual artists, environmental artists, interdisciplinary artists, media artists, multimedia artists, and new genre artists.

FACILITIES and HOUSING Large apartment/work space with kitchen in a wooded environment.

MEALS Lunch provided Monday through Friday at the Creativity Center; per diem given to fellows for all other meals (although they may eat in the campus cafeteria).

RESIDENT SEASON June–August.

AVERAGE LENGTH OF RESIDENCIES 8 weeks.

NUMBER OF ARTISTS IN 1995 4 (selected from 84 applicants).

AVERAGE NUMBER OF ARTISTS PRESENT AT ONE TIME 4.

APPLICATION DEADLINE December 31.

SELECTION PROCESS Panel of professionals in each category make recommendations to Creativity Center Board, which makes final selections.

APPLICATION FEE $10.

SPECIAL PROGRAMS None.

STIPEND $750 to be used on project costs or personal needs.

ARTIST PAYS Personal needs; no residency fee.

ARTIST DUTIES Upon completion of the residency, fellows will make oral presentations of their projects to a selected audience of Creativity Center Board members, evaluators, Northwood University staff, invited guests, and the public.

OTHER ACCOMMODATIONS None.

PUBLIC PROGRAMS None.

HISTORY Northwood University was founded in 1959 by Dr. Arthur E. Turner and Dr. R. Gary

FOR CURRENT APPLICATION REQUIREMENTS:

3225 Cook Road
Midland, MI 48640

TEL
517-837-4478

FAX
517-837-4468

E-MAIL
n/a

WWW
n/a

Stauffer, as a private, business management college, dedicated to a partnership between business and the arts. The association between Alden Dow and the university began with the design, by Dow, of the Northwood campus. The Center was founded in 1978.

MISSION "To encourage individual creativity and to preserve the work and philosophy of Alden Dow."

PAST ARTISTS INCLUDE Pam Becker, Peter Francis, Peter Josyph, Barb and Doug Roesch, Michael Tom, Caroll Michels, Philis Alvic, Leslie Friedman, Stanley Hollingsworth, Marilyn Lanfear, Jane Leister, Ben Shedd.

FROM THE DIRECTOR "Our Creativity Fellowship Program is not the typical artists' colony in that we are looking for creative ideas in any area of the arts, sciences, and humanities. A typical residency is 4–5 individuals that might include a visual or performing artist, a writer or composer, a mathematician or chemist, a philosopher or theologian. We hope for synergy among the Fellows and their projects." —*Carol B. Coppage*

FOUNDED Organization 1907, Residency Program 1979.

LOCATION 8 acres on a wooded hillside in Portland's Northwest District.

CATEGORIES Visual artists in art and craft, book art, ceramics, clay/pottery, digital imaging, drawing, fiber/textiles, installation, jewelry, metal, mixed media, painting, paper art, photography, printmaking, sculpture, and woodworking.

FACILITIES Residents have access to all studios and materials on campus. Housing, housing bathrooms, studios, and public bathrooms are wheelchair-accessible; community accommodates sight- and hearing-impaired residents, and makes accommodations for residents with other disabilities.

HOUSING House for single residents only.

MEALS Artists purchase their own food and prepare their own meals; cafe available on campus.

RESIDENT SEASON Year-round.

FOR CURRENT APPLICATION REQUIREMENTS:

8245 Southwest Barnes Road
Portland, OR 97225

TEL
503-297-5544

FAX
503-297-9651

E-MAIL
n/a

WWW
n/a

AVERAGE LENGTH OF RESIDENCIES Emerging artists, 4-month residencies during academic year. Midcareer artists, summer months.

NUMBER OF ARTISTS IN 1995 8 (selected from 120 applicants).

AVERAGE NUMBER OF ARTISTS PRESENT AT ONE TIME 2–4.

APPLICATION DEADLINES Emerging artists, April 15; midcareer artists, December 1.

SELECTION PROCESS Panel of professionals in each category.

APPLICATION FEE None.

SPECIAL PROGRAMS Workshops.

STIPEND $400 per month, plus travel and material allowance.

ARTIST PAYS Food, personal needs; no residency fee.

ARTIST DUTIES Emerging artists: 12 hours per week of assigned work.

OTHER ACCOMMODATIONS None.

PUBLIC PROGRAMS BFA Program, Certificate Program, Independent Wood Study Program, open classes and workshops.

HISTORY The Oregon College of Art and Craft began as an arts and crafts society during the American Arts and Crafts Movement. Today it is the only accredited college in the nation to focus solely on the crafts.

MISSION "The Junior Residency Program: to provide post-graduate artists an opportunity to pursue a proposed body of work over a four-month period in a stimulating arts environment. The Senior Residency Fellowship Program: to encourage outstanding midcareer

"*I spent the summer working on a group of small sculptures made from a variety of materials, including metal. I don't know if they ever would have happened without the residency. I am thankful for both the financial and psychological support that the residency gave to my efforts.*" —Lisa Gralnick

artists to take time away from their teaching or their studio careers to pursue a focused project."

PAST ARTISTS INCLUDE John McQueen, Karen Tossavainen, Judy Hill, Lisa Gralnick, Vernon Theiss, John Eric Byers, Sharon Marcus, Whitney Nye, Horatio Law, Dana Louis, Brian Shannon, Mary Stewart.

FROM THE DIRECTOR "We have been fostering the arts and crafts since the turn of the century. . . . Our program draws a diverse group . . . a rich mixture of life stories and individual purposes." —*Paul Magnusson*

PHOTO: DAN SADDLER PHOTOGRAPHY

FOUNDED Organization 1910, Residency Program 1990.

LOCATION 110 acres of wooded dunes, between the Kalamazoo River and the Ox-Bow Lagoon, in Saugatuck, Michigan.

CATEGORIES Visual artists in book art, ceramics, clay/pottery, drawing, fiber/textile, glass, installation, jewelry, mixed media, painting, paper art, printmaking, sculpture, and woodworking; fiction writers and poets; performance artists.

FACILITIES Studio space and access printshop with intaglio lithograph, collagraph, relief, and woodcut facilities; papermaking studio; ceramic studio; open-air glassblowing facility; metal sculpture studio. Housing, housing bathrooms, studios, and public bathrooms are wheelchair-accessible; community is in the planning stages of making facilities more accessible to disabled residents.

HOUSING In a pre–Civil War Inn or cabin.

MEALS All meals provided.

RESIDENT SEASON June to August.

FOR CURRENT APPLICATION REQUIREMENTS:

Academic Administration
37 South Wabash, #707
Chicago, IL 60603

TEL
312-899-7455

FAX
312-899-1453

E-MAIL
n/a

WWW
n/a

AVERAGE LENGTH OF RESIDENCIES 1 week.

NUMBER OF ARTISTS IN 1995 12 (selected from 30 applicants).

AVERAGE NUMBER OF ARTISTS PRESENT AT ONE TIME 1–3.

APPLICATION DEADLINE May 15.

SELECTION PROCESS Internal panel of faculty and the director.

APPLICATION FEE None.

SPECIAL PROGRAMS None.

STIPEND None.

ARTIST PAYS $348/week residency fee; travel, materials, personal needs.

ARTIST DUTIES Artists are encouraged to present a slide lecture or reading and to participate in discussions.

OTHER ACCOMMODATIONS None.

PUBLIC PROGRAMS Lectures, courses, workshops, exhibitions, open house.

HISTORY Founded in 1910 by two artists, Marshall Clute and Frederick Frary Fursman, who were faculty members of the School of Art Institute of Chicago.

MISSION "To provide professional and beginning artists with lifelong learning opportunities and to foster an appreciation for art in the surrounding community, while preserving the natural environment that has energized Ox-Bow since its founding."

PAST ARTISTS INCLUDE Robyn Levine, Cynthia Weiss, Carmella Rago, Tom Robinson, Julie Jankowski, Mary Hart, Wayne Forbes, Henry

Feely, Christine French, Roberta Busard, Carmel Crane, Monica Bauer.

FROM THE DIRECTOR "This program is designed for the professional artist to reside and work in a secluded, natural environment, unencumbered by the outside world." —E. W. Ross

Penland School of Crafts

FOUNDED Organization 1929, Residency Program 1963.

LOCATION In the Blue Ridge Mountains, 55 miles northeast of Asheville.

CATEGORIES Craft artists in book, paper, clay, drawing, painting, glass, iron, metal, photography, printmaking, textiles, and wood.

FACILITIES and HOUSING Unfurnished studio; unfurnished apartments.

MEALS Artists purchase their own food and prepare their own meals.

RESIDENT SEASON All year.

AVERAGE LENGTH OF RESIDENCIES 2–3 years.

NUMBER OF ARTISTS IN 1995 3 (selected from 25 applicants).

AVERAGE NUMBER OF ARTISTS PRESENT AT ONE TIME 3–7.

APPLICATION DEADLINE October 28.

FOR CURRENT APPLICATION REQUIREMENTS:

Penland Road
Penland, NC 28765

TEL
704-765-2359

FAX
704-765-7389

E-MAIL
pnlndschl@aol.com

WWW
http://www.arts.ufl.edu/penland/

SELECTION PROCESS Selected by Director in consultation with selection committee.

APPLICATION FEE $25.

SPECIAL PROGRAMS None.

STIPEND None.

ARTIST PAYS Travel, personal needs, residency fee ($50/housing per month; $50/studio per month), utilities, living expenses, materials, equipment, meals.

RESIDENT DUTIES Provide open house, avail themselves to public.

OTHER ACCOMMODATIONS Immediate family accommodated; no pets.

PUBLIC PROGRAMS Workshops, lectures, open house, gallery.

HISTORY Founded in 1923 by primary school teacher Lucy Morgan.

MISSION "To provide a stimulating, supportive environment for persons at transitional points in their careers."

PAST ARTISTS INCLUDE Cynthia Bringle, Jane Peiser, Mark Peiser, Richard Ritter, Debra Frasier, Jim Lawton, Rob Levin.

FROM THE DIRECTOR "Penland School of Crafts began almost 70 years ago with the fundamental vision that craft practice can have an affirming and transformative effect on the lives of the people and their community." —*Ken Botnick*

PHOTO: © ANN HAWTHORNE

FOUNDED Organization 1971, Residency Program 1971.

LOCATION 64-acre tree farm, 50 miles north of Seattle.

CATEGORIES Visual artists in glass, installation, mixed media, printmaking, and sculpture.

FACILITIES Studios include wood and metal shop, and a glass-plate printmaking shop. Tools include fusing, slumping, and *pate-de-verre* kilns. Artists must bring their own glassblowing or flame-working tools. Community is in the planning stages of making facilities accessible to disabled residents.

HOUSING 18 double-occupancy dormitory rooms, with shared bathroom; cottages with 2 double-occupancy rooms and bathrooms.

MEALS Artists purchase their own food and prepare their own meals.

RESIDENT SEASON September 16–November 8.

AVERAGE LENGTH OF RESIDENCIES 7 weeks.

FOR CURRENT APPLICATION REQUIREMENTS:

315 Second Avenue South
Seattle, WA 98104

TEL
206-621-8422

FAX
206-621-0713

E-MAIL
pilchuck-info@pilchuck.com

WWW
http://www.pilchuk.com

NUMBER OF ARTISTS IN 1995 6 (selected from 35 applicants).

AVERAGE NUMBER OF ARTISTS PRESENT AT ONE TIME 6–16.

APPLICATION DEADLINE March 1.

SELECTION PROCESS Outside panel of professionals.

APPLICATION FEE $25.

SPECIAL PROGRAMS None.

STIPEND $1,000.

ARTIST PAYS Travel, food, personal needs, materials; no residency fee.

ARTIST DUTIES None.

OTHER ACCOMMODATIONS None.

PUBLIC PROGRAMS Workshops.

HISTORY Founded in 1971 by Dale Chihuly, with the support of patrons Anne Gould Hauberg and John H. Hauberg.

MISSION "To provide an opportunity for artists with prior achievement in glass and other visual arts media who seek a place and time to develop a particular idea or project involving glass."

PAST ARTISTS INCLUDE Lillian Ball, Nick Cave, Mary Carlson, Joe Marioni, Pat Oleszko, John Scot, Lorna Simpson, TODT.

FROM THE DIRECTOR "The time at Pilchuck is both very long and rich in possibilities, yet seemingly fleeting. It is a place where artistic failures can be as important as successes." —*Pike Powers*

"Pilchuck is a place where artists can be in heaven without having to die." —Buzz Spector

Ragdale Foundation

FOUNDED Organization 1976, Residency Program 1976.

LOCATION 30 miles north of Chicago near Lake Michigan.

CATEGORIES Visual artists in book art, drawing, fiber/textile, film/videomaking, installation, jewelry, mixed media, painting, paper art, and sculpture; fiction writers, literary nonfiction writers, playwrights, poets, and screenwriters; choreographers, composers, dancers, film directors, theater directors, musicians, performance artists, and storytellers; graphic designers; interdisciplinary artists.

FACILITIES and HOUSING The Ragdale House has five rooms for writers; the Barnhouse has three rooms for writers and two for visual artists; the Friends' Studio has living and working space for two visual artists, or one visual artist and one composer. Facilities include a baby grand piano. Beyond work space, there are no additional visual arts facilities, and no major power tools are allowed (due to noise disturbance). Housing, housing bathrooms, and studios are wheelchair-accessible.

FOR CURRENT APPLICATION REQUIREMENTS:

1260 North Green Bay Road
Lake Forest, IL 60045

TEL
847-234-1063

FAX
847-234-1075

E-MAIL
n/a

WWW
n/a

MEALS All meals provided.

RESIDENT SEASON All year, except May and last half of December.

LENGTH OF RESIDENCIES 2 weeks to 2 months.

NUMBER OF ARTISTS IN 1995 168 (selected from 469 applicants).

AVERAGE NUMBER OF ARTISTS PRESENT AT ONE TIME 12.

APPLICATION DEADLINES January 15; June 1.

SELECTION PROCESS Outside panel of professionals in each discipline.

APPLICATION FEE $20

SPECIAL PROGRAMS Fellowships available for Pan-African and older women poets.

STIPEND None.

ARTIST PAYS $15/day residency fee; travel, personal needs, materials.

ARTIST DUTIES None.

OTHER ACCOMMODATIONS Groups are permitted; couples are only accepted if each qualifies independently; no pets or children.

PUBLIC PROGRAMS Readings, concerts, workshops, art exhibits, and seminars in poetry and fiction writing.

HISTORY The Ragdale House and Barnhouse were designed and built in 1897 by the Chicago architect Howard Van Doren Shaw. In 1976, Shaw's granddaughter, Alice Ryerson Hayes, created the Ragdale Foundation to provide a peaceful place for artists of all disciplines to work.

MISSION "Ragdale is a place for artists and writers to work. The Ragdale Foundation is com-

> "At Ragdale, more than any place I've ever been, the individual voice and vision of the artist is still important, and indeed essential. It is not always easy to believe that our lone voices matter or are being heard in the modern age. Ragdale gives the artist the confidence that anything, all things are possible." —Jane Hamilton

mitted to preserving the unique character of the Ragdale house and grounds and the spirit embodied in them to foster creative work by those in need of uninterrupted time, the fellowship of other creative persons, and appropriate work space."

PAST ARTISTS INCLUDE Alex Kotlowitz, Brigit Pegeen Kelly, Stanley Crouch, Barbara Cooper, Kunsu Shim, Sherry Kramer, Lynda Barry, Lawrence Block, Hunt Slonem, Ola Rotimi, Carol Anshaw, Jane Hamilton, Jane Paretsky.

FROM THE DIRECTOR "Located 45 minutes north of Chicago, Ragdale offers 12 artists a homey atmosphere in an antique-filled Arts and Crafts setting. Featuring two buildings on the National Register of Historic Places, Ragdale adjoins 55 acres of virgin prairie, ideal for peaceful contemplation. Delicious communal dinners provide stimulating conversation and a convivial close to each day." —Sonja D. Carlborg

Roswell Artist-in-Residence Program

FOUNDED Organization 1967, Residency Program 1967.

LOCATION 5 acres of land in the high plains of southeastern New Mexico, just outside the city limits of Roswell (pop. 45,000), and 200 miles from Albuquerque, Santa Fe, and El Paso.

CATEGORIES Visual artists in book art, clay/pottery, drawing, fiber/textile, installation, mixed media, paper art, photography, printmaking, sculpture, and woodworking.

FACILITIES and HOUSING 6 houses (with family accommodations) and 9 studios. Community can accommodate hearing-impaired residents and will make special considerations for other disabilities as needed. Community is in the planning stages of making facilities accessible to disabled residents.

MEALS Artists purchase their own food and prepare their own meals.

RESIDENT SEASON Year-round.

AVERAGE LENGTH OF RESIDENCIES 1 year.

FOR CURRENT APPLICATION REQUIREMENTS:

1404 W. Berrendo
Roswell, NM 88201

TEL
505-622-6037

FAX
505-623-5603

E-MAIL
n/a

WWW
n/a

NUMBER OF ARTISTS IN 1995 10 (selected from 200 applicants).

AVERAGE NUMBER OF ARTISTS PRESENT AT ONE TIME 5.

APPLICATION DEADLINES Varies.

SELECTION PROCESS 6-member panels of local and visiting artists and curators choose grant recipients from a slide review process.

APPLICATION FEE $10.

SPECIAL PROGRAMS None.

STIPEND $500/month; $100/month per dependent living at the community.

ARTIST PAYS Travel, food, personal needs, materials, phone; no residency fee.

ARTIST DUTIES None.

OTHER ACCOMMODATIONS Families can be accommodated; no pets.

PUBLIC PROGRAMS Exhibitions, lectures at the Roswell Museum and Art Center.

HISTORY The program began in 1967 through the philanthropic efforts of Donald Anderson (with implementation by the Roswell Museum and Art Center), whose vision it was to bring artists of national importance to live and work in the tranquillity of the high plains of southeast New Mexico.

MISSION "To provide professional studio artists with the unique opportunity to concentrate on their work in a supportive communal environment for periods of six months to one year, allowing artists of vision and technical merit to work without distraction, break new ground and focus on individual goals."

PAST ARTISTS INCLUDE Luis Jimenez, Colleen Sterritt, Alison Saar, Robert Colescott, Richard

> *"The Roswell grant gave me the opportunity for a totally pure focus on my work, telescoping in a single year what might have taken three—and I suspect the questions that got asked here will sustain my work for years."* —Julia Couzens

Schaffer, Stuart Arends, Julia Couzens, Milton Resnick, Eddie Dominguez, Diane Marsh, Robert Jessup, Susan Dopp.

FROM THE DIRECTOR "Artists need time away from the struggle of daily sustenance. They need free time to think, to experiment, to work through their ideas . . . and time to grow [and] . . . to make their vision real. The Roswell Artist-in-Residence Program is one of the very rare places that offers visual artists this opportunity to work freely and undisturbed for a full year. It is truly a 'Gift of Time.'" —*Stephen Fleming*

Sculpture Space, Inc.

FOUNDED Organization 1975, Residency Program 1975.

LOCATION On the site of the old Utica Steam Engine & Boiler Works, in downtown Utica.

CATEGORIES Sculptors.

FACILITIES 6,000 sq. ft. of open space and 1 private studio that accommodates 4 artists at a time. Community will accommodate disabled artists if possible; studios and bathrooms are wheelchair-accessible.

HOUSING Short-term apartment rentals or, when possible, in the homes of Board members and volunteers.

MEALS Artists purchase their own food and prepare their own meals.

RESIDENT SEASON Year-round.

AVERAGE LENGTH OF RESIDENCIES 2 months.

NUMBER OF ARTISTS IN 1995 33 (selected from 69 applicants).

FOR CURRENT APPLICATION REQUIREMENTS:

12 Gates Street
Utica, NY 13502

TEL
315-724-8381

FAX
315-732-5048

E-MAIL
n/a

WWW
n/a

AVERAGE NUMBER OF ARTISTS PRESENT AT ONE TIME 4.

APPLICATION DEADLINES December 15 for funded residencies; ongoing for unfunded residencies.

SELECTION PROCESS Review committee of artists with one outside panelist.

APPLICATION FEE None.

SPECIAL PROGRAMS None.

STIPEND For funded residencies, $2,000.

ARTIST PAYS Travel, food, accommodations (see "Housing"), personal needs, materials; no residency fee.

ARTIST DUTIES To promote the organization as appropriate.

OTHER ACCOMMODATIONS None.

PUBLIC PROGRAMS Exhibitions.

HISTORY Founded in 1975 by a group of sculptors.

MISSION "To provide professional artists with the opportunity and space to create sculptural works on a scale which they otherwise could not afford and in an environment conducive to experimentation."

PAST ARTISTS INCLUDE Les LeVeque, Annie West, Chris Dunbar, Carolyn Speranza, Margie Neuhaus, Elizabeth Stephens, Dorothy Jiji, Alvaro Garcia, David Baskin, Satoru Takahashi, Joan Carlon, Carl Scholtz.

FROM THE DIRECTOR "By providing access to a well-equipped work space and a supportive environment—that includes the special expertise of the Studio Manager—we aim to nurture the creative process that produces innovative works of art." —*Gina Murtagh*

"Sculpture Space is a perfect marriage between thinking and working. [The community provides] a special international climate which enabled me to feel free to experiment and to check my ideas over and over." —Marjetica Potrc

Shenandoah International Playwrights Retreat

FOUNDED Organization 1981, Residency Program 1976.

LOCATION On historic Pennyroyal Farm, north of Staunton, in the Shenandoah Valley of Virginia.

CATEGORIES Playwrights, screenwriters, and translators; actors, theater directors, musicians, performance artists, and storytellers; set designers; collaborative teams and interdisciplinary artists.

FACILITIES 4 performance spaces. Community accommodates disabled residents. Housing and housing bathrooms are wheelchair-accessible, and as the community renovates and adds structures, accessibility will be improved. Community is in the planning stages of making facilities accessible to disabled residents

HOUSING At local hotel or in local homes.

MEALS All meals provided.

RESIDENT SEASON August–September.

AVERAGE LENGTH OF RESIDENCIES 3–6 weeks.

FOR CURRENT APPLICATION REQUIREMENTS:

Route 5, Box 167-F
Staunton, VA 24401

TEL
540-248-1868

FAX
540-248-7728

E-MAIL
n/a

WWW
n/a

NUMBER OF ARTISTS IN 1995 8 (selected from 200 applicants).

AVERAGE NUMBER OF ARTISTS PRESENT AT ONE TIME 8.

APPLICATION DEADLINE February 1.

SELECTION PROCESS Outside panel of professionals, along with artistic staff.

APPLICATION FEE None.

SPECIAL PROGRAMS International Program.

STIPEND None.

ARTIST PAYS Personal needs; no residency fee.

ARTIST DUTIES To work with company of actors, directors, and staff on the play project for which they were accepted, including attending workshops, rehearsals, and performances.

OTHER ACCOMMODATIONS Guests accommodated, with prior notice, for a reasonable fee.

PUBLIC PROGRAMS None.

HISTORY Founded in 1976.

MISSION "To provide young and established writers with a stimulating, challenging environment to test and develop new work in a safe haven, free from the pressures of everyday living."

PAST ARTISTS INCLUDE Karim Alrawi, Michael Henry Brown, Tat Ming Cheung, Sean Clark, Tom Dunn, Julie Jenson, Carol Wright Krause, Oliver Mayer, Kirk Read, Phoef Sutton, Yo-Huei Wang, Jeff Wanshel.

FROM THE DIRECTOR "At Shenandoah, we see the universal, the common thread that links us all. Playwrights from different regions of this world come to live and work with our multi-cultural

> *"No critical encounter was ever as valuable as Shenandoah; none ever more challenging, none ever more ultimately useful to me as a playwright, an artist, and a human being."*
>
> —*Julie Jensen*

company of theatre artists. We explore together the unique vision and voice of each writer . . . by walking one collaborative mile in their shoes." —*Robert Graham Small*

FOUNDED Organization 1971, Residency Program 1981.

LOCATION In the Cascade Head National Science Research Area, overlooking the Salmon River estuary and Pacific Ocean.

CATEGORIES Visual artists in arts and crafts, book art, ceramics, clay/pottery, drawing, fiber/textile, film/videomaking, folk art, installation, mixed media, painting, paper art, photography, printmaking, sculpture, and woodworking; fiction writers, journalists, literary nonfiction writers, playwrights, poets, screenwriters, and translators; actors, audio artists, choreographers, composers, dancers, film directors, theater directors, electronic artists, musicians, performance artists, storytellers, and radio artists; architects, clothing designers, graphic designers, industrial designers, landscape designers, set designers, and urban designers; art conservators, art educators, art historians, art professionals, computer scientists (nature or arts related), environmentalists/naturalists, and scientists; collaborative teams, conceptual artists, environmental artists, interdisciplinary artists, media artists, multimedia artists, and new genre artists.

FOR CURRENT APPLICATION REQUIREMENTS:

P.O. Box 65
Otis, OR 97368

TEL
541-994-5485

FAX
541-994-8024

E-MAIL
n/a

WWW
n/a

FACILITIES 2 studios; 36" × 72" etching press, skutt kiln, 1 mechanical wheel. Studios, public bathrooms, kiln, wheel, press are wheelchair-accessible; community is in the planning stages for making facilities accessible to disabled residents.

HOUSING 2 residences, with kitchens and baths.

MEALS Artists purchase their own food and prepare their own meals.

RESIDENT SEASON October 1–January 21; February 1–May 21.

AVERAGE LENGTH OF RESIDENCIES 3–4 months.

NUMBER OF ARTISTS IN 1995 4 (selected from 30 applicants).

AVERAGE NUMBER OF ARTISTS PRESENT AT ONE TIME 2.

APPLICATION DEADLINE June 20.

SELECTION PROCESS Outside panel of professionals in each category, together with Residency Committee and Executive Director.

APPLICATION FEE None.

SPECIAL PROGRAMS Founders' Series: award of $500 stipend to 1 of the 4 artists in residence each year.

STIPEND None (except recipient of Founders' Series award).

ARTIST PAYS Travel, food, personal needs, materials; no residency fee.

ARTIST DUTIES 20 hours per month of community service; some maintenance responsibilities.

OTHER ACCOMMODATIONS No pets; guests accommodated in residents' living space.

> *"There is something good in everything. And there are places to cure your wounds. Sitka is that kind of place."* —Ferida Durakovic

PUBLIC PROGRAMS Workshops, presentations, exhibitions, lectures, and seminars.

HISTORY The Neskowin Coast Foundation was founded in 1970 to promote interest in and provide the opportunity to study various forms of art, music, and the ecology of the central Oregon coast. In 1971 the foundation built the Sitka Center at Cascade Head Ranch, in Otis, in order to create a program that explores the relationship between fine arts, craft, and natural science.

MISSION "To expand the relationship between art, nature, and humanity . . . in harmony with the inspirational coast environment of Cascade Head."

PAST ARTISTS INCLUDE Damian Manuhwa, Debra Loew, Dawne Douglas, Michael Liddle, Landa Townsend, Kirk Tatom, Vladimir Tsivin, Larry Thomas, Mark Derby, Marlana Stoddard, Weishu Hsu, Catherine Murray.

FROM THE DIRECTOR "There is a trust in a Residency [at the Sitka Center] that acknowledges the prowess in the individual, and allows them to structure their time and energies into constructive activity." —*Randall Koch*

FOUNDED Organization 1946, Residency Program 1946.

LOCATION On 300 acres in the forested lake district of central Maine.

CATEGORIES Visual artists in drawing, fiber/textile, film/videomaking (minimal), installation, mixed media, painting, photography, and sculpture; performance artists; conceptual artists, environmental artists, inderdisciplinary artists, and new genre artists.

FACILITIES Studio space. Community is in the planning stages for making facilities accessible to disabled residents.

HOUSING Dorm-style rooms.

MEALS 3 meals provided each day.

RESIDENT SEASON June to August.

AVERAGE LENGTH OF RESIDENCIES 9 weeks.

NUMBER OF ARTISTS IN 1995 65 (selected from 700 applicants).

FOR CURRENT APPLICATION REQUIREMENTS:

200 Park Avenue South, #1116
New York, NY 10003

TEL
212-529-0505

FAX
212-473-1342

E-MAIL
n/a

WWW
n/a

AVERAGE NUMBER OF ARTISTS PRESENT AT ONE TIME 65 plus ten senior artists.

APPLICATION DEADLINE February 9.

SELECTION PROCESS Reviewed and selected by upcoming faculty and Board of Governors.

APPLICATION FEE $35.

SPECIAL PROGRAMS Camille Hanks Cosby Fellowship for African-American artists, Educational Foundation of America Fellowship for Native American artists, Payson Governors Fund Fellowship for Artists of Asian or Pacific descent, Payson Governors Fund Fellowship for Artists of Central or South American or Caribbean descent.

STIPEND Fellowships offered toward tuition. See special fellowships under "Special Programs," above.

ARTIST PAYS $5,200 residency fee (tuition); travel, personal needs, materials.

ARTIST DUTIES 6 hours per week of service to the school.

OTHER ACCOMMODATIONS No pets or family; weekend guest permitted once per summer.

PUBLIC PROGRAMS Weekly lectures by visiting artists.

HISTORY Founded in 1946.

MISSION "To provide an extended and concentrated period of independent work, made with the critical assistance and camaraderie of residents and visiting artists."

PAST ARTISTS INCLUDE Ellen Gallagher, Tobi Khedoori, Ross Bleckner, David Reed, Janet Fish, Nari Ward, Ellsworth Kelly, Alex Katz, Bill King, Bryon Kim.

> *"Skowhegan helped instill in me a sense of artistic esteem and cultural competency that I did not have before coming to study there."* —David Driskell

FROM THE DIRECTOR "Since no artist is allowed to return, Skowhegan is a once-in-a-lifetime experience in which an optimal level of creativity is allowed and sustained." *—Thomas Sinkelpearl*

South Florida Art Center

FOUNDED Organization 1984, Residency Program 1984.

LOCATION Lincoln Road in Miami Beach.

CATEGORIES Visual artists in book art, ceramics, clay/pottery, digital imaging, drawing, fiber/textile, film/videomaking, folk art, glass, installation, jewelry, mixed media, painting, paper art, photography, printmaking, sculpture, and woodworking; conceptual artists, environmental artists, interdisciplinary artists, and multimedia artists.

FACILITIES 69 artist's studios in the Lincoln Road Arts District, 6 exhibition spaces, cooperative clay workshop, printmaking facility, classroom, darkroom, video and film production and editing equipment. Studios and public bathrooms are wheelchair-accessible.

HOUSING Local apartments for CAVA (Career Advancement for Visual Artists) fellows.

MEALS Artists purchase their own food and prepare their own meals.

FOR CURRENT APPLICATION REQUIREMENTS:

924 Lincoln Road
Miami Beach, FL 33139

TEL
305-674-8278

FAX
305-674-8772

E-MAIL
n/a

WWW
n/a

RESIDENT SEASON Year-round.

AVERAGE LENGTH OF RESIDENCIES CAVA fellows, 4 months per year for 3 years; SFAC artists, 4 years.

NUMBER OF ARTISTS IN 1995 CAVA fellows: 3 (selected from 206 applicants); SFAC artists: 10 (selected from 100 applicants).

AVERAGE NUMBER OF ARTISTS PRESENT AT ONE TIME CAVA fellows, 9; SFAC artists, 60.

APPLICATION DEADLINES Ongoing.

SELECTION PROCESS Outside jury of professionals in each category.

APPLICATION FEE $20.

SPECIAL PROGRAMS CAVA Fellowships, in collaboration with the National Federation for the Advancement of the Arts (for information, contact NFAA at 305-377-1140).

STIPEND CAVA Fellowship, $1,000/month plus housing; SFAC artists, none.

ARTIST PAYS Travel, food, personal needs, materials; $6–$8/square foot plus energy surcharge at $1.60/square foot (SFAC artists pay fee on a sliding scale).

ARTIST DUTIES Must be in studio 20 hours per week.

OTHER ACCOMMODATIONS None.

PUBLIC PROGRAMS Art Adventures (children's program), Studio School, exhibitions, performances.

HISTORY SFAC was founded in 1984 by a group of artists to provide affordable workspace for artists and to combat the problem of artists working in isolation.

MISSION "To provide permanent, affordable space in the Lincoln Road Arts District for Florida's outstanding emerging, midcareer, and established visual artists in an environment which fosters individual artistic development, experimentation, and dialogue among all artists and art forms and ongoing interaction with the public."

PAST ARTISTS INCLUDE Tom Seghi, Eduard Duval-Carrie, Eduardo De La Rosa, Carlos Alves, Juan Si, Carol Brown, George Goodridge, Andres Vidal, Tag Purvis, Deborah Groover, Kirk Mangus, Peter Pinnell

FROM THE DIRECTOR "The South Florida Art Center provides visual artists with both the sanctuary of a studio and cooperative work facilities. [Artists are also encouraged] . . . to expand their visibility and interaction with an international audience through exhibitions and workshops in the heart of an artistic tourist destination spot." —Jane Gilbert

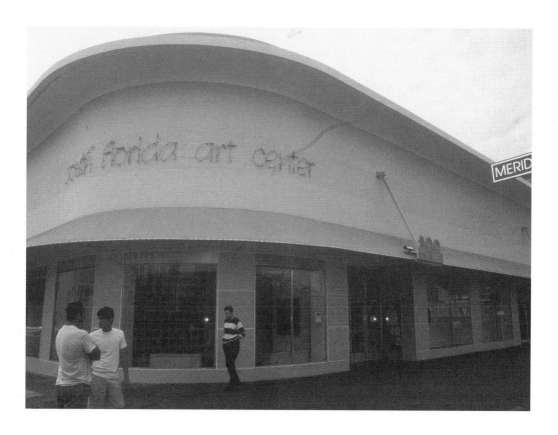

STUDIO for Creative Inquiry

FOUNDED Organization 1989, Residency Program 1990.

LOCATION Campus of Carnegie Mellon University.

CATEGORIES Cross-disciplinary: visual artists in digital imaging, film/videomaking, installation, photography, and sculpture; fiction writers, journalists, literary nonfiction writers, playwrights, poets, and screenwriters; audio artists, choreographers, composers, dancers, film directors, theater directors, electronic artists, performance artists, and radio artists; architects, graphic designers, industrial designers, landscape designers, set designers, and urban designers; art educators, art professionals, computer scientists, critics, environmentalists/naturalists, historians, historic preservationists, linguists, mathematicians, and scientists; collaborative teams, conceptual artists, environmental artists, interdisciplinary artists, media artists, multimedia artists, and new genre artists.

FACILITIES and HOUSING Studios include video editing and recording equipment, as well as access to multimedia labs, computing resources, sculpture studios, and MIDI equipment. Stipends able to cover nearby, affordable rentals. Studios and public bathrooms are wheelchair-accessible; technology available for sight-impaired residents, signers for hearing-impaired residents; community is in the planning stages for making facilities more accessible to disabled residents.

MEALS Artists purchase their own food and prepare their own meals, except for monthly meetings and special events.

RESIDENT SEASON Year-round.

AVERAGE LENGTH OF RESIDENCIES 1 year.

NUMBER OF ARTISTS IN 1995 4 (selected from 10 applicants).

AVERAGE NUMBER OF ARTISTS PRESENT AT ONE TIME 3 full-time, 10 part-time.

APPLICATION DEADLINES None.

SELECTION PROCESS Committee comprised of artists and staff make recommendations to the director.

APPLICATION FEE None.

SPECIAL PROGRAMS Joint Residency with the National Black Programming Consortium and WQED-TV for media artists; performances, exhibitions, and hosting K–12 school visits.

STIPEND $30,000/year plus extensive benefits program. Some artists receive a small project fund.

ARTIST PAYS Travel, food, housing, personal needs; no residency fee.

ARTIST DUTIES 1 public presentation.

OTHER ACCOMMODATIONS None.

FOR CURRENT APPLICATION REQUIREMENTS:

College of Fine Arts, Room 111
Carnegie Mellon University
Pittsburgh, PA 15213-3890

TEL
412-268-3454

FAX
412-268-2829

E-MAIL
mmbm@andrew.cmu.edu

WWW
n/a

"*The STUDIO for Creative Inquiry is an exciting and rich interdisciplinary environment in which to develop artwork. In collaboration with artists, art historians, actors, videographers, audio engineers, and electrical engineers, I was able to accomplish the goals set for my residency—which focused on the creation of interactive, computer-based artwork . . . in the technoculture. The STUDIO's understanding of artists' working processes and receptiveness to experimentation and exploration created an ideal climate in which to work.*" —George Roland

PUBLIC PROGRAMS Open house, special events, workshops, performances.

HISTORY Funded by Apple Computer, the community began as the Center for Art and Technology. In 1989, in an effort to broaden its mission, the Center became the STUDIO for Creative Inquiry.

MISSION "To support cross-disciplinary and exploratory work in the arts by providing artists residencies with stipends, commissions, and studio space, establishing an environment of interdisciplinary practitioners . . . ; to facilitate artistic work with relevant technology; to develop public venues for presenting innovative work."

PAST ARTISTS INCLUDE Lowry Burgess, Ping Cao, Agnes Denes, Rob Fisher, Paul Glabicki, Shigenhiko Hongo, Artur Matuck, Paul Oles, Oopalie Operajita, Xavier Perrot, Seth Riskin, Julian Thayer, Patricia Villalobos.

FROM THE DIRECTOR "Technology is transforming the way we learn and experience the world. This transformation impacts significantly upon the work of the artist. To remain up to date with current technology, artists require access to new tools and techniques. They need supportive environments which connect their talents with the skills and interests of practitioners from disciplines outside of art. Art-making, like most endeavors in our culture, has become a more complex undertaking. Artists need innovative organizations like STUDIO for Creative Inquiry to supply the support structure for today's art-making." —Bryan Rogers

FOUNDED Organization 1986, Residency Program 1986.

LOCATION In Illinois farm country, 3-hour drive from Chicago, 30 miles from Mississippi River.

CATEGORIES Visual artists in arts and crafts, book art, drawing, fiber/textile, folk art, installation, jewelry, mixed media, painting, paper art, photography, and sculpture.

FACILITIES 8 studios (no darkroom).

HOUSING Separate apartment for each resident.

MEALS Artists purchase their own food and prepare their own meals.

RESIDENT SEASON June–August.

AVERAGE LENGTH OF RESIDENCIES 2 months.

NUMBER OF ARTISTS IN 1995 5 (selected from 20 applicants).

AVERAGE NUMBER OF ARTISTS PRESENT AT ONE TIME 5.

APPLICATION DEADLINE Last Monday in February.

FOR CURRENT APPLICATION REQUIREMENTS:

P.O. Box 291
Galesburg, IL 61402

TEL
309-344-1177

FAX
309-344-1177 (voice call first)

E-MAIL
n/a

WWW
n/a

SELECTION PROCESS Outside panel of professionals in each category.

APPLICATION FEE None.

SPECIAL PROGRAMS None.

STIPEND None.

ARTIST PAYS Travel, food, personal needs, materials; no residency fee.

ARTIST DUTIES Artists must have slides of their work available for formal presentation, participate in media publicity, show results of their summer work, complete a program evaluation upon departure.

OTHER ACCOMMODATIONS None.

PUBLIC PROGRAMS Exhibitions, receptions, dinners with community, sponsors, and local artists.

HISTORY Founded in 1986 as a way to bring artists to Galesburg.

MISSION "To provide free housing and studio space for two months for five visiting artists, with one or two short exhibits, and occasional informal presentations and receptions."

PAST ARTISTS INCLUDE Denice Tschumi, Scott Greenig, Nan Wollman, Carole Spelic, Albert Liu, Michael Albright, Allan Montgomery, Susan Wink, Carla Rae Johnson, Shawne Major, Carla Markwart, Chris Verene.

FROM THE DIRECTOR "The Galesburg community looks forward to meeting and welcoming the residents each summer, and we are glad to learn about each artist's work." —*Mona Tourlentes*

"It will always be with fondness and good memories that I think about Galesburg, Illinois! The summer was delightful, productive, and so necessary for my creative survival." —*Carla Rae Johnson*

Sundance Institute

FOUNDED Organization 1981, Residency Program 1981.

LOCATION At the Sundance Resort in Utah.

CATEGORIES Screenwriters, filmmakers.

FACILITIES AVID editing system, digital video.

HOUSING Private room in resort.

MEALS All meals provided.

RESIDENT SEASON Screenwriters in January and June. Filmmakers in June.

AVERAGE LENGTH OF RESIDENCIES Screenwriters, 5 days. Filmmakers, 3 weeks.

NUMBER OF ARTISTS IN 1995 18 (selected from 2,000 applicants).

AVERAGE NUMBER OF ARTISTS PRESENT AT ONE TIME 10–12.

APPLICATION DEADLINES June 28 for January; November 15 for June.

FOR CURRENT APPLICATION REQUIREMENTS:

225 Santa Monica Boulevard, 8th Floor
Santa Monica, CA 90401

TEL
310-394-4662/801-328-3456

FAX
310-394-8353/801-575-5175

E-MAIL
sundance@deltanet.com

WWW
http://www.sundance.org/sundance/
institute

SELECTION PROCESS Staff review, then finalists are sent to outside panel of professionals that form selection committee.

APPLICATION FEE $25.

SPECIAL PROGRAMS Screenwriters Lab, Filmmakers Lab, Producers Conference, Playwrights Lab.

STIPEND None, though travel, meals, and lodging are covered by Sundance Institute.

ARTIST PAYS Personal needs.

ARTIST DUTIES Meetings and production work.

OTHER ACCOMMODATIONS None.

PUBLIC PROGRAMS Sundance Film Festival, International Program, Sundance Children's Theatre, New Media Initiative.

HISTORY Founded in 1981 by Robert Redford and other filmmakers.

MISSION "To support the development of emerging screenwriters and directors of vision and the national and international exhibition of independent dramatic and documentary films."

PAST ARTISTS INCLUDE Frank Pierson, Richard Price, Alan Rudolph, Joan Tewkesbury, Tom Rickman, Waldo Salt, Richard LaGravenese, Alice Arlen, Judith Rascoe, Scott Frank, Arthur Penn.

FROM THE DIRECTOR "Sundance offers screenwriters and filmmakers a safe environment in which to work, think, and talk about the craft of writing and directing, a place to take risks, experiment, and push the boundaries of their work, and a place to develop what is often their first feature project." —*Michelle Satter*

PHOTO: SANDRA MILLER

Ucross Foundation Residency Program

FOUNDED Organization 1981, Residency Program 1983.

LOCATION In the cattle and sheep ranching country of northeast Wyoming, in the foothills of the Big Horn Mountains, 27 miles southeast of Sheridan.

CATEGORIES Visual artists in arts and crafts, book art, digital imaging (with own equipment), drawing, fiber/textile, film/videomaking, folk art, installation, jewelry (with own equipment), mixed media, painting, paper art, photography, printmaking, sculpture, and woodworking; fiction writers, journalists, literary nonfiction writers, playwrights, poets, screenwriters, and translators; actors, audio artists, choreographers, composers, dancers, film directors, theater directors, electronic artists (with own equipment), musicians, performance artists, and storytellers; architects, clothing designers, graphic designers, industrial designers, landscape designers, set designers, and urban designers; art conservators, art educators, art historians, art professionals, computer scientists, critics, environmentalists/naturalists, general scholars, historians, historic preservationists, linguists, mathematicians, and scientists; collaborative teams, conceptual artists, environmental artists, interdisciplinary artists, media artists, multimedia artists, and new genre artists.

FACILITIES and HOUSING 4 writing studios, 4 studios for visual artists (including 1 printmaking studio); separate, private bedrooms, shared bathrooms. Community accommodates disabled residents. Housing, housing bathrooms, studios, and public bathrooms are wheelchair-accessible.

MEALS All meals provided (lunch delivered to studios) Monday–Friday; food provided for Saturday and Sunday for artists to prepare their own meals.

RESIDENT SEASON August–early December; February–early June.

AVERAGE LENGTH OF RESIDENCIES 2–8 weeks.

NUMBER OF ARTISTS IN 1995 60 (selected from 270 applicants).

AVERAGE NUMBER OF ARTISTS PRESENT AT ONE TIME 8 (maximum).

APPLICATION DEADLINES March 1 and October 1.

SELECTION PROCESS Outside, rotating panel of professionals in each category.

APPLICATION FEE $20.

SPECIAL PROGRAMS Etching and letterpresses available.

STIPEND None.

ARTIST PAYS Travel, personal needs, materials; no residency fee.

ARTIST DUTIES None.

FOR CURRENT APPLICATION REQUIREMENTS:

2836 Highway 14-16 East
Clearmont, WY 82835

TEL
307-737-2291

FAX
307-737-2322

E-MAIL
ucrossfdn@aol.com

WWW
n/a

"The most important thing that happened for me here was a discovery of 'the way that I work' in a much more solid tangible form—and this happened because of landscape, being around other artists who value their work, and a mind free of the worry of deadlines and feeding myself." —Jan Beatty

OTHER ACCOMMODATIONS None.

PUBLIC PROGRAMS Conference facilities, exhibitions.

HISTORY Founded in 1981, Ucross is at "Big Red," a complex of buildings built in 1882 that were once the headquarters of the Pratt and Ferris Cattle Company.

MISSION "To encourage exceptional creative work and foster the careers of serious artists."

PAST ARTISTS INCLUDE E. Annie Proulx, Ann Patchett, Debra Spark, Hugh Ogden, Stephanie Heyl, David Bungay.

FROM THE DIRECTOR "Ucross is a magical place. Our goal is to enhance the environment in which individuals can realize their fullest potential." —*Elizabeth Guheen*

Vermont Studio Center

FOUNDED Organization 1984, Residency Program 1984.

LOCATION Northern Vermont.

CATEGORIES Visual artists in drawing, mixed media, painting, photography, printmaking, and sculpture; fiction writers, journalists, literary nonfiction writers, playwrights, poets, and screenwriters.

FACILITIES 40 painting studios, 12 sculpture studios, sculpture shop, printmaking studio for 4 printmakers, darkroom, 12 rooms for writers. Studios, public bathrooms, and lecture hall are wheelchair-accessible; community is in the planning stages of making facilities more accessible to disabled residents. Community will accommodate sight- and hearing-impaired residents, but now have no special equipment to do so.

HOUSING 6 residence houses, dining hall.

MEALS All meals provided.

RESIDENT SEASON Year-round.

FOR CURRENT APPLICATION REQUIREMENTS:

P.O. Box 613
Johnson, VT 05656

TEL
802-635-2727

FAX
802-635-2730

E-MAIL
vscut@pwshift.com

WWW
n/a

AVERAGE LENGTH OF RESIDENCIES 1 month.

NUMBER OF ARTISTS IN 1995 440 (selected from 1,000 applicants).

AVERAGE NUMBER OF ARTISTS PRESENT AT ONE TIME 45.

APPLICATION DEADLINES Ongoing admissions; full fellowship deadlines: October 15 for writers, March 31, July 31, October 31 for others.

SELECTION PROCESS Outside panel of professionals in each category.

APPLICATION FEE $25.

SPECIAL PROGRAMS Intensive Drawing Program, Vermont Artists Program.

STIPEND $10 per day for international artists. Also, some grants available (see "Artist Pays," below).

ARTIST PAYS $1,300 average/4-week session residency fee (partial grants and work exchanges available, and juried competitions for full fellowship covering all fees available); travel, personal needs, materials.

ARTIST DUTIES None for full fellowship or Vermont Studio Residency Grant residents; 5–10 hours per week of physical plant work for Work-Exchange Aid residents.

OTHER ACCOMMODATIONS None.

PUBLIC PROGRAMS Reading Series, Visual Arts Slide Lectures, gallery exhibitions, Saturday Community Art Program, Vermont Artists Weeks, Weekly Community Life Drawing Sessions.

HISTORY Founded by Jon Gregg, Louise Von Weise, and Fred Osborne.

MISSION "To build an ideal international creative community that supports serious artists and

writers by providing them with the seclusion of distraction-free working time, the companionship of professional peers, and the option of the counsel of inspired mentors."

PAST ARTISTS INCLUDE Jake Berthot, John Walker, William Bailey, Joan Snyder, Louise Fishman, Grace Hartigan, Neil Welliver, Joel Shapiro, Bill Jensen, Grace Paley, Donald Hall, Galway Kinnell, Maxine Kumin.

FROM THE DIRECTOR "The Vermont Studio Center is an international creative community that offers a unique format which provides artists with the independent, distraction-free studio time found in a colony, plus the added option of studio visits from a roster of prominent visiting artists and writers, available weekly on a year-round basis." —*Jonathan T. Gregg*

Villa Montalvo

FOUNDED Organization 1930, Residency Program 1942.

LOCATION 175 acres in the eastern foothills of the Santa Cruz Mountains, 20 miles from San Jose, 50 miles from San Francisco.

CATEGORIES Visual artists in book art, drawing, fiber/textile, installation, mixed media, painting, paper art, photography, printmaking, and sculpture; fiction writers, journalists, literary nonfiction writers, playwrights, poets, screenwriters, and translators; composers, theater directors (in collaboration with theater company), and musicians; set designers (in collaboration with theater company); critics and environmentalists/naturalists; collaborative teams and environmental artists.

FACILITIES and HOUSING 5 furnished apartments, with private bath and kitchen; 3 of the apartments include studio space, while the Barn Studio provides space for painters and sculptors. Sight-impaired residents with guide dogs can be accommodated. Housing, studios, and public bathrooms are wheelchair-accessible. A new facility with greater accessibility will be built in 1998.

FOR CURRENT APPLICATION REQUIREMENTS:

P.O. Box 158
Saratoga, CA 95071

TEL
408-741-3421

FAX
408-741-5592

E-MAIL
villamnt@artswire.org

WWW
n/a

MEALS Artists purchase their own food and prepare their own meals. Once a week potluck.

RESIDENT SEASON Year-round.

AVERAGE LENGTH OF RESIDENCIES 6 weeks.

NUMBER OF ARTISTS IN 1995 30 (selected from 300 applicants).

AVERAGE NUMBER OF ARTISTS PRESENT AT ONE TIME 5.

APPLICATION DEADLINES March 1 and September 1.

SELECTION PROCESS Outside panel of professionals in each category.

APPLICATION FEE $20.

SPECIAL PROGRAMS Special fellowships for women.

STIPEND Four $400 fellowships given each year, based on merit.

ARTIST PAYS $100 security deposit (refunded); travel, food, personal needs, materials; no residency fee.

ARTIST DUTIES None.

OTHER ACCOMMODATIONS No pets or children; spouses are welcome; overnight visitors for short stays with prior notice.

PUBLIC PROGRAMS Performing Arts Season, Young Writer's Competition, Montalvo Biennial Poetry Competition, Gallery, Open House, Readings.

HISTORY Built in 1912 by former San Francisco Mayor and U.S. Senator James Duval Phelan, the estate's Mediterranean flavor reflects Phelan's love for the Villa Medici in Rome. The estate was named for the 16th century Spanish writer Garcia Ordonez de Montalvo, who coined the name "California."

MISSION "To provide artists from a wide range of backgrounds the benefits of a beautiful and inspiring location, where they are free to devote their time solely to creation and to the nourishment and engendering of the artistic process. Montalvo provides a retreat from the pressures of work and family life, in which an eclectic community of artists from a multicultural base enrich each other."

PAST ARTISTS INCLUDE Georges Bensoussan, Nguyen Qui Duc, M'Hamed Benguettaf, Rene Yung, Andrew Schultz, Santa Barraza, Roberto Mannino, Loida Martiza Perez, Chris Komater, James Kasebere, Tsippi Fleisher, Mokhtar Paki Pudeniic.

FROM THE DIRECTOR "Villa Montalvo's international residency program offers solitude for reflection and creative work in a natural setting. Montalvo's small interdisciplinary community gives artists the benefit of long hours of uninterrupted time to focus on their work, with opportunities for interaction with one another and members of nearby neighborhoods. Uniquely situated, Montalvo offers both an expanse of 175 acres of park land for inspiration, as well as access to nearby urban and suburban areas that provide a wide range of cultural events."
—*Judy Moran*

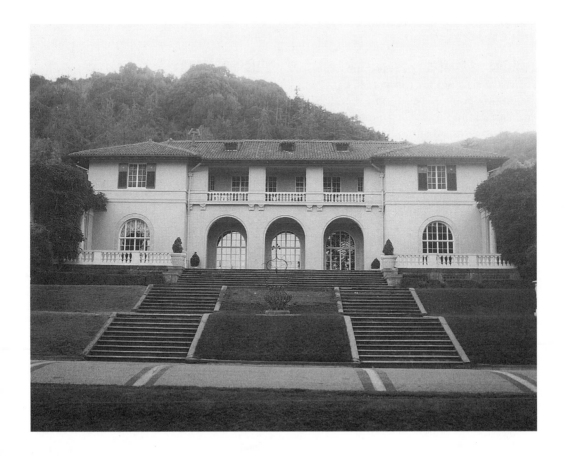

The Virginia Center for the Creative Arts

FOUNDED Organization 1971, Residency Program 1971.

LOCATION 450 acres in the foothills of the Blue Ridge Mountains of southern Virginia, 160 miles from Washington, DC.

CATEGORIES Visual artists in book art, digital imaging, drawing, fiber/textile (one-of-a-kind, non-production work), film/videomaking, folk art, installation, mixed media, painting, paper art, photography, printmaking, sculpture, and woodworking (not furniture); fiction writers, literary nonfiction writers, playwrights, poets, screenwriters, and translators; audio artists, choreographers, composers, electronic artists, and performance artists; collaborative teams, conceptual artists, environmental artists, interdisciplinary artists, media artists, multimedia artists, and new genre artists.

FACILITIES and HOUSING 12 studios for writers, 9 for visual artists, 3 for composers, darkroom, swimming pool; 22 bedrooms, shared bathrooms. Community can accommodate sight- and hearing-impaired residents. Housing and studios are wheelchair-accessible; several artists using wheelchairs have been in residence, though bathrooms have no special facilities. Community is in the planning stages of making facilities more accessible to disabled residents.

MEALS All meals provided.

RESIDENT SEASON Year-round.

AVERAGE LENGTH OF RESIDENCIES 4 weeks.

NUMBER OF ARTISTS IN 1995 320 (selected from 972 applicants).

AVERAGE NUMBER OF ARTISTS PRESENT AT ONE TIME 22–24.

APPLICATION DEADLINES January 15, May 15, September 15.

SELECTION PROCESS Outside panel of professionals in each category.

APPLICATION FEE $25.

SPECIAL PROGRAMS International Exchanges and Fellowship Outreach Program.

STIPEND None.

ARTIST PAYS Voluntary $30/day residency fee; travel, personal needs, materials.

ARTIST DUTIES None.

OTHER ACCOMMODATIONS None.

PUBLIC PROGRAMS Art exhibits, readings, concerts.

HISTORY The VCCA was founded in 1971 by Charlottesville writers Nancy Hale and Elizabeth Langhorne, who wanted to create a MacDowell-type colony in Virginia.

MISSION "To provide serious artists with working facilities or conditions that they do not have

FOR CURRENT APPLICATION REQUIREMENTS:

Mt. San Angelo
Sweet Briar, VA 24595

TEL
804-946-7236

FAX
804-946-7239

E-MAIL
vcca@artswire.org

WWW
n/a

"*VCCA is a wonderful place—a composer-away-from-home's best friend!*" —*David Del Tredici*

on a normal, daily basis, such as adequate space, undisturbed time, and relief from day-to-day responsibilities."

PAST ARTISTS INCLUDE David Del Tredici, Michael Torke, John Casey, Naomi Wolf, Aileen Ward, W. D. Snodgrass, Peter Viereck, Yuriko Yamaguchi, Eileen Simpson, Ellen Driscoll, Jacque Hnizdovsky, Mona Simpson.

FROM THE DIRECTOR "Mt. San Angelo, the home of the Virginia Center for the Creative Arts, is an exciting place. The setting is beautiful and there are many amenities, such as year-round swimming, tennis courts, and a good library. There are no hierarchies among fellows or staff and consequently very little competitiveness. As a result, artists work well here and want to come back." —*Bill Smart*

PHOTO: CRAIG PLEASANTS

Walker Woods

FOUNDED Organization 1993, Residency Program 1993.

LOCATION Metropolitan Atlanta between Buckhead and La Vista Park, near the Emory University campus.

CATEGORIES Book artists; writers who have not published a book in English with a major publisher, including fiction writers, journalists, literary nonfiction writers, playwrights, poets, screenwriters, and translators; actors, performance artists, storytellers, and radio artists; critics; landscape architects; collaborative teams and environmental artists.

FACILITIES and HOUSING Residents live as a family, taking up projects in the garden or house. Flexibility is a must. Community has a hot tub, two dogs, a waterfall, and lots of community contact. Housing and housing bathrooms are wheelchair-accessible; community is in the planning stages of making facilities more accessible to disabled residents.

MEALS Food provided; breakfast and lunch are make-your-own; dinners are communal, with residents taking turns cooking.

FOR CURRENT APPLICATION REQUIREMENTS:

1397 La Vista Road NE
Atlanta, GA 30324

TEL
404-634-3309

FAX
404-634-3309

E-MAIL
n/a

WWW
n/a

RESIDENT SEASON Year-round.

AVERAGE LENGTH OF RESIDENCIES 2 weeks–4 months.

NUMBER OF ARTISTS IN 1995 5 (selected from 52 applicants).

AVERAGE NUMBER OF ARTISTS PRESENT AT ONE TIME 4–8.

APPLICATION DEADLINES January 15, March 1, June 1, August 1.

SELECTION PROCESS Selected by Board of Directors.

APPLICATION FEE $20 (per lifetime).

SPECIAL PROGRAMS Some work exchange available.

STIPEND None.

ARTIST PAYS $250–600/month residency fee depending on room (partial scholarship and work exchanges available); travel, personal needs, materials (computers provided).

ARTIST DUTIES Housekeeping and gardening.

OTHER ACCOMMODATIONS Pets welcome; family welcome for visits with prior notice.

PUBLIC PROGRAMS Anti-Mediocrity Day, Red-Hot Valentine Party.

HISTORY Walker Woods was founded in 1993, in memory of Reuters' bureau chief and foreign correspondent Richard Leigh Walker.

MISSION "To provide a gathering place of great minds and talents in Atlanta in the tradition of Gertrude Stein's Paris salon."

PAST ARTISTS INCLUDE Michelle Richmond, Lila Summer, He Feng Juen, Mantoshe Singh Devji.

FROM THE DIRECTOR "We welcome artists of the future—serious about excellence, frivolous about fun, and easy to live with. Since this is our home for part of the year, we like to enjoy them and get to know them as friends. Many languages are spoken here and ideas shared—definitely not for ultra-conservatives or very particular people." —*Dalian Moore*

FOUNDED Organization 1986, Resident Program 1986.

LOCATION 32 acres of open, wooded, and rolling hills, surrounded by sheep farm, nature conservancy land, and the Sheepscot River; 3 hours from Boston, 1 hour from Portland, ME.

CATEGORIES Visual artists in arts and crafts, book art, ceramics, clay/pottery, drawing, folk art, industrial art, installation, mixed media, painting, photography, and sculpture; architects, landscape architects, and set designers; general scholars; collaborative teams, conceptual artists, environmental artists, interdisciplinary artists, and new genre artists.

FACILITIES Double-level studio, 2 low-fire propane car kilns, high-fire gas kiln, one wood-fire kiln, electric kilns, raku, pit-firing, potters wheels, Soldner clay mixer, Walker pug mill, extruder, slab rollers. Housing, housing bathrooms, and studios are wheelchair-accessible; community is in the planning stages for making facilities more accessible to disabled residents.

FOR CURRENT APPLICATION REQUIREMENTS:

R.R.2, Box 845
Newcastle, ME 04553-9716

TEL
207-882-6075

FAX
207-882-6075 (call first)

E-MAIL
lgipson@SATURN.caps.maine.edu

WWW
n/a

HOUSING Dorm-style rooms, with central living area and dining room.

MEALS All meals provided.

RESIDENT SEASON Summer, June–August; Winter, September–May (9-month residencies for 2 artists).

AVERAGE LENGTH OF RESIDENCIES 2 weeks–3 months.

NUMBER OF ARTISTS IN 1995 37 (selected from 51 applicants).

AVERAGE NUMBER OF ARTISTS PRESENT AT ONE TIME 12.

APPLICATION DEADLINES April 15 for funded residencies; proposals for "Artists Invite Artists" (see "Special Programs") accepted September–November; ongoing for others.

SELECTION PROCESS Jurying by past residents, professors in MFA programs, and Watershed Board Program committee.

APPLICATION FEE $20.

SPECIAL PROGRAMS Artists Invite Artists (2 artists invite up to 10 other artists with whom they want to work); Watershed Workshop for People with AIDS; Workshop for Battered Women.

STIPEND None.

ARTIST PAYS $700 for 2-week session residency fee; travel, personal needs, materials (other than clay).

ARTIST DUTIES None, unless on assistantship (10–15 hours per week).

OTHER ACCOMMODATIONS Groups can be arranged; guests and family accepted if space available.

PUBLIC PROGRAMS Open studio, slide talk evenings, Community Classes in Clay.

> *"Watershed appears so unassumming, no frills. The studios, the gravel lane, meadows, ponds, and woods . . . the vast night sky. The artists of all ages form temporary families. Staffed by artists, the food is divine, the work fruitful. Watershed is a magical, inspired place where the artist . . . is nourished."* —Christina Bertoni

HISTORY Founded after Watershed Brick and Clay Products Company closed and investor Margaret Griggs approached artist George Mason to initiate a residency program for artists in clay.

MISSION "To provide serious artists with time and space to create in clay."

PAST ARTISTS INCLUDE Linda Arbuckle, John Chalke, Karon Doherty, Peter Gourfain, John Glick, Chris Gustin, Anne Kraus, Judy Moonelis, Matt Nolen, Henry Pim, Chris Staley, Arnie Zimmerman.

FROM THE DIRECTOR "Watershed encourages the exchange of ideas, collaboration, experimentation, and self-inquiry." —*Lynn Gipson*

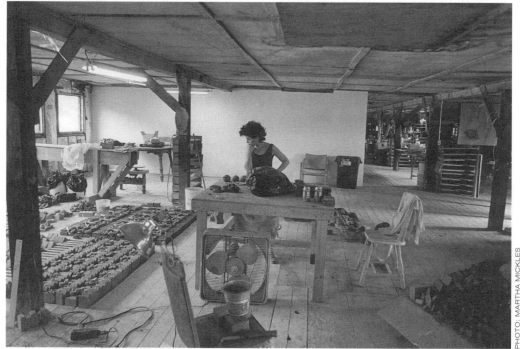

PHOTO: MARTHA MICKLES

The Women's Art Colony Farm

FOUNDED Organization, 1978, Residency Program 1978.

LOCATION 85-acre tree farm with large pond.

CATEGORIES Visual artists in arts and crafts, book art, drawing, fiber/textile, film/videomaking, mixed media, painting, paper art, photography, sculpture, and woodworking; fiction writers, journalists, literary non-fiction writers, playwrights, and poets; audio artists, composers, musicians, performance artists, and storytellers; art conservators, art educators, art historians, art professionals, computer scientists, critics, and general scholars; conceptual artists, environmental artists, interdisciplinary artists, and media artists.

FACILITIES Studio space in renovated barns; swimming pond, video/filmmaking equipment, woodshop, darkroom, and silk-screen studio. Some housing, housing bathrooms, and studios are wheelchair-accessible.

HOUSING Private room in farm house or renovated barn.

FOR CURRENT APPLICATION REQUIREMENTS:

20 Overlook Road
Poughkeepsie, NY 12603

TEL
914-473-9267

FAX
n/a

E-MAIL
n/a

WWW
n/a

MEALS Artists contribute $80 per week for food and prepare meals and eat together.

RESIDENT SEASON June–August.

AVERAGE LENGTHY OF RESIDENCIES 1–3 months.

NUMBER OF ARTISTS IN 1995 12 (selected from 250 applicants).

AVERAGE NUMBER OF ARTISTS PRESENT AT ONE TIME 10.

APPLICATION DEADLINES Ongoing.

SELECTION PROCESS Selections made by Director.

APPLICATION FEE None.

SPECIAL PROGRAMS None.

STIPEND None.

ARTIST PAYS Travel, $80 per week food contribution (see "Meals"), personal needs, and materials; no residency fee.

ARTIST'S DUTIES 5 hours per day of farming.

OTHER ACCOMMODATIONS Occasionally guests are accommodated.

PUBLIC PROGRAMS None.

HISTORY Founded in 1978 by Kate Millett in order to make an empowering and encouraging atmosphere for women artists.

MISSION "To provide a self-supporting and economically independent colony for women."

PAST ARTISTS INCLUDE Jane Winter, Anne Keating, Phyllis Chesler, Sophie Keir, Suzanne Zuckerman, Stephanie Schroeder, Cynthia MacAdams, Janet Melvin, Mary Christian McEwen, Linda Clarke.

FROM THE DIRECTOR "The farm is about the work you bring to the place, the paintings and prose

"Some women come to the farm with valuable skills to share, others come with little or no experience. We put an emphasis on learning new skills and literally want everyone to learn everything. By the end of the summer we all catch the "fever" and we start to believe that we really can do anything and everything." —Tamara Bower

you do here, readings in the evening, afternoons in the studios, mornings in the fields, the place itself, its beauty and shelter . . . a commitment to an ongoing community of women."
—*Kate Millett*

Women's Studio Workshop

FOUNDED Organization 1974, Residency Program 1979, Fellowship Program, 1990.

LOCATION Among marsh and woodland in the rolling Shawangunk Mountains of the Mid-Hudson river valley, 2 hours north of New York City.

CATEGORIES Visual artists in book art, paper art, photography, and printmaking.

FACILITIES Screenprinting: power washer, textile printing surface, squeegees. Papermaking: 2 custom Hollander beaters, vats, hydraulic press, stainless steel vacuum table, moulds and deckles. Darkroom: 4 enlargers, color capabilities, separate finishing room, dry mount facilities, copy camera, photostat processor. Intaglio: Charles Brand presses, viscosity rollers, separate ventilated acid room, hot plate, flexible shaft rotary tool, hand tools. Community is in the planning stages of making facilities accessible to disabled residents.

HOUSING Private rooms in shared, on-site apartment.

FOR CURRENT APPLICATION REQUIREMENTS:

P.O. Box 489
Rosendale, NY 12472

TEL
914-658-9133

FAX
914-658-9031 *(Mon.–Fri., 10 A.M.–5 P.M. only)*

E-MAIL
wsw@mhv.net

WWW
http://www.webmark.com/wsw/
wswhome.htm

MEALS Artists purchase their own food and prepare their own meals; occasional potlucks.

RESIDENT SEASON September–June.

AVERAGE LENGTH OF RESIDENCIES 3 weeks.

NUMBER OF ARTISTS IN 1995 10 (selected from 33 applicants).

AVERAGE NUMBER OF ARTISTS PRESENT AT ONE TIME 2 visiting; 6 local; 4 staff.

APPLICATION DEADLINES July 1 and November 1 for fall and spring fellowships; November 15 for Artists' Book Residency grant.

SELECTION PROCESS Committee for Fellowships; previous years' recipient for Artists' Book Grant.

APPLICATION FEE None.

SPECIAL PROGRAMS Visiting artists are invited to present their work in an informal slide lecture series.

STIPEND Artists' Book Grant recipients only: $1,800 for 6 weeks, materials up to $450.

ARTIST PAYS $200/week residency fee; travel, food, personal needs, materials.

ARTIST DUTIES None.

OTHER ACCOMMODATIONS No pets or children. Guests invited by staff only.

PUBLIC PROGRAMS None.

HISTORY Founded in 1979 as a center for contemporary art activities, based in the visual arts.

MISSION "Founded and run by women to serve as a supportive working environment for all persons interested in the arts. . . . To create professional opportunities and employment for

> *"Beyond the beautiful surrounds of the Hudson River Valley, I found the energy of this place to be inspirational."* —Joan Morris

women, to encourage women of diverse cultural backgrounds to work at the studios, and to encourage the general public's involvement with the arts."

PAST ARTISTS INCLUDE Susan Mills, Kumi Korf, Clarissa Sligh, Susan Amons, Binda Colebrook, Valerie Maynard, Mei Ling Hom, Susan E. King, Alison Knowles, Margarita Becerra-Cano, Rose Marasco, Jean Sanders.

FROM THE DIRECTOR "We are often asked about choosing to come together and work as 'women' artists. I believe that both women and men benefit from women's empowerment. We welcome men to work at WSW, to experience a space run by women." —*Laura Moriarty*

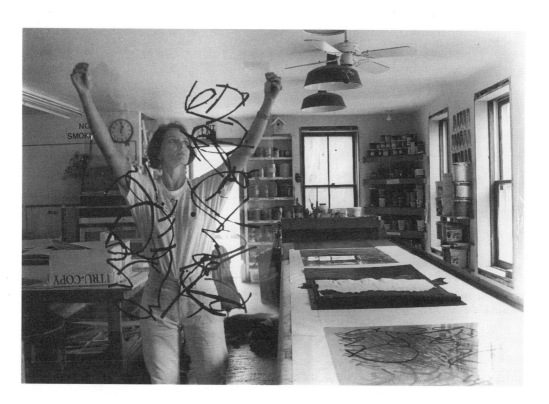

FOUNDED Organization 1902, Residency Program 1988.

LOCATION 600 acres of mountains, pines, meadows, forests, and streams.

CATEGORIES Visual artists in arts and crafts, drawing, painting, paper art, printmaking, and sculpture; fiction writers, literary nonfiction writers, playwrights, poets, and screenwriters.

FACILITIES Private studios. Community is in the planning stages of making facilities accessible to disabled residents.

HOUSING Private room at the Inn.

MEALS Artists purchase their own food and prepare their own meals.

RESIDENT SEASON June–September.

AVERAGE LENGTH OF RESIDENCIES 4 weeks.

NUMBER OF ARTISTS IN 1995 50 (selected from 200 applicants).

FOR CURRENT APPLICATION REQUIREMENTS:

34 Tucker Street
Woodstock, NY 12498

TEL
914-679-2079

FAX
914-679-4529

E-MAIL
n/a

WWW
n/a

AVERAGE NUMBER OF ARTISTS PRESENT AT ONE TIME 10–15.

APPLICATION DEADLINE April 15.

SELECTION PROCESS Outside jury of professionals in each category.

APPLICATION FEE $5.

SPECIAL PROGRAMS None.

STIPEND None.

ARTIST PAYS $400/month residency fee, travel, food, personal needs, materials.

ARTIST DUTIES None.

OTHER ACCOMMODATIONS No.

PUBLIC PROGRAMS Lectures, exhibitions, presentations, gallery, classes, workshops, theatre performances.

HISTORY Founded in 1902 by Ralph Radcliffe Whitehead, to create a utopian arts community.

MISSION "To be a broad-based, multi-arts, and environmental organization for the mid-Hudson community."

PAST ARTISTS INCLUDE Mariella Bisson, Richard Peabody, J. B. Miller, Peter McCaffrey, Sarah Burnham, Catherine Berger, Sapphire, Tom Grady.

FROM THE DIRECTOR "Byrdcliffe brings together a diverse group of people into a beautiful place in order to provide them with a creative atmosphere." —*Carolyn Harris*

"*I have been to four other art colonies besides Byrdcliffe. They all offer similar benefits: the gift of unstructured time to do one's work; a supportive community; and a beautiful setting. The most important part of being at an art colony, I believe, is that it validates the often difficult task of being an artist. . . . I found Byrdcliffe especially conducive to both getting work done and finding a community of like-minded people. There is a timeless, soothing quality in the landscape; the house is deeply comfortable. People seem to relax at Byrdcliffe, creating both friendships and art.*" —Catherine Berger

The Corporation of Yaddo

FOUNDED Organization 1900, Residency Program 1926.

LOCATION 400 acres of lakes, woodlands, and gardens in Saratoga Springs, New York, 3 hours from New York City.

CATEGORIES Visual artists in digital imaging (no facilities), drawing, fiber/textile, film/video-making, glass (no facilities), installation, mixed media, painting, photography, printmaking, and sculpture; fiction writers, journalists, literary nonfiction writers, playwrights, poets, screenwriters, and translators; choreographers, composers, film directors, and performance artists; collaborative teams, conceptual artists, environmental artists, interdisciplinary artists, multimedia artists, and new genre artists.

FACILITIES Private studio; darkroom. Housing, housing bathrooms, darkroom, and studios are wheelchair-accessible.

HOUSING Private bedrooms.

MEALS All meals provided.

FOR CURRENT APPLICATION REQUIREMENTS:

P.O. Box 395
Saratoga Springs, NY 12866

TEL
518-584-0746

FAX
518-584-1312

E-MAIL
n/a

WWW
n/a

RESIDENT SEASON Year-round.

AVERAGE LENGTH OF RESIDENCIES 4 weeks.

NUMBER OF ARTISTS IN 1995 190 (selected from 933 applicants).

AVERAGE NUMBER OF ARTISTS PRESENT AT ONE TIME 35 during summers; 15 during other seasons.

APPLICATION DEADLINES January 15 and August 1.

SELECTION PROCESS Outside panel of professionals in each category.

APPLICATION FEE $20.

SPECIAL PROGRAMS None.

STIPEND None.

ARTIST PAYS Travel, personal needs, materials; no residency fee.

ARTIST DUTIES None.

OTHER ACCOMMODATIONS None.

PUBLIC PROGRAMS None.

HISTORY Originally a farm, gristmill, and tavern operated by a Revolutionary War veteran, the Yaddo estate was eventually purchased by investment banker Spencer Trask and his wife, the poet Katrina Trask. After the deaths of their four children, the Trasks decided to make their estate a creative haven for artists, writers, and composers. The corporation of Yaddo was formed in 1900, and Yaddo welcomed its first guests in 1926.

MISSION "To support professional working artists, chosen by panels of their peers, by providing them with the space, uninterrupted time and supportive community they need to work at their best. Maintaining and enhancing a cli-

"Any creative artist comprehends the paradox of industrious leisure—the luxurious necessity—of Yaddo. The hours and months spent there have been the most important of my life." —Ned Rorem

mate of diversity within its community of artists remains one of Yaddo's primary objectives."

PAST ARTISTS INCLUDE Milton Avery, James Baldwin, Truman Capote, Aaron Copland, Patricia Highsmith, Langston Hughes, Ulysses Kay, Flannery O'Conner, Sylvia Plath, Katherine Anne Porter, Clifford Still, and William Carlos Williams.

FROM THE FOUNDERS OF YADDO "In order to insure for Yaddo a larger influence and . . . in the hope that it may continue as a practical force in the world for all time, we desire to found here a permanent Home to which shall come from time to time . . . authors, painters, sculptors, musicians and other artists both men and women, few in number but chosen for creative gifts and besides and not less for the power and the will and the purpose to make these gifts useful to the world. . . . It is such as these whom we would have enjoy the hospitality of Yaddo, their sole qualification being that they have done, are doing, or give promise of doing good and earnest work." —*Spencer and Katrina Trask, 1900*

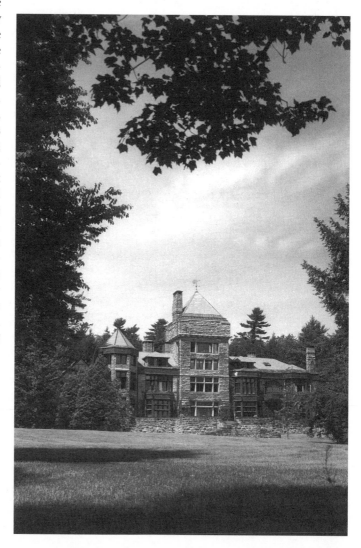

The Yard, Inc.

FOUNDED Organization 1973, Residency Program 1973.

LOCATION On the island of Martha's Vineyard.

CATEGORIES Actors, choreographers, dancers, musicians, and performance artists; collaborative teams, environmental artists, and interdisciplinary artists.

FACILITIES Theater and housing complex, rehearsal and performance space, video equipment, and critiques by The Yard's Artistic Advisor Bessie Schonberg. Studios and theater are wheelchair-accessible.

HOUSING Semi-private bedrooms in comfortable houses, full kitchen.

MEALS Artists purchase their own food and prepare their own meals.

RESIDENT SEASON April–October; spring and fall for Artist-in-School Residencies.

AVERAGE LENGTH OF RESIDENCIES 5 weeks.

NUMBER OF ARTISTS IN 1995 6 choreographers (se-

FOR CURRENT APPLICATION REQUIREMENTS:

P.O. Box 405
Chilmark, MA 02535

TEL
508-645-9662

FAX
508-645-3770

E-MAIL
n/a

WWW
n/a

lected from 75 applicants); 17 dancers (selected from 110 auditioning).

AVERAGE NUMBER OF ARTISTS PRESENT AT ONE TIME 124.

APPLICATION DEADLINE December 15.

SELECTION PROCESS Outside panel of professionals in each category, as well as The Yard's artistic director and artistic advisor, followed by interviews with final candidates.

APPLICATION FEE None.

SPECIAL PROGRAMS Artist-in-Schools Residencies, Patricia N. Nanon Residencies, Choreographers/Dancers Session, The Company Development Session.

STIPEND $200–$250 per week per resident; $100 travel allowance.

ARTIST PAYS Travel (though travel allowance of $100 provided), food, personal needs, materials (though there is some production allowance); no residency fee.

ARTIST DUTIES Performers are expected to create and develop new works by resident choreographers, adhere to daily schedule of classes, rehearse and perform, teach company and/or community dance classes, as requested by The Yard, take part in special events, and participate fully in all phases of the residency program.

OTHER ACCOMMODATIONS No pets; guests on occasion.

PUBLIC PROGRAMS Performances, Community Classes, Dance/Theatre Jr. Workshop, A Day at the Yard open house.

HISTORY Founded in 1973 by Patricia N. Nanon.

MISSION "To promote growth and experimentation in theatre arts . . . to give professional artists the time and space to create and perform

"I think of The Yard as being my artistic nurturing ground. Having spent three summers as a dancer and two as a choreographer, I can state . . . that the environment of The Yard is truly exhilarating." —David Dorfman

dance, music, theatre pieces in a concentrated, supportive environment while in residence. . . ."

PAST ARTISTS INCLUDE Martha Bowers, Ann Carlson, Carolyn Dorfman, David Dorfman, Paula Josa-Jones, Tony Kushner, Jack Moore, Danial Shapiro, Joanie Smith, Jawole Willa Jo Zollar, Doug Varone, Roxanne D'Orleans Juste.

FROM THE DIRECTOR "The Yard . . . [is] a playground without walls, a place to explore, experiment, construct, a place of possibility, joy, love, anger, frustration, a place of mutual stimulation, sharing, testing, a space in which to come together and to be alone." —*Patricia N. Nannon*

FOUNDED Organization 1975, Resident Program 1980.

LOCATION 20 acres, set amidst woodlands, meadows, and natural springs in the historic eighteenth-century village of Yellow Springs, 30 miles northwest of Philadelphia.

CATEGORIES Playwrights and screenwriters; actors, audio artists, choreographers, composers, dancers, theater directors, electronic artists, musicians, performance artists, storytellers, and radio artists; collaborative teams, conceptual artists, environmental artists, interdisciplinary artists, media artists, multimedia artists, and new genre artists.

FACILITIES Theater, outdoor performance space, audio studio, studio space, and seminar and conference space.

HOUSING 3-story masonry house on 7-acre wooded site that provides for up to 18 residents with common dining and living areas.

MEALS All meals provided.

RESIDENT SEASON May–October.

FOR CURRENT APPLICATION REQUIREMENTS:

1645 Art School Road
Chester Springs, PA 19425

TEL
610-827-9111

FAX
610-827-7093

E-MAIL
ysiglobl@libertynet.org

WWW
n/a

AVERAGE LENGTH OF RESIDENCIES For ensemble residencies, 2–3 weeks.

NUMBER OF ARTISTS IN 1994 43 (selected by curatorial invitation).

AVERAGE NUMBER OF ARTISTS PRESENT AT ONE TIME 10–20, generally two ensembles.

APPLICATION DEADLINES Most residencies arranged by invitation (varies according to program interests at Yellow Springs).

SELECTION PROCESS Outside panel of professionals in each category.

APPLICATION FEE None.

SPECIAL PROGRAMS Varies, depending on current interests at Yellow Springs.

STIPEND In the past, the range has been between $250–$3,000. A few special project commissions for new works have been provided to ensembles. All living expenses are provided, some material allowance available, and a portion of travel is paid if resident travels more than 150 miles to Yellow Springs.

ARTIST PAYS Some travel expense (see "Stipend"), personal needs, materials (see "Stipend"); no residency fee.

ARTIST DUTIES None.

OTHER ACCOMMODATIONS None.

PUBLIC PROGRAMS Presentations.

HISTORY Founded in 1975 by John Clauser.

MISSION "To investigate American culture from an interdisciplinary perspective, to define the linkages and patterns of cultural change within local, regional, and national contexts, to develop new connections among individuals, institutions, and cultures previously uncon-

nected, to facilitate the projects of artists as a way to illuminate the contemporary experience, to enable participants to make the most creative use of the resources and time available to them, and to communicate the results in ways that project useful insight onto American life."

PAST ARTISTS INCLUDE Ann Carlson, Ping Chong, Papo Colo, Guillermo Gomez-Peña, Ruth Malaczech, Pauline Oliveros, Don Pullen, Martha Rossler, Richard Schechner, Morton Subotnick, Kei Takei, Mor Thiam.

FROM THE DIRECTOR "The Yellow Springs working environment interfuses cultures, nationalities, disciplines, and generations, and it models its problem-solving undertakings on the practices of creative artists. The Institute has deep institutional experience in supporting the creative processes of professionals. Its Artist's Laboratory residencies have enabled more than 200 ensembles from all over the world to develop and present new works, to absorb experiences and impressions from a variety of sources, to come into meaningful contact with other creative individuals, cultures and value systems, to gain new techniques, vocabularies and methodologies, and to collaborate with other artists and thinkers." —*John Clauser*

Other Venues

The following is a list of programs that are very similar to the seventy artists' communities included in this directory. They include single-person residencies, fellowship grants, studio collectives, workshops, apprenticeships, and other programs that support artists' creativity.

Acadia National Park
Artist-in-Residence Program, P.O. Box 177
Bar Harbor, ME 04609
207-288-5507
Visual Artists

The Adamant Program
P.O. Box 73
Adamant, VT 05640
802-223-2324
Musicians

American Dance Festival
P.O. Box 90772
Durham, NC 27708
919-684-5459
Choreographers, Dancers

Apostle Islands National Lakeshore
Artist-in-Residence Program, Route 1, Box 4
Bayfield, WI 54814
715-779-3397
Visual Artists

Arranged Introductions
155 Wooster Street, #6F
New York, NY 10012
212-420-5965
Performing Artists, Visual Artists

The Art Studio
720 Franklin Street
Beaumont, TX 77701
409-838-5393
Visual Artists

Art Park
P.O. Box 371
Lewiston, NY 14092
716-754-9000
Visual Artists

Artists at the Yard
Hunter's Point Shipyard
San Francisco, CA 94107
415-822-0922
Visual Artists, Mixed-Media

Arts Habitat
11685 McCarthy Road
Carmel Valley, CA 93924
408-659-3060
Performing Artists, Visual Artists, Writers

AS220
115 Empire Street
Providence, RI 02903
401-831-9327
Musicians, Performing Artists, Visual Artists, Filmmakers, Writers

Badlands National Park
Artist-in-Residence Program, P.O. Box 6
Interior, SD 57750
605-433-5361
Visual Artists

Baltimore Clayworks
5706 Smith Avenue
Baltimore, MD 21209
410-578-1919
Clay Artists

Bernheim Arboretum and Research Forest
Claremont, KY 40110
502-543-2451
Visual/Environmental Artists

Brandywine Workshop
730 South Broad Street
Philadelphia, PA 19146
215-546-3675
Printmakers

Buffalo National River
Artist-in-Residence Program, P.O. Box 1173
Harrison, AR 72601
501-741-5443
Visual Artists

Byrd Hoffman Foundation, Inc./The Watermill Center
131 Varick Street, Suite 908
New York, NY 10013
tel 212-620-0220; fax 212-627-0129
Musicians, Theatre Artists, Filmmakers, Dancers, Visual Artists

Center for Photography at Woodstock
59 Tinker Street
Woodstock, NY 12498
914-679-9957
Photographers

Charlotte's Hollow Foundation for the Arts
6993 Wesleyan Church Road
Pataskala, OH 43062
614-927-3566
Musicians, Visual Artists, Photographers, Print-
makers, Writers

Chester Springs Studio
1668 Art School Road, P.O. Box 329
Chester Springs, PA 19425
610-827-2722
Visual Artists

Contemporary Crafts Association
3934 SW Corbett Avenue
Portland, OR 97201
503-223-2654
Arts and Crafts Artists

Crow's Shadow Institute
Route 1, Box 517
Pendleton, OR 97801
541-276-3954
Visual Artists, Printmakers

Dieu Donne Papermill
433 Broome Street
New York, NY 10013
212-226-0573
Papermakers

Dobie Paisano Fellowship Program
University of Texas
Austin, TX 78712
512-471-7620
Texas Writers

Experimental Television Center
109 Lower Fairfield Road
Newark Valley, NY 13811
607-687-4341
Electronic Media Artists

George Bennet Fellowship Program
Phillips Exeter Academy, 20 Main Street
Exeter, NH 03833
603-772-4311
Writers

Harvestworks
596 Broadway Suite 602
New York, NY 10012
212-431-1130
Multi-Media Artists

Henry Street Settlement
Abrons Art Center, Visual Arts Program
466 Grand Street
New York, NY 10002
212-598-0400
Visual Artists

Indiana Dunes National Lakeshore
Artist-in-Residence Program
1100 North Mincral Springs
Porter, IN 46304
812-882-1776
Visual Artists

Intersection for the Arts
446 Valencia Street
San Francisco, CA 94103
415-626-1636
Writers

Isle Royale National Park
Artist-in-Residence Program
800 East Lakeshore Drive
Houghton, MI 49931-1895
906-482-0984
Visual Artists

La Napoule Arts Foundation
21 West 68th Street, Suite 1F
New York, NY 10023
212-496-1039
Art Historians, Choreographers, Composers,
Musicians, Visual Artists, Writers

Lakeside Studio
15251 Lakeshore Road
Lakeside, MI 49116
616-469-1377
Visual Artists, Ceramicists, Jewelry Makers

Louisiana Artists' Guild
Art Council of New Orleans
225 Baronne Street, Suite 1712
New Orleans, LA 70112-1712
tel 504-523-1465; fax 504-529-2430
Glass, Ceramics, Metal, and Printmaking Artists

The Mary Ingraham Bunting Institute of Radcliffe
College
34 Concord Avenue
Cambridge, MA 02138
617-495-8212
Women—Writers, Visual Artists, Scholars

Maryland Hall for Creative Arts
801 Chase Street
Annapolis, MD 21401
410-263-5544
Visual Artists

New Arts Program
173 West Main Street, P.O. Box 82
Kuztown, PA 19530
610-683-6440
Performing Artists, Visual Artists, Writers

Nexus Contemporary Art Center
535 Means Street
Atlanta, GA 30318

404-577-3579
Visual Artists, Writers

Norcal Sanitary Fill Artists in Residence Program
401 Tunnel Avenue
San Francisco, CA 94134
415-553-2913
Visual Artists

Oak Bluffs Institute
General Delivery
Oak Bluffs, MA 02557
tel 508-693-3342; fax 508-693-2102
*In planning stages; a center dedicated to develop-
 ment of African-American culture.*

Oregon Writers Colony
P.O. Box 15200
Portland, OR 97215
503-771-0428
Writers

Palenville Interarts Colony
2 Bond Street
New York, NY 10012
212-254-4614
All Disciplines: temporarily not accepting applications

Pictured Rocks National Lakeshore
Artist-in-Residence Program, P.O. Box 40
Munising, MI 49862
906-387-2607
Visual Artists

Pratt Fine Arts Center
1902 South Main Street
Seattle, WA 98144
206-328-2200
*Visual Artists, Glass Makers, Metal Workers,
 Printmakers*

Richwood Forum for the Arts, Inc.
27 East Main Street
Richwood, WV 26261
304-846-9218
Performing Artists, Visual Artists, Writers

Rocky Mountain National Park
Artist-in-Residence Program
Estes Park, CO 80517
970-586-1399
Visual Artists

Sleeping Bear Dunes National Lakeshore
Artist-in-Residence Program, 9922 Front Street
Empire, MI 49630
616-326-5134
Visual Artists

Soapstone
622 SE 29th Avenue

Portland, OR 97214
503-236-9862
Women Writers

Stone Quarry Hill Art Park
Stone Quarry Road
Cazenovia, NY 13035
315-655-3196
Visual Artists

The Studio Museum of Harlem
144 West 125th Street
New York, NY 10027
212-864-4500
Visual Artists

The Thurber House
77 Jefferson Avenue
Columbus, OH 43215
614-464-1032
Writers

The Writers' Center at Chautauqua
P.O. Box 408
Chautauqua, NY 14722
717-872-8337
Writers

Yellowstone National Park
Artist-in-Residence Program, P.O. Box 168
Yellowstone National Park, WY 82190
307-344-2265
Visual Artists

Yosemite National Park
Artist-in-Residence Program, P.O. Box 100
Yosemite National Park, CA 95389
209-372-4946
Visual Artists

With headquarters in Berlin, Germany, Res Artis is the international equivalent to the Alliance of Artists' Communities in the United States. Many US programs (many of which are also members of the Alliance) are members of Res Artis.

The following names, adresses, and phone/fax numbers, supplied by Res Artis, represents neither a list only of artists' communities nor a list only of Res Artis members. Instead, it's a combined list of artists' communities, art agencies, and key contacts that support international artist exchanges. Every effort was made to check spellings, addresses, and phone/fax numbers, but details change and there may be some "translation" errors. If you have trouble reaching one of these programs, contact Res Artis directly at:

Res Artis
Kunstlerhaus Bethanien
Mariannenplatz 2
10997 Berlin
Germany
TEL: 30-616-90-30
FAX: 30-616-90

ARMENIA

Dilijan International Composers' Retreat
Dilijan
Armenia
TEL: 7-827-203032

AUSTRALIA

200 Gertrude Street
200 Gertrude Street
Fitzroy
Victoria 3065
Australia
TEL: 61-3-94193406
FAX: 61-3-94192519

Allegretta Art Studios and Exhibition Space
PO Box 1137
Freemantle 6160
Australia
TEL: 61-9-4308145

The Artists' Foundation of Western Australia
8 Phillimore Street
PO Box 999
Freemantle 6160
Western Australia
TEL: 61-9-4832696
FAX: 61-9-2424815

Art Gallery of New South Wales
Art Gallery Road
Domain Sydney
NSW 2000
Australia
TEL: 61-2-2251700
FAX: 61-2-2216226

Artspace
43-51 Cowper Wharf Road
Woolloomooloo 2011
New South Wales
Australia
TEL: 61-2-3681899
FAX: 61-2-3681705

Bundanon Trust
PO Box 3343
North Nowra 2541
New South Wales
Australia
TEL: 61-44-235999
FAX: 61-6-2515505

Varuna Writers' Centre
141 Cascade Street
Katoomba
New South Wales
Australia
TEL: 61-47-825674
FAX: 61-47-826220

Western Australia Project
355a Willarong Road
Caringbah NSW 2229
Australia
TEL: 61-2-5262989

AUSTRIA

Bundesministerium für Wissenschaft, Forschung und Kunst
Freyung 1
1014 Wien
Austria
TEL: 43-1-531207510
FAX: 43-1-531207620

Tiroler Landesregierung-Kulturabteilung
Sillgasse 8
6020 Innsbruck
Austria
TEL: 43-512-576377
FAX: 43-512-576377200

WUK
Wahringstrasse 59
1090 Wien
Austria
TEL: 43-1-4012135
FAX: 43-1-4084251
E-MAIL: wukpress@to.or.at

BELGIUM
Centre Frans Masereel
Zaardendijk 20
2460 Kasterlee
Belgium
TEL: 32-14-852252
FAX: 32-14-850591

BULGARIA
Akrabov
4000 Plovdiv 30 Trakia Str
Bulgaria
TEL: 359-32-449318
FAX: 359-32-448159

CANADA
Artscape
60 Atlantic Avenue Suite 111
Toronto
Ontario M6K 1X9
Canada
TEL: 416-392-1038
FAX: 416-392-1059

Atelier Silex
1095 rue Père Frédéric
Trois Rivières
Québec G9A 3S4
Canada
TEL: 819-379-0121
FAX: 819 371-2918

**The Banff Centre for the Arts Leighton Artists'
 Colony**
Box 1020
Banff
Alberta TOL OCO
Canada
TEL: 403-762-6100
FAX: 403-762-6659
E-MAIL: colinfunk@banffcentreabca

**Centre des Arts Contemporains du Québec
 à Montréal**
4247 Rue Saint-Dominique
Montréal
Québec H2W 2A9
Canada
TEL/FAX: 514-842-4300

Centre National de Sculpture Est Nord Est
333 Avenue de Gaspé-Ouest
Saint Jean Port Joli
Québec G0R 3G0
Canada
TEL: 418-598-6363
FAX: 418-598-7071

La Chambre Blanche
185 Rue Christoph Colomb Est
Québec
Québec G1K 3S6
Canada
TEL: 418-529-2715
FAX: 418-529-0048

Le Centre Delsen Wiram
782 Champagneur Bureau B
Outremont
Québec H2V 3P8
Canada
TEL: 514-277-6318

Degirmendere Project
2403 3rd Avenue NW
Calgary
Alberta T2N 0L2
Canada
TEL/FAX: 403-270-9528

Quartier Ephémère
16 Rue Prince
Montréal
Québec H3C 2M8
Canada
TEL: 514 392-1554
FAX: 514-392-0579

**Saskatchewan Writers & Artists Colonies &
 Retreats**
PO Box 3986
Regina
Saskatchewan S4P 3R9
Canada
TEL: 306-757-6310
FAX: 306-565-8554

CYPRUS
Monagri Foundation
Archangelos Michael Monastery
4746 Monagri
Limassol District
Cyprus

TEL: 357-5-434165
FAX: 357-5-434166

CZECH REPUBLIC
Academy Of Fine Arts
u Akademie 4
17000 Praha 7
Czech Republic
TEL/FAX: 42 2 373641

Jnj Gallery
Nerudova 26
118 00 Prague 1
Czech Republic
TEL: 42 2 533313

Milkwood International
Stradova 19
Ceske Budejovice 37007
Czech Republic
TEL: 42-38-54450
FAX: 42-38-7311788
E-MAIL: 101546.2703@compuserve.com

Svoboda Foundation
Masarykovo Rabrezi 250
110 00 Prague 1
Czech Republic
TEL: 42-2-291884
FAX: 42-2-2919573

DENMARK
Eca Provisional Office
c/o Danish Council of Artists
Amagertory 13
DK 1160 Copenhagen
Denmark

Gaesteatelier Hollufgaard
Hestehaven 201
5220 Odense SO
Denmark

Holufgarfyens Billedhugger Vaerkstefionie
Gaesteatelier Hollufgaard Hestehaven 201
5220 Odense SO
Denmark
TEL: 45-65-958988
FAX: 45-65-958490

The National Workshop For Arts And Crafts
Gammel Dok Pakhus
Strandade 27B Copenhagen 1401
Denmark
TEL: 45-32960510
FAX: 45-31570252

Puilasoq Sydgrönlandskulturhus
PO Box 154

3920 Qaqortoq
Greenland, Denmark

Tikon-Tranekaer Centre for Art and Nature
Ostergade 10
5900 Rudkobing
Denmark
TEL: 45-62513294

EQUADOR
Fundación Paul Rivet
Casilla 01-01-0749
Luis Cordero 9-32 Cuenca
Equador
TEL: 593-7-840099
FAX: 593-7-835655

ESTONIA
Hereditas
Vene 12-6a
Tallinn EE0001
Estonia
TEL: 372-2-448629
FAX: 372-6-313496

FINLAND
Arts Council of Finland
Myllykallionrinne 2 D 27
00200 Helsinki
Finland
FAX: 358 0 6856730

Jyväskylän Grafikkekakeskus
Hannikaisenkatu 39
40100 Jyvaskyla
Finland
TEL: 358-41-624817
FAX: 358-41-619009

Kivitalo-Villa Kivi Writers' Centre
Linnunlauluntie 10
00100 Helsinki
Finland
TEL: 358-0-445392
FAX: 358-0-492278

Nordiskt Konstcentrum
Suomenlinna Sveaborg
Suomi SF 00190 Helsinki
Finland
TEL: 358-0-668143
FAX: 358-0-668594
E-MAIL: siksi@siksippfi

Studio Foundation of Finnish Artists Suomen
 Taiteilijaseura
Yrjonkatu 11f
00120 Helsinki
Finland

TEL: 358-0-607181
FAX: 358-0-607561

FRANCE

Abbaye aux Dames
11 Place de l'Abbaye
BP 125, 17104 Saintes Cedex
France
TEL: 33-46-974830
FAX: 33-46-925856

Ancienne Laiterie
Centre Europeen de la Jeune Creation
15 rue de Hohwald
F-6700 Strasbourg
France
TEL: 33-88-751005
FAX: 33-88-755878

Angle Art Contemporain
12 rue Notre Dame
26130 St Paul Trois Cháteaux
France
TEL: 33-75-047303
FAX: 33-75-045425

Art 3
73 rue Denis Papin
26000 Valence
France
TEL: 33-75-812516
FAX: 33-75-811796

Artifex
Route de Narbonne
11430 Gruissan
France
TEL: 33-1-45881116
FAX: 33-1-45802189

Art in Provence
Institute for American Studies
27 Place de l'Université
13625 Aix-en-Provence
France

Art Transit
11-19 Boulevard Boussin
13004 Marseille
France
TEL: 33-91-854278
FAX: 33-91-851347

Association Fracaise d'Action Artistique
244 Boulevard Saint Germain
75007 Paris
France
TEL: 33-1-43-178327
FAX: 33-1-43-178282

Ateliers de Pont-Aven
Place de l'Hôtel de Ville
29930 Pont-Aven
France
TEL: 33-98-061443
FAX: 33-98-060126

Banlieues d'Europe Centre Européen de la Jeune Création
"La Laiterie"
15 rue du Hohwald
67000 Strasbourg
France
TEL: 33-88-750105
FAX: 33-88-755878

The Camargo Foundation
13260 Cassis
France
TEL: 33-42-011157
FAX: 33-42-013657

Carré Jaune-la Base
6 bis rue Vergniaud
93200 Levallois-Perret
France
TEL: 33-1-47-584958
FAX: 33-1-47-580789

Centre d'Art Contemporain d'Herblay
40 rue du Général de Gaulle
95220 Herblay
France
TEL:33-1-39-789383
FAX: 33-1-39-978660

Centre d'Art Contemprain Parc Saint Legér Mairie
58320 Pougues-les-Eaux
France
TEL: 33-86-688606
FAX: 33-86-688683

Centre International de Poésie Couvent du Refuge
1 rue des Honneurs
13002 Marseille
France
TEL: 33-91-912645
FAX: 33-91-909951

Centre National d'Écriture du Spectacles la Charteuse
BP 30
30400 Villeneuve-lez-Avignon
France
TEL: 33-90-152424
FAX: 33-90-257621

Château Beychevelle
33250 Saint Julien Beychevelle
France

TEL: 33-56-59234600
FAX: 33-56-592900

Château Fallet
87 chemin de la Nerthe
L'Estaque
13016 Marseille
France
TEL: 33-91-464565
FAX: 33-91-038161

Cité Internationale Des Arts
18 rue de l'Hôtel de Ville
75004 Paris
France
TEL: 33-1-42-787172
FAX: 33-1-42-743693

Conservatoire Du Littoral
47 avenue de Certes
BP 29
33980 Audenge
France
TEL: 33-56-269408

Cypres-Centre Interculturel de Pratiques Recherches et Échanges Transdisciplinaires
1 rue Emile-Tavan
13100 Aix-en-Provence
France
TEL: 33-42-275735
FAX: 33-42-276399

Fondation Albert Gleizes
Moly-Sabata
38550 Sablons
France
TEL: 33-74-842847

Fondation Cartier
261 boulevard Raspail
75014 Paris
France
TEL/FAX: 33-1-42185650

Fondation Claude Monet
Institut de France Academie des Beaux Arts
27620 Giverny
France
TEL: 33-32-512821
FAX: 33-32-515418

Fondation Royaumont
Abbaye de Royaumont
Asnières sur Oise
95270 Luzarches
France
TEL: 33-1-30-354018
FAX: 33-1-34-68-00-60

Fonds Régional d'Art Contemporain des Pays de la Loire
Garenne-Lemot
Gétigné
44190 Clisson
France
TEL/FAX: 33-40-039260

Friches Belle de Mai
41 rue Jobin
13003 Marseille
France
TEL: 33-91-420702
FAX: 33-91-058928

Grame
6 Quai Jean-Martin
BP 1185
69202 Lyon Cedex 01
France
TEL: 33-78-393202
FAX: 33-78-283509

Institut Claude Nicolas Ledoux
Saline Royale d'Arc-et-Senans
25610 Arc-et-Senans
France
TEL: 33-81-544500
FAX: 33-81-544501

Joseph Karolyi Foundation
18 rue du Pré aux Clercs
75007 Paris
France
TEL: 33-1-45-484448
FAX: 33-1-43-598878

L'Abattoir
52 quai Saint Cosme
71100 Chalon sur Saône
France
TEL: 33-85-480522
FAX: 33-85-9311796862

La Belle Auriole
666000 Opoule
France
TEL: 33-68-291926
FAX: 33-68-645164

La Chartreuse Centre National Dicriture de Spectacles
La Chartreuse
BP 30 F-30400 Villeneuve lez Avignon
France
TEL: 33-90-250546
FAX: 33-90-257621

Les Ateliers Fourwinds
La Julière
13930 Aureille

France
TEL/FAX: 33-90-599342

Les Ateliers les Arques
46250 Cazals
France
TEL: 33-65-228170
FAX: 33-65-228996

Pépinières Européennes pour Jeunes Artistes
6 rue de Braque
75003 Paris
France
TEL: 33-1-39-171100
FAX: 33-1-39-171109

Unesco-Aschberg Bursaries for Artists
International Fund for the Promotion of Culture
1 rue Miollis
75015 Paris
France
TEL: 33-1-45681508
FAX: 33-1-45670407
E-MAIL: yr.isar@unesco.org

Villa Arson
20 Av Stephen Liégard
06105 Nice Cedex 2
France
TEL: 33-93-844004
FAX: 33-93-844155

Villa Saint Clair
17 rue Louis Ramond
34200 Sete
France
TEL: 33-67-743707
FAX: 33-67-460626

GERMANY

Akademie Schloss Solitude
Schloss Solitude Haus 3
70197 Stuttgart
Germany
TEL: 49-711-694087
FAX: 49-711-6990770
E-MAIL: akademie@solitude.s.shuttle.de

Atelierhaus Worpswede
Auf der Heidwende 41
2862 Worpswede
Germany
TEL/FAX: 49-511323820

Barkenhoff-Stiftung Worpswede
Osterholzer Strasse 23
27711 Osterholz-Scharmbeck
Germany
TEL: 49-479116203
FAX: 49-479116358

Deutscher Akademischer Austauschdienst
Jägerstrasse 23
1080 Berlin
Germany
TEL: 49-3023120819
FAX: 49-302292512

Haus Lukas
Dorfstrasse 35
18347 Ahrenshoop
Germany
TEL: 49-38-22080633
FAX: 49-38-22080334

Künstlerbahnhof Ebernburg
Berlinerstrasse 77
55583 Bad MUnster am Stein Ebernberg
Germany
TEL: 49-67 081046
FAX: 49-67-083475

Künstlergut Prösitz
Dorfstrasse 01
04688 Prositz
Germany
TEL: 49-34385-51315
FAX: 49-34385-52447

Künstlerhaus Cismar
Schleswig-Ilolsteinisches Landesmuseum
 Aussenstelle
Kloster Cismar
Baderstrasse 40
23743 Cismar/Gromitz
Germany
TEL: 49-431-5964729
FAX: 49-431-5964835

Künstlerhaus Dortmund
Sunderweg 1
44147 Dortmund
Germany
TEL: 49-231-820304
FAX: 49-231-826847

Künstlerhaus Lauenburg: Am-Elbe
Elbstrasse 54
21481 Lauenburg am Elbe
Germany
TEL: 49-4153-590981
FAX: 49-4153-590995

Künstlerhaus Meinersen
Hauptstrasse 2
38536 Meinersen
Germany
TEL: 49-53-728915
FAX: 49-53-728980

Künstlerhaus Schloss Balmoral
Villenpromenade 11
56130 Bad Ems

Germany
TEL: 49-260394190
FAX: 49-2603941916

Künstlerhaus Bethanien
Mariannenplatz 2
10997 Berlin
Germany
TEL: 49-30-6169030
FAX: 49-30-61690330
100530.2613@compuserve.com

Künstlerhaus Schloss Wiepersdorf
Bettina von Arnim Strasse 13
14913 Wiepersdorf
Germany
TEL: 49-337466690
FAX: 49-3374669919

Künstlerhaus Schöppingen
Postfach 1140
CH-4437 Schöppingen
Germany

Künstlerhof Schreyahn Samtgemeinde Luchow
Teodor-Körnerstrasse 14
29439 Luchow
Germany
TEL: 49-58411260
FAX: 49-5841126279

Künstlerstätte Stuhr-Heiligenrode
Gemeinde Stuhr
Blockenerstrasse 6
2805 Stuhr
Germany
TEL: 49-421-56950
FAX: 49-421-5695300

Oberpfälzer Künstlerhaus
Fronberger Strasse 31
92421 Schwandorf
Germany
TEL: 49-94-319716
FAX: 49-94-3196311

Schloss Bröllin
International Theatre Research Location
17309 Brollin
Germany
TEL/FAX: 49-39-747235

Schloss Plüschow
Mecklenburgisches Kunstlerhaus
Am Park 6
23936 Pluschow
Germany
TEL/FAX:49-3841-616236

Schloss Salzau
Die Ministerin Fxr Wissenschaft
Forschung und Kultur

Postfach 1109
24100 Kiel Schleswig-Holstein
Germany

Sudhaus
Hechingenstrasse 203
72072 Tubingen
Germany
TEL: 49-7071-74696
FAX: 49-7071-760187

HUNGARY
Nagyatád Sculpture Symposium
Pf 28, Baross u.2
7501 Nagytad
Hungary
TEL/FAX: 36-82 351497

Textronic
2890 Tata
Varalja U 20
Hungary
TEL/FAX: 36-34-384000

ICELAND
Hafnarborg in Hafnarfjördur
Institute for Art and Culture
Strangata 34
220 Hafnarfjordur
Iceland
TEL: 354-5550080
FAX: 354-5654480

Internat AA
Felag Islenzkra Myndistarmann
Klappersif 2611 H
101 Reykjavik
Iceland

Nordic House
Hrinbraut
101 Reykjavik
Iceland
TEL: 35-417030

Reykjavik Municipal Gallery Artist-In-Residency
 Programme
Kjarvalstadir v/Flókagötu
101 Reydjavik
Iceland

Samband Íslenskra Myndlisarmanna
Hverfisgata 12
101 Reykjavik
Iceland

Straumur Listamidstöd Artist-In-Residency
 Programme
Hafnarfjardabaer
Stradgötu 6

220 Hafnarfjordur
Iceland

Upplýsingamidstöd Myndlistar
Hverfisgata 12
Reykjavik
Iceland

INDIA

Auroville
Prarthana - Samasti II
Auroville-605101
Tamilnadu
India
TEL: 91-413-623821
FAX: 91-413-62274
E-MAIL: avnews@auroville.org.in

International Centre for Cultural Development
Pareeksha Bhavan
TC32/1719
Anayara PO
Thiruvananthapuram
695029 Kerela
India South
TEL/FAX: 91-47-173368

Lalit Kala Akademi-Garhi Artists Village
Rabindra Bhavan
Ferozeshah Road
New Delhi 110001
India
TEL: 91-11-381435

Sanskriti Pratishthan Foundation
C-6/53 Safdarjung Development Area
New Delhi 110016
India
TEL: 91-11-6963226/6961757
FAX: 91-11-6853383

Xal Praxis Foundation
29 New Queen's Road
Bombay 400 004
India
TEL: 91-022-3630421
FAX: 91-022-3631423
(United Kingdom: 44-1714022212)

IRELAND

Ballinglen Project
Clarksfield
Ballycastle, Co. Mayo
Ireland
TEL: 353-96-43184

Cill Rialaig Project
Ballinskelligs, Co. Kerry
Ireland

TEL: 353-66-79297
FAX: 353-66-79324

Effoldstown Farm
Lusk, Co. Fingal
Ireland
TEL: 353-1-8437755
TEL: 353-1-6616728

The Fire Station Artists' Studios
9-11 Lower Buckingham Street
Dublin 1
Ireland
TEL: 353-1-8556735
FAX: 353-1-8555176

Flaxart Studios
Edenderry Mill
Crumlin Road
Belfast
Northern Ireland
TEL/FAX: 44-1232-740463

The Irish Museum Of Modern Art-Artists' Work Programme
The Royal Hospital, Kilmainham
Dublin 8
Ireland
TEL: 353-1-6718666
FAX: 353-1-6718695

The National Sculpture Factory
Albert Road
Cork
Ireland
TEL: 353-21-314353
FAX: 353-21-313247

Sirius Project
The Oly Yard Club
Cogh, Co. Cork
Ireland
TEL: 353-21-813790
FAX: 353-21-811018

Tallaght Community Arts Centre
Virginia House
Old Blessington Road
Tallaght
Dublin 8
Ireland
TEL: 353-1-4621501
FAX: 353-1-4621640

The Tyrone Guthrie Centre at Annaghmakerrig
Newbliss, Co. Monaghan
Ireland
TEL: 353-47-54003
FAX: 353-47-54380
E-MAIL: 101450.3652@compuserve.com

ISRAEL

Fondation de Jerusalem
11 Rivka Street
POB 1312 Jerusalem 91012
Israel
TEL: 972-2-751711
FAX: 972-2-734462

Mishkenot Sha'ananim
POB 8215
Jerusalem 91081
Israel
TEL: 972-2-254321
FAX: 972-2-246015

ITALY

Civitella Ranieri Center
Umbertide 06019
Italy
TEL: 39-75-9417612
FAX: 39-75-9417613
email: grappadog@aol.com
(NY: 212-226-2002)

La Loggia
Via Collina 40
50020 Montefiridolfi
Firenze
Italy
TEL: 39-055-8244458
FAX: 39-055-8244283

Projetto Civitella d'Agliano
CP 120
01023 Bolsena
Italy
Tel/ FAX: 39-761-799750

Villa Medicis: Académie de France à Rome
1 Piazza Trinita dei Monti
00187 Rome
Italy
TEL: 39-6-6761253
FAX: 39-6-6761305

JAPAN

Fumio Nanjo
Twin Building
Daikanyama B-102
30-8 Sarugakuche
Shibuya-Ku Tokyo 150
Japan
TEL: 3-3780-0491
FAX: 3-3780-0753

Sai-No-Kuni Programme
The Museum of Modern Art Saitama
3-30-1 Tokiwa Urawa City
Saitama Prefecture Ko Matsunaga
Japan

TEL: 81 48-8240111
FAX: 81-48-8240119

South & West Districts Development Divisions
Ibaraki Prefectural Government
1-5-38 Sannomaru Mito 310
Japan

Tama Life 21 Association
2nd Floor Tokyo Tachikawa Chiiki Bosal Center
3233-2 Midori-cho Tachikawa-shi Tokyo 190
Japan

KENYA

Paa Ya Paa Arts Centre
Phillda Ragland NJAU
Ridgeways off Kiambu Road
PO Box 49646
Nairobi
Kenya
TEL/FAX: 254-2-512257

KOREA

Korean Nature Artists Association - Yatoo
314-090 2F 114-11 Kyo-Dong
Kong-Ju Chungnam
Korea
TEL: 82-416-8415420
FAX: 82-416-8564336

LITHUANIA

Europos Parkas
Joneikiskiu Kaimas
Azulaukes pastas
4013 Vilnius
Lithuania
TEL: 370-2-502242
FAX: 370-2-652368

Jutempus
Kauno 5
2006 Vilnius
Lithuania
TEL: 370-2-748459
FAX: 370-2-222423

THE NETHERLANDS

Elba Foundation
Artist Residence
PO Box 488
6500 AL Nijmegan
The Netherlands
TEL: 31-0-80603984

Europees Keramisch Werkcentrum
Zuid-Willlemsvaart 215
5211 SG's-Hertogenbosch
The Netherlands

TEL: 31-0-73124500
FAX: 31-0-73124568

Gulliver-Felix Meritis Foundation
Keizersgracht 324
1016 EZ Amsterdam
The Netherlands
TEL: 31-20-6262321
FAX: 31-20-6249368
E-MAIL: felixnl@gn.apc.org
E-MAIL: gch@felix.meritis.nl

Jan Van Eyck Academie
Academieplein 1
Maastricht 6211
The Netherlands
TEL: 31-43-254285
FAX: 31-43-256474

Rijksakademie van Beeldende Kunsten
Sarphatistraat 470
1018 Amsterdam
The Netherlands
TEL: 31-20-5270300
FAX: 31-20-5270301

NORWAY
Hordaland Kunstnersentrum
Klosteret 17
5005 Bergen
Norway
TEL: 47-55-900140
FAX: 47-55-00312

Nordic Artists' Centre Dale
PB 45
6810 Dale
Norway
TEL: 47-57-736811
FAX: 47-57-736740
E-MAIL: nordisk.kunst@datasalg.no

POLAND
Centre of Polish Sculpture
Ul Topolowa 1
26-681 Oronsko
Poland
TEL/FAX: 848-21916

Galeria Wyspa Fundacya Wyspa Progress
Ul Chlebnicka 13-16
80830 Gdansk
Poland
TEL/FAX: 48-58-12816

International Baltic Arts Centre
Baltycka Galeria Sztuki
76-270 Ustka
V1 Nowotki 1A
Poland

Ujazdowski Castle
Al Ujazdowksi 6
00-401 Warsaw
Poland
TEL: 48-2-6281271
FAX: 48-2-6289550

PORTUGAL
Arco
Rua Santiago 18
P-1100 Lisboa
Portugal
TEL/FAX: 351-1-870261

Ermida do Espirito Santo
Rua Recreio dos Artistas
Apartado no 341
9704 Angra do Heroismo
Ilha Terceira Azores
Portugal
FAX: 351-95-22644

Fundação da Casa de Mateus
Casa de Mateus
5000 Vila Real
Portugal
TEL: 351-59-323121
FAX: 351-59-326553

ROMANIA
Centrul de Cultura George Enescu
Tescani - Bacau
Romania
TEL/FAX: 40-34362727

The Intermedia Foundation
c/o Academia de Arta
St G-Ral Budisteanu Nr
19 Bucuresti 707447
Romania

SAUDI ARABIA
Meftaha Plastic Art Village
King Fahd Cultural Centre
PO Box 1229 Abha
Saudi Arabia

SENEGAL
Art Horizon
Sicap Mermoz Villa 7041
BP 5439
Dakar - Fann Senegal
West Africa
TEL: 22-1251612
FAX: 22-40741

SLOVAKIA

Slovak Union of Visual Artists
Foreign Relations Department
Partizanska 21
CS-81351 Bratislava
Slovakia
TEL: 07-313759
FAX: 07-333154

Suvorovova 12
81331 Bratislava
Slovakia
TEL: 42-7-59845
FAX: 42-7-490140

SPAIN

Arteleku
Barrio de Mastutene Poligono 28 20014
Donostia Guipozcoa
Spain
TEL: 34-43-453662
FAX: 34-43-462256

Blau Vert
084640 Sant Esteve de Palautordera
Catalunya
Spain
TEL/FAX: 34-3-8482365

Centre d'Art I Natura Farrerad de Pallars
Ajuntament de Farrera
Casa de Vila
Tirvia, per Llavorsi
Llcida, Catalunya
Spain
TEL/FAX: 34-73-622106

**Escola de Ceremica I Centre d'Artesania de la
 Bisbal**
Apartat Correus 43
La Bisbal d'Emporda
Catalunya
Spain
TEL: 34-72-640794

Fundación Cultural Olivar de Castillejo
Calle Menéndez Pidal 3-B
28036 Madrid
Spain
TEL: 34-1-597161
FAX: 34-1-3590133

Fundación Tallers Josep Llorens Artigas
Cami del Reco
Gallifa
Barcelona, Catalunya
Spain
TEL/FAX: 34-3-8662434

Fundación Valparaiso
Apartado de Correos 836

04638 Mojacar Playa
Almeria
Spain

La Nau de Sabadell
Museu de Sabadell
08201 Sabadell, Catalunya
Spain
TEL: 34-43-7270104
FAX: 34-43-7275507

La Nau Universitat de Valencia
Calle Nau
46003 Valencia
Spain
TEL: 34-6-3864105
FAX: 34-6-3864620

La Rectoria Centre d'Art Contemporani
08459 Sant Pere de Vilamajor
Barcelona, Catalunya
Spain
TEL: 34-3-8450059
FAX: 34-3-8450232

Mama (Multimedia Agency Mental Art)
Calle Portal de Valldigna 14-6
Valencia 46003
Spain
TEL/FAX: 34-6-3423707
E-MAIL: carmen.senabre@uv.es

TGV
Pl Ajuntament 17
46002 Valencia
Spain
TEL: 34-6-3512336

Villanueva de Jiloca
50370 Zaragoza
Spain
TEL: 34-76-802069

SWEDEN

International Artists' Studio Prgramme/Iaspis
c/o Konstnärmämmden Box 1212
Birger Jarls Torg 5nb
11182 Stockholm
Sweden
TEL: 46-8-141490
FAX: 46-8-6130095

Konstespidemin in Gothenburg
Haraldsgaten
41314 Goteborg
Sweden
TEL: 46-31-828558
FAX: 46-31-828568
E-MAIL: konstep@tripnet.se

Millesgarden
Carl Milles Vag 2
181 34 Lidingo
Sweden
TEL: 46-8-7315060
FAX: 46-8-7670902

SWITZERLAND
Alte Kirche Boswil
Flurtrasse 22
Boswil Aargau 5623
Switzerland
TEL: 41-57-461825
FAX: 41-57-463032

Fondation Samuël Buffat
8 chemin de la Boisserette
1208 Geneva
Switzerland
TEL: 41-22-7860403
FAX: 41-37-247103

Internationale Austausch Ateliers der Region
 Basel
Christoph Merian Stiftung Basel
St Alban-Vorstadt
4002 Basel
Switzerland
TEL: 41-61-2711288
FAX: 41-61-2711271

Stiftung Binz 39
Seegartenstrasse 32
CH-8810 Horgen
Switzerland
TEL: 41-1-7257606
FAX: 41-1-7257608

TUNISIA
Centre Culturel International
Hammamet
Tunisia
TEL: 216-2-80410
FAX: 216-2-80722

TURKEY
Gümüslük Akademisi
Gümüslük Bodrum
Turkey
TEL: 90-252-943178
FAX: 90-252-3943834

Istiklal Cad 140/20
Beyoglu 80070
Istanbul
Turkey
TEL: 90-212-2939871
FAX: 90-212-2493110

UNITED KINGDOM
Acme Studios
44 Copperfield Road
Bow London E3 4RR
United Kingdom
TEL: 44-181-9816811
FAX: 44-181-9830567

Alaska Studios
61 Grange Road
London SE 1 UD
United Kingdom
TEL: 44-171-7399168

The Arvon Foundation
Lumb Bank
Heptonstall Hebden Bridge
West Yorkshire HX7 6DF
United Kingdom
TEL: 44-1422-843714

Balls Pond Studios
8b Culford Mews
Eslington London N1 4DX
United Kingdom
TEL: 44-171-9234736
FAX: 44-171-2750401

Brockhall Village
Lancashire BB6 8AY
United Kingdom
TEL: 44-1254-245650
FAX: 44-1254-245657

Cable Street Studios
Thames House
566 Cable Street
London EI 9HB
United Kingdom
TEL/FAX: 44-171-7901309

Cae Henad
Llanfachreth Dolgellan
Gwynedd LL40 2EH
United Kingdom
TEL: 44-1341-423864

Chisenhale Studios & Gallery
64-68 Chisenhale Road
London E3 5QZ
United Kingdom
TEL: 44-181-9814518
FAX: 44-181-9807169

The Dean Clough Galleries
Halifax HX3 5AX
United Kingdom
TEL: 44-1422-344555
FAX: 44-1422-341148

Delfina Studios
(Alliance of Artists' Communities member)

50 Bermondsey Street
Southwark London SEI 4UD
United Kingdom
TEL: 44-171-3576600
FAX: 44-171-3570250

Gasworks Studios
Triangle Arts Trust
155 Vauxhall Street
The Oval
London SE11 5RH
United Kingdom
TEL: 44-171-5875202
FAX: 44-171-5820159

Glasgow Sculpture Studios
85 Hanson Street
Glasgow G31 2HF
Scotland
TEL: 44-1241-5510562

International Visual Artists Exchange
Birmingham Art Trust Unit 4 Old Union Mill
17-23 Grosvenor Street
West Birmingham B16 8HW
United Kingdom
TEL: 44-121-6436040
FAX: 44-121-6437686

New Horizons Artists Bursaries
Calouste Gulbenkian Foundation
98 Portland Place
London W1N 4ET
United Kingdom
TEL: 44-171-6365313
FAX: 44-171-6373421

The Patrick Allan-Fraser of Hospitalfield Trust
Hospitalfield House
Arbroath DD11 2NH
Scotland
TEL: 44-1241-872333
FAX: 44-1241-875568

**Shave International Artists' Workshops and
 Residencies**
Shave Farm South Brewham
Nr Bruton Somerset BA10 OLG
United Kingdom
TEL/FAX: 44-1749-813258

The Small Mansion Arts Centre
Gunnersbury Park
Popes Lane
London W3 8LQ
United Kingdom

Welsh Project
Gilfachgwydd
Llangeitho
Dyfed Cymru-Wales SY25 6QJ

United Kingdom
TEL: 44-1974-821494

VENEZUELA
Fundarte
Pent-House Parque Central
Caracas 1010
Venezuela
TEL: 58-2-5774073
FAX: 58-2-5742749

Indices

Artistic Categories

Organization Name	VISUAL ARTS	Arts & Crafts	Book Artists	Ceramicists	Clay Artists/Potters	Digital Imaging	Drawing	Fiber/Textile Artists	Film/Video makers	Folk Artists	Glass Artists	Industrial Artists	Installation Artists	Jewelry Makers	Mixed Media Artists	Painters	Paper Artists	Photographers	Printmakers	Sculptors	Woodworkers
American Academy in Rome	X	X	X	X	X	X	X	X	X	X	X	X	X	X	X	X	X	X	X	X	
Anderson Ranch Arts Center	X	X	X	X	X	X	X					X	X	X	X		X	X	X	X	
Archie Bray Foundation for the Ceramic Arts	X	X	X	X								X							X		
Arrowmont School of Arts and Crafts	X		X	X	X	X	X	X		X	X	X	X		X	X	X	X	X	X	
Art Awareness, Inc.	X			X		X						X			X		X	X			
Art Farm	X		X	X		X	X	X				X	X	X	X	X	X		X	X	
ART/OMI	X	X					X	X	X	X		X	X	X	X	X	X	X	X	X	
ArtPace	X	X		X	X		X	X	X	X	X	X	X	X	X	X	X	X	X	X	
Atlantic Center for the Arts	X	X	X	X			X	X	X	X		X	X	X	X	X	X	X	X	X	
Bemis Center for Contemporary Arts	X	X	X	X			X	X	X	X	X	X	X		X	X	X	X	X	X	
Blue Mountain Center	X	X	X	X	X		X	X	X	X		X	X		X	X	X	X	X		
Capp Street Project	X											X									
The Carving Studio and Sculpture Center, Inc.	X	X	X	X	X		X	X	X	X	X	X	X		X	X	X	X	X	X	
Centrum	X	X				X	X	X	X	X	X	X	X	X	X	X	X	X	X		
Contemporary Artists Center	X			X		X	X	X					X	X		X		X	X		
Creative Glass Center of America	X									X	X										
Djerassi Resident Artists Program	X	X	X	X	X	X	X	X	X			X	X	X	X	X	X	X	X	X	
Dorland Mountain Arts Colony	X	X	X	X		X	X	X	X	X	X	X	X	X	X	X	X	X	X	X	
Dorset Colony House																					
Edward F. Albee Foundation/William Flanagan Memorial Creative Persons Center	X	X	X	X	X		X	X	X	X	X	X	X	X	X	X	X	X	X	X	
Exploratorium																					
The Fabric Workshop and Museum	X	X	X			X	X	X				X		X	X	X	X	X	X		
Fine Arts Work Center in Provincetown	X	X			X	X	X					X		X	X	X	X	X	X	X	
Friends of Weymouth, Inc.																					
The Gell Writers Center of the Finger Lakes	X	X																			
The Hambidge Center for Creative Arts/Sciences	X	X	X	X		X	X	X				X	X	X	X	X	X	X	X		

Organization																							
Headlands Center for the Arts	X	X		X	X	X	X	X	X	X	X	X	X	X	X	X	X	X		X		X	X
Hedgebrook		X		X	X	X	X	X	X	X	X	X										X	
The Institute for Contemporary Art, P.S. 1 Museum and The Clock Tower Gallery	X	X	X	X	X	X	X	X	X	X	X	X	X	X	X	X	X	X	X	X	X	X	X
Jacob's Pillow Dance Festival and School	X		X	X		X		X	X							X	X	X	X		X		
John Michael Kohler Arts Center, Arts/Industry Program	X	X	X	X	X	X	X	X	X	X	X	X	X	X	X	X	X	X	X	X	X	X	X
Kala Institute	X	X	X	X	X	X						X	X	X	X	X	X		X		X	X	X
Kalani Honua Eco-Resort, Institute for Culture and Wellness	X	X	X	X	X	X	X	X	X	X	X	X	X	X	X	X	X	X	X	X	X	X	X
Light Work Visual Studies, Inc.	X		X			X										X	X	X		X		X	
The MacDowell Colony, Inc.	X	X	X	X	X	X	X		X		X	X	X	X	X	X	X	X	X	X	X	X	X
Mary Anderson Center for the Arts	X	X	X	X	X	X	X	X	X	X	X	X	X	X	X	X	X	X	X	X	X	X	X
Mattress Factory	X			X			X		X							X	X	X			X		
Medicine Wheel Artists' Retreat	X	X	X	X	X	X	X	X	X	X	X	X	X	X	X	X	X	X	X	X	X	X	X
The Millay Colony for the Arts	X	X	X	X	X	X		X	X							X	X	X	X	X	X	X	
Montana Artists Refuge	X	X	X	X	X	X	X		X							X	X	X	X	X	X	X	
Nantucket Island School of Design and the Arts	X	X	X	X	X	X	X	X	X	X	X	X	X	X	X	X	X	X	X	X	X	X	X
National Playwrights Conference at the Eugene O'Neill Theater Center																							
Norcroft: A Writing Retreat for Women																							
Northwood University Alden B. Dow Creativity Center	X	X	X	X	X	X	X	X	X	X	X	X	X	X	X	X	X	X	X	X	X	X	X
Oregon College of Art and Craft	X	X	X	X	X	X	X	X	X	X	X	X	X	X	X	X	X	X	X	X	X	X	X
Ox-Bow	X	X	X	X	X	X	X	X	X	X	X	X	X	X	X	X	X	X	X	X	X	X	X
Penland School of Crafts	X	X	X	X	X	X	X	X	X	X	X	X	X	X	X	X	X	X	X	X	X	X	X
Pilchuck Glass School	X			X					X	X						X	X	X	X	X	X		X
Ragdale Foundation	X	X		X	X	X	X	X	X	X		X	X	X	X	X	X	X		X	X	X	
Roswell Artist-in-Residence Program	X		X	X	X	X	X	X	X	X	X	X	X	X	X	X	X	X	X	X	X	X	X

Artistic Categories

Organization Name	VISUAL ARTS	Arts & Crafts	Book Artists	Ceramicists	Clay Artists/Potters	Digital Imaging	Drawing	Fiber/Textile Artists	Film/Videomakers	Folk Artists	Glass Artists	Industrial Artists	Installation Artists	Jewelry Makers	Mixed Media Artists	Painters	Paper Artists	Photographers	Printmakers	Sculptors	Woodworkers
Sculpture Space, Inc.	X																				
Shenandoah International Playwrights Retreat																					
Sitka Center for Art and Ecology	X	X	X	X		X	X	X	X			X	X	X	X	X	X	X	X	X	X
Skowhegan	X					X	X	X				X		X	X		X		X		
South Florida Art Center	X	X	X	X	X	X	X	X	X	X		X	X	X	X	X	X	X	X	X	
STUDIO for Creative Inquiry	X				X			X				X			X		X		X		
Studios Midwest	X	X				X	X		X			X		X	X	X	X		X	X	
Sundance Institute	X							X													
Ucross Foundation Residency Program	X	X			X		X	X	X			X	X	X	X	X	X	X	X	X	X
Vermont Studio Center	X					X	X								X	X	X	X	X		
Villa Montalvo	X	X				X	X					X		X	X	X	X	X	X		
The Virginia Center for the Creative Arts	X	X			X	X	X	X	X			X		X	X	X	X	X	X	X	
Walker Woods	X	X	X								X										
Watershed Center for the Ceramic Arts	X	X	X	X		X	X		X			X		X	X	X	X	X	X	X	
The Women's Art Colony Farm	X	X	X			X	X	X						X	X	X	X	X	X	X	
Women's Studio Workshop	X	X													X	X	X	X	X		
The Woodstock Guild's Byrdcliffe Arts Colony	X					X								X	X	X		X	X		
The Corporation of Yaddo	X	X			X	X	X	X		X		X		X	X		X	X	X	X	
The Yard, Inc.																					
Yellow Springs Institute																					

Artistic Categories

Organization Name	WRITING	Fiction Writers	Journalists	Literary/Nonfiction Writers	Playwrights	Poets	Screenwriters	Translators	MUSIC/DANCE/PERFORM...	Actors	Audio Artists	Choreographers	Composers	Dancers	Directors (Film)	Directors (Theatre)	Electronic Artists	Musicians	Performance Artists	Storytellers	Radio Artists
American Academy in Rome	X	X	X	X	X			X	X			X						X			
Anderson Ranch Arts Center																					
Archie Bray Foundation for the Ceramic Arts																					
Arrowmont School of Arts and Crafts															X						
Art Awareness, Inc.	X			X				X	X		X	X			X			X			
Art Farm										X											
ART/OMI	X	X	X	X	X	X	X	X	X	X	X	X	X	X	X	X	X	X	X		
ArtPace								X		X											
Atlantic Center for the Arts	X	X	X	X	X	X	X	X	X	X	X	X	X	X	X	X	X	X	X	X	
Bemis Center for Contemporary Arts	X							X						X	X		X	X			
Blue Mountain Center	X	X	X	X	X	X	X	X	X	X	X	X	X	X	X			X	X		
Capp Street Project																					
The Carving Studio and Sculpture Center, Inc.																					
Centrum	X	X	X	X	X	X	X	X	X	X	X	X	X		X	X	X	X	X	X	
Contemporary Artists Center	X	X						X										X	X		
Creative Glass Center of America																					
Djerassi Resident Artists Program	X	X	X	X	X	X	X	X	X	X	X	X	X			X	X	X	X		
Dorland Mountain Arts Colony	X	X	X	X	X	X	X	X	X	X	X	X	X		X	X	X	X	X		
Dorset Colony House	X	X	X	X	X	X	X	X													
Edward F. Albee Foundation/William Flanagan Memorial Creative Persons Center	X	X	X	X	X	X	X	X	X	X	X	X	X	X	X	X	X	X	X	X	
Exploratorium								X	X		X										
The Fabric Workshop and Museum								X													
Fine Arts Work Center in Provincetown	X	X		X	X	X	X											X			
Friends of Weymouth, Inc.	X	X	X	X	X	X	X											X			

195

Artistic Categories

Organization Name	WRITING	Fiction Writers	Journalists	Literary/ Nonfiction Writers	Playwrights	Poets	Screenwriters	Translators	MUSIC/DANCE/ PERFORMANCE	Actors	Audio Artists	Choreographers	Composers	Dancers	Directors (Film)	Directors (Theatre)	Electronic Artists	Musicians	Performance Artists	Storytellers	Radio Artists
The Gell Writers Center of the Finger Lakes	X	X	X	X	X	X	X	X			X							X	X		
The Hambidge Center for Creative Arts and Sciences	X	X	X	X	X	X	X	X			X	X	X	X			X	X	X		
Headlands Center for the Arts	X	X	X	X	X	X	X	X	X	X	X	X	X	X	X	X	X	X	X	X	
Hedgebrook	X	X	X	X	X	X	X	X													
The Institute for Contemporary Art, P.S. 1 Museum and The Clock Tower Gallery								X										X			
Jacob's Pillow Dance Festival and School								X	X		X	X	X	X			X	X			
John Michael Kohler Arts Center, Arts/Industry Program																					
Kala Institute																					
Kalani Honua Eco-Resort, Institute for Culture and Wellness	X	X	X	X	X	X	X	X	X	X	X	X	X	X	X	X	X	X	X	X	
Light Work Visual Studies, Inc.	X	X	X	X	X	X	X	X		X	X	X	X	X	X	X	X	X	X		
The MacDowell Colony, Inc.	X	X	X	X	X	X	X	X	X	X	X	X	X	X	X	X	X	X	X	X	
Mary Anderson Center for the Arts	X	X	X	X	X	X	X	X	X		X	X	X	X	X		X	X	X		
Mattress Factory				X				X	X	X								X	X		
Medicine Wheel Artists' Retreat	X	X	X	X	X	X	X	X	X	X	X	X	X	X	X	X	X	X	X	X	
The Millay Colony for the Arts	X	X	X	X	X	X	X	X	X		X	X	X	X	X		X	X	X		
Montana Artists Refuge	X	X	X	X	X	X	X	X	X	X	X	X	X	X	X	X	X	X	X	X	
Nantucket Island School of Design and the Arts	X	X	X	X	X	X	X	X	X	X	X	X	X	X	X	X	X	X	X	X	
National Playwrights Conference at the Eugene O'Neill Theater Center	X			X	X	X															
Norcroft: A Writing Retreat for Women	X	X	X	X	X	X	X														
Northwood University Alden B. Dow Creativity Center	X	X	X	X	X	X	X	X	X	X	X	X	X	X	X	X	X	X	X	X	
Oregon College of Art and Craft																					

Organization																				
Ox-Bow	X	X										X				X				
Penland School of Crafts								X												
Pilchuck Glass School																				
Ragdale Foundation	X	X	X	X	X	X	X	X	X	X	X	X	X	X	X	X	X	X	X	
Roswell Artist-in-Residence Program														X					X	
Sculpture Space, Inc.																				
Shenandoah International Playwrights Retreat	X	X	X	X	X		X	X		X	X		X	X	X	X	X	X	X	
Sitka Center for Art and Ecology	X	X	X	X	X	X	X	X	X	X	X	X	X	X	X	X	X	X	X	X
Skowhegan				X	X			X							X					
South Florida Art Center																				
STUDIO for Creative Inquiry	X	X	X	X	X	X	X	X	X	X	X	X	X	X	X	X	X	X	X	
Studios Midwest																				
Sundance Institute	X			X	X	X														
Ucross Foundation Residency Program	X	X	X	X	X	X	X	X	X	X	X	X	X	X	X	X	X	X	X	
Vermont Studio Center	X	X	X	X	X	X														
Villa Montalvo	X	X	X	X	X	X	X	X	X	X	X	X	X	X	X	X	X			
The Virginia Center for the Creative Arts	X	X	X	X	X	X	X	X	X		X	X	X	X		X				
Walker Woods	X	X	X	X	X	X	X	X	X							X	X	X	X	X
Watershed Center for the Ceramic Arts																				
The Women's Art Colony Farm	X	X	X	X	X	X	X	X	X	X	X	X		X		X	X			
Women's Studio Workshop																				
The Woodstock Guild's Byrdcliffe Arts Colony	X	X	X	X	X	X	X	X	X	X	X	X	X		X		X		X	
The Corporation of Yaddo	X	X	X	X	X	X	X	X	X	X	X	X	X				X	X	X	X
The Yard, Inc.								X	X		X	X	X	X		X	X			
Yellow Springs Institute	X		X	X	X	X	X	X	X	X	X	X	X	X	X	X	X	X	X	X

197

Artistic Categories

Organization Name	ARCHITECTURE & DESIGN	Architects	Clothing Designers	Graphic Designers	Industrial Designers	Landscape Architects	Set Designers	Urban Designers	SCHOLARSHIP	Art Conservators	Art Educators	Art Historians	Art Professionals	Computer Scientists	Critics	Environmentalists/Naturalists	General Scholarship	Historians	Historic Preservationists	Linguists	Mathematicians	Scientists
American Academy in Rome	X	X		X	X	X	X	X	X	X	X						X	X				
Anderson Ranch Arts Center								X								X						
Archie Bray Foundation for the Ceramic Arts																						
Arrowmont School of Arts and Crafts								X	X	X		X										
Art Awareness, Inc.	X	X																				
Art Farm																						
ART/OMI								X						X								
ArtPace						X		X			X			X								
Atlantic Center for the Arts	X	X		X	X	X	X	X	X	X	X											
Bemis Center for Contemporary Arts																						
Blue Mountain Center																						
Capp Street Project																						
The Carving Studio and Sculpture Center, Inc.																						
Centrum	X	X		X	X	X	X	X	X	X	X	X	X	X	X	X	X	X	X	X	X	
Contemporary Artists Center																						
Creative Glass Center of America					X																	
Djerassi Resident Artists Program	X	X																				
Dorland Mountain Arts Colony	X	X																				
Dorset Colony House																						
Edward F. Albee Foundation/William Flanagan Memorial Creative Persons Center	X	X				X			X	X	X	X		X			X	X	X			
Exploratorium									X	X												
The Fabric Workshop and Museum	X	X	X	X				X	X	X	X											
Fine Arts Work Center in Provincetown	X	X		X					X	X												

Organization																									
Friends of Weymouth, Inc.																									
The Gell Writers Center of the Finger Lakes			X														X	X		X					
The Hambidge Center for Creative Arts and Sciences	X		X						X								X	X		X					X
Headlands Center for the Arts	X		X	X			X	X	X	X	X	X		X	X	X	X	X	X	X	X	X	X	X	X
Hedgebrook																									
The Institute for Contemporary Art, P.S. 1 Museum and The Clock Tower Gallery																									
Jacob's Pillow Dance Festival and School					X	X	X		X					X	X	X	X	X		X	X				
John Michael Kohler Arts Center, Arts/Industry Program	X	X	X	X	X	X	X		X									X							
Kala Institute																									
Kalani Honua Eco-Resort, Institute for Culture and Wellness	X	X	X	X	X	X	X	X	X	X	X	X	X	X	X	X	X	X	X	X	X	X	X	X	X
Light Work Visual Studies, Inc.	X		X	X	X	X	X	X	X		X	X	X			X									
The MacDowell Colony, Inc.	X	X	X	X	X	X			X																
Mary Anderson Center for the Arts	X	X	X	X	X	X	X	X	X	X	X	X	X	X	X	X	X	X	X	X	X	X	X	X	X
Mattress Factory	X		X	X	X																				
Medicine Wheel Artists' Retreat	X	X	X	X	X	X	X	X	X	X	X	X	X	X	X	X	X	X	X	X	X	X	X	X	X
The Millay Colony for the Arts													X												
Montana Artists Refuge	X	X	X	X	X	X	X	X	X																
Nantucket Island School of Design and the Arts	X	X	X	X	X	X	X	X	X	X	X	X	X	X	X	X	X	X	X	X	X	X	X	X	X
National Playwrights Conference at the Eugene O'Neill Theater Center																									
Norcroft: A Writing Retreat for Women																									
Northwood University Alden B. Dow Creativity Center	X	X	X	X	X	X	X	X	X	X	X	X	X	X	X	X	X	X	X	X	X	X	X	X	X
Oregon College of Art and Craft																									
Ox-Bow																									

199

Artistic Categories

Organization Name	ARCHITECTURE & DESIGN	Architects	Clothing Designers	Graphic Designers	Industrial Designers	Landscape Architects	Set Designers	Urban Designers	SCHOLARSHIP	Art Conservators	Art Educators	Art Historians	Art Professionals	Computer Scientists	Critics	Environmentalists/Naturalists	General Scholarship	Historians	Historic Preservationists	Linguists	Mathematicians	Scientists
Penland School of Crafts	X																					
Pilchuck Glass School			X																			
Ragdale Foundation	X																					
Roswell Artist-in-Residence Program																						
Sculpture Space, Inc.																						
Shenandoah Int'l. Playwrights Retreat	X					X																
Sitka Center for Art and Ecology	X	X	X	X	X	X	X	X	X	X	X	X	X	X	X						X	
Skowhegan																						
South Florida Art Center																						
STUDIO for Creative Inquiry	X	X	X	X	X	X	X	X	X	X	X	X	X	X	X		X	X	X	X	X	
Studios Midwest																						
Sundance Institute																						
Ucross Foundation Residency Program	X	X	X	X	X	X	X	X	X	X	X	X	X	X	X	X	X	X	X	X	X	
Vermont Studio Center																						
Villa Montalvo	X					X	X	X							X							
The Virginia Center for the Creative Arts																						
Walker Woods	X				X			X						X								
Watershed Center for the Ceramic Arts	X	X			X	X		X								X						
The Women's Art Colony Farm									X	X	X	X	X	X		X						
Women's Studio Workshop																						
The Woodstock Guild's Byrdcliffe Arts Colony																						
The Corporation of Yaddo																						
The Yard, Inc.																						
Yellow Springs Institute																						

Organization Name	OTHER/UNCLASSIFIABLE	Collaborative Teams	Conceptual Artists	Environmental Artists	Interdisciplinary Artists	Media Artists	Multimedia Artists	New Genre Artists	OTHER
American Academy in Rome	X	X	X	X	X	X	X		Writers by nomination only.
Anderson Ranch Arts Center	X			X			X		
Archie Bray Foundation for the Ceramic Arts									Installation artists only if project relates to clay.
Arrowmont School of Arts and Crafts	X		X	X		X			Stained glass only, no hot glass.
Art Awareness, Inc.	X	X	X				X		
Art Farm	X		X			X			
ART/OMI	X	X	X	X			X		No equipment for film/video. Limited equipment for photographers and printmakers.
ArtPace	X	X	X	X	X	X	X		
Atlantic Center for the Arts	X	X	X	X	X	X	X		Production designers, furniture designers, graphic artists.
Bemis Center for Contemporary Arts	X	X	X	X		X	X		
Blue Mountain Center	X	X		X	X	X			
Capp Street Project	X	X	X	X	X	X	X		
The Carving Studio and Sculpture Center, Inc.									Open to all genres, but artists responsible for providing own equipment.
Centrum	X	X		X	X	X	X		
Contemporary Artists Center	X	X		X					
Creative Glass Center of America									
Djerassi Resident Artists Program	X	X	X	X		X	X		
Dorland Mountain Arts Colony	X	X		X	X				Collaborating artists must apply individually. Dorland has no electricity; kerosene lamps and propane power only.
Dorset Colony House	X	X				X			
Edward F. Albee Foundation/William Flanagan Memorial Creative Persons Center	X		X	X		X	X		Provide studio space and silence. Artists must provide own equipment.
Exploratorium	X		X	X	X	X	X		Artists working at the intersection between art and science. Also, phenomena-based artists.
The Fabric Workshop and Museum	X	X			X	X			Textile designers.
Fine Arts Work Center in Provincetown	X	X	X				X		

Artistic Categories

Organization Name	OTHER/UNCLASSIFIABLE	Collaborative Teams	Conceptual Artists	Environmental Artists	Interdisciplinary Artists	Media Artists	Multimedia Artists	New Genre Artists	OTHER
Friends of Weymouth, Inc.	X								
The Gell Writers Center of the Finger Lakes	X			X					
The Hambidge Center for Creative Arts and Sciences	X	X	X	X	X		X		Electronic artists must provide own equipment.
Headlands Center for the Arts	X	X	X	X	X	X	X		
Hedgebrook						X	X		Open only to woman writers.
The Institute for Contemporary Art, P.S. 1 Museum and The Clock Tower Gallery	X	X	X	X	X	X	X		
Jacob's Pillow Dance Festival and School	X			X					
John Michael Kohler Arts Center, Arts/Industry Program	X	X	X	X			X		Projects in clay, cast iron, brass, metal. Program especially geared toward those who wish to work in a foundry.
Kala Institute	X					X	X		Traditional printmaking combined with electronic media (interactive CD-ROMs, 2D and 3D animation, digital video and sound). Painters may come if they are working on monoprints.
Kalani Honua Eco-Resort, Institute for Culture and Wellness	X	X	X	X	X	X	X		All genres welcome, but artist must provide own equipment.
Light Work Visual Studies, Inc.	X	X				X	X		Must bring own equipment for digital imaging.
The MacDowell Colony, Inc.	X	X	X	X	X	X	X		
Mary Anderson Center for the Arts	X	X	X	X	X	X	X		Encourages collaborative teams. Accepts but have no special facilities for dancers or glass artists.
Mattress Factory	X	X		X	X				
Medicine Wheel Artists' Retreat	X	X	X	X	X	X	X		Open to all genres, but artists must provide own equipment.
The Millay Colony for the Arts	X	X	X	X			X		
Montana Artists Refuge	X	X	X	X		X	X		
Nantucket Island School of Design and the Arts	X	X	X	X	X	X	X		Special residency program for interdisciplinary artists, AIR - Artists Interdisciplinary Residency. Film/video, woodworking, electronic and multimedia would require artist to provide own equipment.
National Playwrights Conference at the Eugene O'Neill Theater Center						X	X		
Norcroft: A Writing Retreat for Women	X					X			Any woman doing creative writing that would be described as feminist can apply.
Northwood University Alden B. Dow Creativity Center	X	X	X	X	X	X	X		Open to all genres, but artists responsible for providing own equipment.

Program	Notes
Oregon College of Art and Craft	Metal workers.
Ox-Bow	Papermakers.
Penland School of Crafts	Metal, iron, wood.
Pilchuck Glass School	
Ragdale Foundation	
Roswell Artist-in-Residence Program	Accept applications from all studio based, visual art except performance artists and production crafts.
Sculpture Space, Inc.	
Shenandoah International Playwrights Retreat	
Sitka Center for Art and Ecology	Computer science only if nature or arts related.
Skowhegan	Film/video is minimal.
South Florida Art Center	
STUDIO for Creative Inquiry	Biologists.
Studios Midwest	
Sundance Institute	
Ucross Foundation Residency Program	Have no equipment for jewelry and digital imaging; artist must provide own equipment.
Vermont Studio Center	
Villa Montalvo	Directors and set designers in collaboration with theater company.
The Virginia Center for the Creative Arts	Fiber/textile artists only if it is one of a kind, non-production kind of work. Woodworkers, but not furniture makers.
Walker Woods	Biographers and landscape architects can apply for work scholarship.
Watershed Center for the Ceramic Arts	
The Women's Art Colony Farm	
Women's Studio Workshop	
The Woodstock Guild's Byrdcliffe Arts Colony	
The Corporation of Yaddo	No special facilities for digital imaging or glass artists.
The Yard, Inc.	
Yellow Springs Institute	

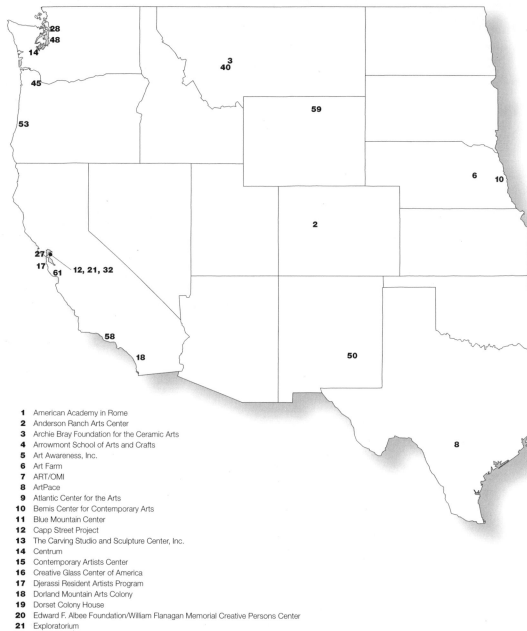

40 Montana Artists Refuge
41 Nantucket Island School of Design and the Arts
42 National Playwrights Conference at the Eugene O'Neill
 Theater Center
43 Norcroft: A Writing Retreat for Women
44 Northwood University Alden B. Dow Creativity Center
45 Oregon College of Art and Craft
46 Ox-Bow
47 Penland School of Crafts
48 Pilchuck Glass School
49 Ragdale Foundation
50 Roswell Artist-in-Residence Program
51 Sculpture Space, Inc.
52 Shenandoah International Playwrights Retreat
53 Sitka Center for Art and Ecology
54 Skowhegan
55 South Florida Art Center
56 STUDIO for Creative Inquiry
57 Studios Midwest
58 Sundance Institute
59 Ucross Foundation Residency Program
60 Vermont Studio Center
61 Villa Montalvo
62 The Virginia Center for the Creative Arts
63 Walker Woods
64 Watershed Center for the Ceramic Arts
65 The Women's Art Colony Farm
66 Women's Studio Workshop
67 The Woodstock Guild's Byrdcliffe Arts Colony
68 The Corporation of Yaddo
69 The Yard, Inc.
70 Yellow Springs Institute

Regions

Northeast

Midwest

New England

Southeast

Southwest

West (Mountain)

West (Pacific)

Seasons and Deadlines

Organization Name	Summer	Fall	Winter	Spring	Application Deadlines
American Academy in Rome	X	X	X	X	Nov. 15
Anderson Ranch Arts Center		X	X	X	Mar. 15
Archie Bray Foundation for the Ceramic Arts	X	X	X	X	Mar. 1
Arrowmont School of Arts and Crafts	X	X	X	X	Apr. 30
Art Awareness, Inc.	X				May 30; Oct. 30 for the following year
Art Farm	X	X		X	Apr. 1 for summer; 2 months prior to residency the rest of the season
ART/OMI	X	X	X	X	Visual artists, Mar. 1; writers, ongoing
ArtPace	X	X	X	X	By nomination only, every 2 years (dates vary)
Atlantic Center for the Arts	X	X	X	X	Varies, approximately 3 months prior to start of residency
Bemis Center for Contemporary Arts	X	X	X	X	Sep. 30
Blue Mountain Center	X	X			Feb. 1
Capp Street Project	X	X	X	X	Varies, call for info
The Carving Studio and Sculpture Center, Inc.	X	X	X	X	None
Centrum		X	X	X	Oct. 1
Contemporary Artists Center	X	X	X	X	Applications accepted all year, until slots are filled; Residency Grants for summer residency, Mar. 30
Creative Glass Center of America	X	X	X	X	Late spring
Djerassi Resident Artists Program	X	X		X	Feb. 15
Dorland Mountain Arts Colony	X	X	X	X	Mar. 1; Sep. 1
Dorset Colony House	X	X		X	Ongoing
Edward F. Albee Foundation/William Flanagan Memorial Creative Persons Center	X	X			Apr. 1
Exploratorium	X	X		X	None
The Fabric Workshop and Museum	X	X	X		By invitation only
Fine Arts Work Center in Provincetown		X	X	X	Feb. 1 (postmark)
Friends of Weymouth, Inc.	X	X	X	X	None
The Gell Writers Center of the Finger Lakes	X	X	X	X	Ongoing

Seasons and Deadlines

Organization Name	Summer	Fall	Winter	Spring	Application Deadlines
The Hambidge Center for Creative Arts and Sciences	X	X	X	X	Jan. 31; Aug. 31
Headlands Center for the Arts	X	X	X	X	Early June for California, North Carolina, and Ohio programs (only artists from these states are eligible to apply for residency program); International program deadlines vary for artists from Sweden, Taiwan, the Czech Republic, Mexico, and Canada
Hedgebrook	X	X	X	X	Oct. 1; Apr. 1
The Institute for Contemporary Art, P.S. 1 Museum and The Clocktower Gallery	X	X	X	X	Apr. 15
Jacob's Pillow Dance Festival and School	X	X	X		None
John Michael Kohler Arts Center, Arts/Industry Program	X	X	X	X	Aug. 1
Kala Institute	X	X	X	X	Apr. 26 for fellowship applications; others ongoing
Kalani Honua Eco-Resort, Institute for Culture and Wellness	X	X	X	X	Ongoing
Light Work Visual Studies, Inc.	X	X	X	X	Ongoing
The MacDowell Colony, Inc.	X	X	X	X	Jan. 15 for May–Aug.; Apr. 15 for Sep.–Dec.; Sep. 15 for Jan.–Apr.
Mary Anderson Center for the Arts	X	X	X	X	None, except for specific fellowships
Mattress Factory	X	X	X	X	None
Medicine Wheel Artists' Retreat	X	X	X	X	Ongoing
The Millay Colony for the Arts	X	X	X	X	Feb. 1 for Jun.–Sep.; May 1 for Oct.–Jan.; Sep. 1 for Feb.–May
Montana Artists Refuge	X	X	X	X	Ongoing
Nantucket Island School of Design and the Arts		X		X	Ongoing
National Playwrights Conference at the Eugene O'Neill Theater Center	X				Dec. 1
Norcroft: A Writing Retreat for Women	X	X		X	Oct. 1
Northwood University Alden B. Dow Creativity Center	X				Dec. 31
Oregon College of Art and Craft	X	X	X	X	Emerging artists Apr. 15; Midcareer artists Dec. 1
Ox-Bow	X		X		May 15
Penland School of Crafts	X	X	X	X	Oct. 28

Organization					Deadline
Pilchuck Glass School	X	X			Mar. 1
Ragdale Foundation	X	X	X	X	Jan. 15; Jun. 1
Roswell Artist-in-Residence Program	X	X	X	X	Varies
Sculpture Space, Inc.	X	X	X	X	Dec. 15 for funded residencies; ongoing for unfunded residencies
Shenandoah International Playwrights Retreat	X	X	X		Feb. 1
Sitka Center for Art and Ecology	X	X	X	X	Jun. 20
Skowhegan	X	X			Feb. 9
South Florida Art Center	X	X	X	X	Ongoing
STUDIO for Creative Inquiry	X	X	X	X	None
Studios Midwest	X	X			Last Monday in Feb.
Sundance Institute	X	X	X		Jun. 28 for Jan.; Nov. 15 for Jun.
Ucross Foundation Residency Program	X	X	X	X	Mar. 1; Oct. 1
Vermont Studio Center	X	X	X	X	Ongoing, Full-Fellowship; Oct. 15 for writers; Mar. 31, Jul. 31, Oct. 31 for others
Villa Montalvo	X	X	X	X	Mar. 1; Sep. 1
The Virginia Center for the Creative Arts	X	X	X	X	Jan. 15; May 15; Sep. 15
Walker Woods	X	X	X	X	Jan. 15; Mar. 1; Jun. 1; Aug. 1
Watershed Center for the Ceramic Arts	X	X	X	X	Apr. 15 for funded residencies; proposals for Artists Invite Artists accepted Sep.–Nov.; ongoing for others
The Women's Art Colony Farm	X	X			Ongoing
Women's Studio Workshop	X	X	X	X	Jul. 1 and Nov. 1 for fall and spring fellowships; Nov. 15 for Artists' Book Residency Grant
The Woodstock Guild's Byrdcliffe Arts Colony	X	X			Apr. 15
The Corporation of Yaddo	X	X	X	X	Jan. 15; Aug. 1
The Yard, Inc.	X	X		X	Dec. 15
Yellow Springs Institute	X	X	X	X	By invitation

Fees and Stipends

Organization Name	Application Fee	Residency Fee Amount	Artist's Expenses	Meals	Stipend
American Academy in Rome	$40	None	Travel, food, personal needs, materials	Two meals per day, except Sunday and holidays	$5,800–$8,900, depending on length of term
Anderson Ranch Arts Center	$10	None	Travel, food, personal needs, some materials	Five dinners and five continental breakfasts provided per week. Artists make all their other meals.	Modest materials stipend
Archie Bray Foundation for the Ceramic Arts	$20	$150/month	Travel, food, rent, personal needs, materials	Artists purchase their own food and prepare their own meals	None
Arrowmont School of Arts and Crafts	$10	$175/month for house, studio, and utilities	Travel, meals, personal needs, materials	Provided at half-price when school is operating with kitchen use. For all other meals, artists purchase their own food and prepare own meals.	None, though some scholarships available
Art Awareness, Inc.	None	None	Travel, food, personal needs, materials	Artists purchase own food and prepare their own meals	None
Art Farm	None	None	Travel, food, personal needs, materials (though some—wood, clay, scrap metal—available)	Artists purchase own food and prepare own meals, and vegetable garden grown for residents' use	None
ART/OMI	None	None	Travel, materials, personal needs	All meals provided	None
ArtPace	None	None	The Foundation provides travel and materials	Artists responsible for own groceries and meals, but they are provided with a living stipend of $1500/mo.	$1,500 per month
Atlantic Center for the Arts	None	$100/week, additional housing fee $25/night (optional)	Travel, food, and personal needs	Artists purchase own food and prepare own meals	None, though scholarships are available
Bemis Center for Contemporary Arts	$25	None	Travel, food, personal needs, materials	Artists purchase own food and prepare own meals	$500 per month
Blue Mountain Center	$20	None	Travel, personal needs, materials	All meals provided	None
Capp Street Project	None	None	Food, personal needs	Artists purchase own food and prepare own meals	$4,000, plus $8,000 for materials

Organization	Application Fee	Residency Fee	Costs to Artist	Food	Stipend/Awards
The Carving Studio and Sculpture Center, Inc.	None	None	Travel (sometimes funded), food, personal needs, materials (though extensive tools available and stone access)	Artists purchase own food and prepare own meals	None
Centrum	$10	None	Travel, food, personal needs, materials ($100 fee for printmakers selected for stipend)	Artists purchase own food and prepare own meals	$300 available to approximately 15 artists each year
Contemporary Artists Center	Regular applications None, Residency grant applications $10	Varies	Travel, food, personal needs, materials (some scholarships available)	Lunch and dinner included in the summer; in fall and spring artists purchase own food and prepare own meals.	None
Creative Glass Center of America	None	None	Travel, food, personal needs	Artists purchase own food and prepare own meals	$1,500
Djerassi Resident Artists Program	$25	None	Travel, personal needs, materials, supplies	All meals provided	Gerald Oshita Memorial Fellowship of $2500 for composer of color. Other awards on occasion
Dorland Mountain Arts Colony	None, $50 processing fee upon acceptance	$300/month	Travel, food, shipment of materials, personal needs, materials	Artists purchase own food and prepare own meals; transportation for groceries provided	Varies
Dorset Colony House	None	$95/week	Travel, food, personal needs, materials, $95 per week voluntary fee	Artists purchase own food and prepare own meals	None
Edward F. Albee Foundation/William Flanagan Memorial Creative Persons Center	None	None	Travel, food, personal needs, materials	Artists purchase own food and prepare own meals	None
Exploratorium	None	None	Food, personal needs	Artists purchase own food and prepare own meals, but they are given a per diem if they are from out of town	None, except for negotiated payment for commissioned work, plus travel, meals, and materials
The Fabric Workshop and Museum	None	None	Travel, food, personal needs, materials	Artists purchase own food and prepare own meals	None
Fine Arts Work Center in Provincetown	$35	None, summer workshops fee-based	Travel, food, personal needs, materials, meals	Artists purchase own food and prepare own meals	$375/month. (Visual artists, additional $75/month for supplies.)

Fees and Stipends

Organization Name	Application Fee	Residency Fee Amount	Artist's Expenses	Meals	Stipend
Friends of Weymouth, Inc.	None	None	Travel, food, personal needs, materials	Artists purchase own food and prepare own meals	None
The Gell Writers Center of the Finger Lakes	None	$25/day members, $35/day non-members	Travel, food, personal needs, materials	Artists purchase own food and prepare own meals	$1,250 for Gell Fellowship recipients only
The Hambidge Center for Creative Arts and Sciences	$20	$125/week	Travel, some food, personal needs, materials	Dinner provided Monday–Friday (May–October); artists purchase own food and prepare own meals all other times	Available only as part of scholarships that cover resident fees
Headlands Center for the Arts	None	None	Food, personal needs, materials	Dinner five times per week; artists purchase food and prepare all other meals	$500/month for live-in residents, $2,500 stipend for California non-live-in residents, airfare to and from San Francisco for non-California residents
Hedgebrook	$15	None	Personal needs, materials; applicants may apply for travel scholarships	Breakfast is self-serve, lunch is brought to residents' cottages, dinner is a communal meal in farmhouse dining room	None
The Institute for Contemporary Art, P.S. 1 Museum and The Clock Tower Gallery	None	None	National artists responsible for travel, food, personal needs, and all materials	Artists purchase own food and prepare own meals	International artists are sponsored by participating governments which includes $18,000 for annual living expenses, $2,000 for travel, and $1,000 for materials
Jacob's Pillow Dance Festival and School	None	None	Food, personal needs	Artists purchase own food and prepare own meals	None
John Michael Kohler Arts Center, Arts/Industry Program	None	None	Food, personal needs, shipping costs	Artists purchase own food and prepare own meals	$120 per week, plus travel reimbursement (within continental U.S.), materials
Kala Institute	None	$108–$324/month; no residency fee for fellowship recipients	Travel, food, personal needs, materials	Artists purchase own food and prepare own meals; full kitchen provided	None
Kalani Honua Eco-Resort, Institute for Culture and Wellness	$10	$60–$100/day (before discount)	Travel, food, personal needs, materials	Artists purchase own food and prepare own meals	None, though there is a 50% reduction in lodging fee
Light Work Visual Studies, Inc.	None	None	Travel, food, personal needs, materials	Artists purchase own food and prepare own meals	$1,200

Organization	Application Fee	Fee	Artist Pays For	Meals	Stipend
The MacDowell Colony, Inc.	$20 (one application per person per year)	Amount is voluntary	Materials, personal needs, voluntary residence fees; limited travel funds available for those in financial need	All meals provided	None
Mary Anderson Center for the Arts	$15	$30/day suggested minimum	Travel, personal needs, materials—unless a resident receives a fellowship which provides personal expenses covered by the award	All meals provided or reimbursed. Breakfast is do-it-yourself; lunch and dinner prepared. Sunday and Monday nights are do-it-yourself dinner, though the Center will reimburse restaurant receipts up to $6.50.	None; some fellowship support
Mattress Factory	None	None	Personal needs	Artists given per diem for meals	$500–$1,000
Medicine Wheel Artists' Retreat	None	$175–$295/week	Travel, personal needs, materials	All meals provided (vegetarian selection included)	None
The Millay Colony for the Arts	None	None	Travel, personal needs, materials	All food provided. Dinners prepared weeknights.	None
Montana Artists Refuge	None	$200–$400/month, utilities vary by season	Travel, food, personal needs, materials (some financial assistance, up to 50%, to help pay fee)	Artists purchase own food and prepare own meals	None
Nantucket Island School of Design and the Arts	$20	Varies	Travel, food, personal needs, materials	Artists purchase own food and prepare own meals; kitchen available	None, though some financial assistantships/work exchanges are available
National Playwrights Conference at the Eugene O'Neill Theater Center	$10	None	Personal needs	All meals provided	$1,000
Norcroft: A Writing Retreat for Women	None	None	Travel, personal needs, materials	Food provided, but artists prepare their own meals	None
Northwood University Alden B. Dow Creativity Center	$10	None	Personal needs	Lunch provided Monday through Friday at the Creativity Center; fellows purchase own food and prepare all other meals (per diem)	$750 to be used on project costs or personal needs
Oregon College of Art and Craft	None	None	Food, personal needs	Artists purchase own food and prepare own meals, cafe available on campus	$400 per month, plus travel and material allowance

Fees and Stipends

Organization Name	Application Fee	Residency Fee Amount	Artist's Expenses	Meals	Stipend
Ox-Bow	None	$348/week	Travel, personal needs, materials	All meals provided	None
Penland School of Crafts	$25	$50/month housing, $50/month studio	Travel, food, utilities, personal needs, materials, equipment	Artists purchase own food and prepare own meals	None
Pilchuck Glass School	$25	None	Travel, food, personal needs, materials	Artists purchase own food and prepare own meals	$1,000
Ragdale Foundation	$20	$15/day	Travel, personal needs, materials	All meals provided	None
Roswell Artist-in-Residence Program	$10	None	Travel, food, personal needs, materials, phone	Artists purchase own food and prepare own meals	$500/month; $100/month per dependent living at the community
Sculpture Space, Inc.	None	None	Travel, food, personal needs, materials, accommodations	Artists purchase own food and prepare own meals	For funded residencies, $2,000
Shenandoah International Playwrights Retreat	None	None	Personal needs	All meals provided	None
Sitka Center for Art and Ecology	None	None	Travel, food, personal needs, materials	Artists purchase own food and prepare own meals	None (except recipient of Founders' Series award)
Skowhegan	$35	$5,200 tuition, room, and board	Travel personal needs, materials	Three meals provided each day	Fellowships offered toward tuition
South Florida Art Center	$20	$6–$8/sq. ft. and energy surcharge of $1.60/sq. ft.	Travel, food, personal needs, materials (SFAC artists pay subsidized fee for studio space)	Artists purchase own food and prepare own meals	CAVA Fellowship $1,000/month plus housing; SFAC artists, none
STUDIO for Creative Inquiry	None	None	Travel, food, housing, personal needs	Artists purchase own food and prepare own meals, except for monthly meetings and special events	$30,000/year plus extensive benefits program. Some artists receive a small project fund.
Studios Midwest	None	None	Travel, food, personal needs, materials	Artists purchase own food and prepare own meals	None
Sundance Institute	$25		Personal needs	All meals provided	None, though travel and lodging are covered by Sundance Institute
Ucross Foundation Residency Program	$20	None	Travel, personal needs, materials	All meals provided; lunch delivered to studios, Monday-Friday; food provided for artists to prepare on weekends	None

Organization	Application Fee	Residency Fee	Artist Covers	Meals	Stipend/Support
Vermont Studio Center	$25	$1,300/month; aid/work exchange available	Travel, personal needs, materials	All meals provided	$10 per day for international artists
Villa Montalvo	$20	None	$100 security deposit (refunded), travel, food, personal needs, materials	Artists purchase own food and prepare own meals; once-a-week potluck	Four $400 fellowships given each year, based on merit
The Virginia Center for the Creative Arts	$25	$30/day voluntary fee	Travel, personal needs, materials	All meals provided	None
Walker Woods	$20 (per lifetime)	$250–600/month; aid/work exchange available	Travel, personal needs, materials (computers provided)	Breakfast and lunch on your own dinners are communal, with residents taking turns cooking	None
Watershed Center for the Ceramic Arts	$20	$700/two weeks	Travel, personal needs, materials (other than clay)	All meals provided	None
The Women's Art Colony Farm	None	None	Travel, $80/week for food, personal needs, materials	Artists contribute $80/week for food and prepare meals and eat together	None
Women's Studio Workshop	None	$200/week	Travel, food, personal needs, materials	Artists purchase own food and prepare own meals, occasional pot-lucks	Artists' Book Grants $1,800 for six weeks, materials up to $450
The Woodstock Guild's Byrdcliffe Arts Colony	$5	$400/month	Travel, food, personal needs, materials	Artists purchase own food and prepare own meals	None
The Corporation of Yaddo	$20	None	Travel, personal needs, materials	All meals provided	None
The Yard, Inc.	None	None	Travel, food, personal needs, materials (though there is some production allowance)	Artists purchase own food and prepare own meals	$200–$250 per week per resident; $150 travel allowance
Yellow Springs Institute	None	None	Travel, personal needs, materials	All meals provided	In the past, the range has been between $250–$3,000. A few special project commissions for new works have been provided to ensembles. All living expenses are provided, some materials and travel allowance available.

Disabled Access*

Organization Name	Housing	Housing Bathrooms	Studios	Public Bathrooms	Sight-Impaired	Hearing-Impaired	Other Disabilities	Comments
American Academy in Rome	X	X	X					
Anderson Ranch Arts Center	X	X	X					Accessible wood shop, dark room, ceramics facilities. Most studios and bathrooms are accessible. All will be soon.
Archie Bray Foundation for the Ceramic Arts								Call to see if accommodations can be made for specific needs.
Arrowmont School of Arts and Crafts	X	X	X	X	X			Currently, a new accessible studio under construction. Do not have any special facilities for sight- or hearing-impaired residents, but will make accommodations.
Art Awareness, Inc.								Call to see if accommodations can be made for specific needs.
Art Farm								Call to see if accommodations can be made for specific needs.
ART/OMI	X	X		X	X			
ArtPace		X	X	X				If an artist is selected every effort will be made to accommodate them. In 1997 all areas will be wheelchair-accessible.
Atlantic Center for the Arts	X	X	X	X				Four rooms especially equipped for handicapped.
Bemis Center for Contemporary Arts								Accessible installation space, fabrication studio spaces. In 1997 housing, studios, and bathrooms will be wheelchair-accessible.
Blue Mountain Center								Possible to accommodate sight- or hearing-impaired residents, but there are no special facilities.
Capp Street Project	X		X					
The Carving Studio and Sculpture Center, Inc.		X	X	X				
Centrum								Cottages are not yet wheelchair-accessible, however the cottages are in a State Park that does have wheelchair-accessible facilities.
Contemporary Artists Center			X					
Creative Glass Center of America		X	X	X				
Djerassi Resident Artists Program					X		MS, Chronic Fatigue Syndrome	
Dorland Mountain Arts Colony					X			Wheelchair-accessibility is possible but would be difficult. Call for details.
Dorset Colony House				X	X			
Edward F. Albee Foundation/William Flanagan Memorial Creative Persons Center	X	X						Have had disabled residents and deal with each artist's disability on an individual basis.

216

Accessibility information table (organizations listed with accessibility marks and notes):

Organization	Notes
Exploratorium	Will make accommodations as needed.
The Fabric Workshop and Museum	
Fine Arts Work Center in Provincetown	
Friends of Weymouth, Inc.	No special facilities for sight- or hearing-impaired residents but would make every effort to accommodate them should they apply.
The Gell Writers Center of the Finger Lakes	Accessible letter press print shop. All alarm systems flash as well as sound.
The Hambidge Center for Creative Arts and Sciences	
Headlands Center for the Arts	
Hedgebrook	
The Institute for Contemporary Art, P.S. 1 Museum and The Clock Tower Gallery	
Jacob's Pillow Dance Festival and School	
John Michael Kohler Arts Center, Arts/Industry Program	It would be very difficult to get around in a wheelchair. We would have to consider each individual according to their needs and the extent of his/her disability.
Kala Institute	Accessible Electronic Media Center with seven Mac work stations. Work to improve access is underway.
Kalani Honua Eco-Resort, Institute for Culture and Wellness	Accessible studio space (5 rooms), computers, copy machines. Will accommodate sight- and hearing-impaired residents but no special facilities.
Light Work Visual Studies, Inc.	Both the apartment and the building that houses Lightwork are wheelchair-accessible.
The MacDowell Colony, Inc.	Accessible film editing, darkroom, printmaking studio, composers' studio with piano. All buildings are accessible. No special facilities for sight- or hearing-impaired residents. Staff adapts to needs of each resident. (Speech-impaired)
Mary Anderson Center for the Arts	Accessible kiln, 2 Vandercook printing presses.
Mattress Factory	Call to see if accommodations can be made for specific needs.
Medicine Wheel Artists' Retreat	Accessibility depends on the site. Have sign language literate staff member.
The Millay Colony for the Arts	By 1997 hope to have a completely accessible building.
Montana Artists Refuge	Call to see if accommodations can be made for specific needs.
Nantucket Island School of Design and the Arts	Two cottages are accessible, currently working to improve access in bathrooms. Have excellent cooperation with local EMT. Have had blind students in clay and dance classes and elders and students with hearing impairments. (Grand Mal Epilepsy)

Disabled Access*

Organization Name	Housing	Housing Bathrooms	Studios	Public Bathrooms	Sight-Impaired	Hearing-Impaired	Other Disabilities	Comments
National Playwrights Conference at the Eugene O'Neill Theater Center	X	X	X	X				Accessible route from housing to studio.
Norcroft: A Writing Retreat for Women	X	X	X					Call to see if accommodations can be made for specific needs.
Northwood University Alden B. Dow Creativity Center								Will make accommodations for residents with other disabilities.
Oregon College of Art and Craft	X	X	X	X	X			Call to see if accommodations can be made for specific needs.
Ox-Bow	X	X	X					Call to see if accommodations can be made for specific needs.
Penland School of Crafts								Call to see if accommodations can be made for specific needs.
Pilchuck Glass School	X	X	X					Call to see if accommodations can be made for specific needs.
Ragdale Foundation	X	X						Will try to accommodate each individual's special needs.
Roswell Artist-in-Residence Program					X			Flexible, will do what they can to accommodate residents with disabilities.
Sculpture Space, Inc.			X	X				As they renovate and add structures, accessibility will be addressed.
Shenandoah International Playwrights Retreat	X	X		X	X			Accessible kiln, potter's wheel, slide projection, printing press (etching). One studio and bathroom for sight-impaired residents. No specific facilities for hearing-impaired residents.
Sitka Center for Art and Ecology	X	X	X	X	X			Call to see if accommodations can be made for specific needs.
Skowhegan			X	X				Would make adjustments to accommodate artists with disabilities. Have access to technologies for sight-impaired residents and access to signers for hearing-impaired residents.
South Florida Art Center			X	X				Call to see if accommodations can be made for specific needs.
STUDIO for Creative Inquiry	X	X	X	X	X			Call to see if accommodations can be made for specific needs.
Studios Midwest								Have no special facilities for sight- or hearing-impaired residents, but will make accommodations to serve these populations.
Sundance Institute								Accessible lecture hall. Can accommodate sight- and hearing-impaired residents, but do not have any special facilities.
Ucross Foundation Residency Program	X	X	X	X				Accessible studios and housing are available but limited in number. A new facility with greater accessibility will be built in 1998.
Vermont Studio Center	X	X	X	X				Do not have a roll-in shower but have had artists in wheelchairs in residence.
Villa Montalvo	X	X	X	X	X			
The Virginia Center for the Creative Arts	X	X	X					

Organization						Notes
Walker Woods	X	X				
Watershed Center for the Ceramic Arts	X	X	X			
The Women's Art Colony Farm	X	X	X			
Women's Studio Workshop						Call to see if accommodations can be made for specific needs.
The Woodstock Guild's Byrdcliffe Arts Colony						Call to see if accommodations can be made for specific needs.
The Corporation of Yaddo	X	X				Accessible darkroom and visual artists' studios. Will try to accommodate any disability.
The Yard, Inc.		X				Accessible theatre.
Yellow Springs Institute						Call to see if accommodations can be made for specific needs.

*Please also see "Facilities" and "Housing" under the individual community descriptions. We also advise that you call the communities for current information, since most are continually improving their ability to serve disabled artists.

About the Alliance of Artists' Communities

The Alliance of Artists' Communities is a national service organization that supports the field of artists' communities and residency programs. It does this by encouraging collaboration among members of the field, raising the visibility of the field, providing leadership on field issues, setting standards for administrative procedures, and promoting philanthropy in a field that is chronically under-recognized and under-funded.

The Alliance of Artists' Communities grew out of the John D. and Catherine T. MacArthur Foundation's Fellowship Program's 1990 program entitled "Special Initiative on Artists' Colonies, Communities, and Residencies." The eighteen recipients of grants under this one-time program began meeting in early 1991, then formed the Alliance in September of 1992 with seed money from the MacArthur Foundation and the National Endowment for the Arts. The Alliance continues operation with the support of dues from its members, funding from The Pew Charitable Trusts, and further support of our education and outreach activities from the MacArthur Foundation and other philanthropic entities.

Now made up of twenty-seven leading, non-profit artists' communities (Institutional Members) and thirty-five Associate and Individual Members from across the country, the Alliance continues to accept new members who provide artists with time, space, facilities, and a community environment in which to create their work. (See the Preface for the Alliance's four main criteria for institutional membership.)

Alliance Mission Statement

The Alliance of Artists' Communities is a national consortium of organizations and individuals established to improve the environment in which artists' communities support artists and their creative processes. The Alliance promotes the leadership role artists' communities play in enriching the nation's cultural heritage and seeks to strengthen artists' communities in fulfilling their respective missions.

Alliance Executive Committee

Charles Amirkhanian (Djerassi Resident Artists Program), *Chair*

Suzanne Fetscher (Atlantic Center for the Arts), *Vice-Chair*

Judith Barber (The Hambidge Center for Creative Arts and Sciences)

Laurence Miller (ArtPace)

Judy Moran (Villa Montalvo Artist Residency Program)

Kathryn Reasoner (Headlands Center for the Arts)

Michael Wilkerson (Fine Arts Work Center in Provincetown)

Mary Carswell (The MacDowell Colony, Inc.), *Ex-Officio (and Former Chair)*

Peter Richards (Exploratorium), *Ex-Officio*

Alliance Staff

Tricia Snell, *Executive Director*

Miriam Z. Feuerle, *Project Coordinator*

Alliance Institutional Members

Anderson Ranch Arts Center, *Snowmass Village, CO*

ART/OMI, *Omi & New York, NY*

ArtPace, *San Antonio, TX*

Atlantic Center for the Arts, *New Smyrna Beach, FL*

Bemis Center for Contemporary Arts, *Omaha, NE*

Capp Street Project, *San Francisco, CA*

Djerassi Resident Artists Program, *Woodside, CA*

Exploratorium, *San Francisco, CA*

Fine Arts Work Center in Provincetown, *Provincetown, MA*

The Gell Writers Center of the Finger Lakes, *Rochester, NY*

The Hambidge Center, *Rabun Gap, GA*

Headlands Center for the Arts, *Sausalito, CA*

Hedgebrook, *Langley, WA*

The Institute for Contemporary Art/P.S. 1 Museum, *Long Island City, New York*

The MacDowell Colony, *Peterborough, NH*

221

Allworth Books

Allworth Press publishes quality books to help individuals and small businesses. Titles include:

Arts and the Internet by V. A. Shiva
(softcover, 6 × 9, 208 pages, $18.95)

The Artist's Complete Health and Safety Guide, Second Edition by Monona Rossol (softcover, 6 × 9, 344 pages, $19.95)

Legal Guide for the Visual Artist, Third Edition by Tad Crawford (softcover, 8½ × 11, 256 pages, $19.95)

Business and Legal Forms for Fine Artists, Revised Edition by Tad Crawford (softcover, 8½ × 11, 144 pages, $16.95)

The Fine Artist's Guide to Marketing and Self-Promotion by Julius Vitali (softcover, 6 × 9, 224 pages, $18.95)

Caring For Your Art, Revised Edition by Jill Snyder
(softcover, 6 × 9, 192 pages, $16.95)

Booking and Tour Management for the Performing Arts by Rena Shagan (softcover, 6 × 9, 272 pages, $19.95)

Mastering the Business of Writing by Richard Curtis
(softcover, 6 × 9, 272 pages, $18.95)

The Writer's Legal Guide by Tad Crawford and Tony Lyons
(softcover, 6 × 9, 304 pages, $19.95)

Lectures on Art by John Ruskin, introduction by Bill Beckley
(softcover, 6 × 9, 224 pages, $18.95)

The Laws of Fésole: Principles of Drawing and Painting from the Tuscan Masters by John Ruskin, introduction by Bill Beckley
(softcover, 6 × 9, 208 pages, $18.95)

Please write to request our free catalog. If you wish to order a book, send your check or money order to Allworth Press, 10 East 23rd Street, Suite 400, New York, NY 10010. Include $5 for shipping and handling for the first book ordered and $1 for each additional book. Ten dollars plus $1 for each additional book if ordering from Canada. New York State residents must add sales tax.

If you wish to see our catalog on the World Wide Web, you can find us at Millennium Production's Art and Technology Web site:

http://www.arts-online.com/allworth/home.html
or at **http://www.interport.net/~allworth**